# 地域を活かす！

おいしい
お土産の
アイデアと
デザイン

IDEAS AND DESIGN
FOR DELICIOUS
SOUVENIRS

g

インパクト・コミュニケーションズ編

はじめに

贈る楽しみや贈られる喜び。
旅の醍醐味の大きなひとつがお土産選びでしょう。
全国各地に地域の特性を存分に発揮した、
アイデアあふれるお土産があります。
手にとるだけでワクワクする愛らしいお菓子や
強烈なインパクトを放つ絶品ギフトまで、
味はもちろん、個性豊かなラインナップを楽しむことができます。

SNS全盛時代において、それぞれの地域で商品開発に携わる方たちは、
ファンづくりをしながら、どうブランドを育んでいくのかをテーマに
試行錯誤を繰り返しています。
また、商品の個性を徹底的に追求することで他商品との差別化をはかり、
ブランド力を進化させる試みに果敢にチャレンジしています。

本書では、全国の土産物の中から最新のものを中心に
お土産としての魅力にあふれた108ブランドを厳選して紹介します。
パッケージデザインのみならず、商品の内容やポイントなども解説。
商品開発に関わるメーカーご担当者、
パッケージデザインに携わるデザイナーの
皆様の一助となる一冊になれば幸いです。

最後になりましたが、本書の制作に多大なご協力いただきました
企業の皆様、クリエイターの方々に、心からお礼を申し上げます。

# contents

# 地域のつくり手に潜む強みを探し出し、
# 買い手と気持ちをつなぐ商品を生み出す

「地域の特性を活かし、売り場で思わず手に取りたくなるような土産品を
開発したい——」。そんなとき持つべき視点とは？
これまで数々の全国の中小企業や店に伴走し、
オリジナリティあふれる商品を生み出してきたセメントプロデュースデザインの
クリエイティブ・ディレクター金谷 勉氏に話を伺った。

### 金谷 勉　Kanaya Tsutomu

PROFILE

広告制作会社を経て、1999年にデザインプロデュース会社「セメントプロデュースデザイン」
設立。現在、大阪・東京を拠点に、大手企業の広告からWeb、プロダクト、パッケージ、イベン
ト企画など幅広く手掛ける。各地の中小メーカーや行政団体と連携した商品開発・プロ
デュースの実績も多く、同テーマの勉強会も開催。著書に『小さな企業が生き残る』(日経
BP) がある。

## 商品開発をスタートする前に

　金谷氏が日本各地のものづくりの現場でプロジェクトに携わるようになったのは、2011年頃からのこと。愛知県瀬戸市で陶器原型職人の商品開発をサポートしたことがきっかけだった。

「お世話になっていた方の紹介で偶然ご一緒することになり、表面に精巧な凹凸（模様）のあるマグカップを商品化しました。手間はかかりますが、高い手彫り技術を活かした“そこでしかつくれないもの”です」（金谷氏、以下同）

　発売されるとたちまち話題となりメディアにも取り上げられ、それを契機として、金谷氏のもとには全国から中小メーカーや地方自治体が相談に訪れるようになった。

　現在、セメントプロデュースデザイ

ンでは商品開発のスタートアップから流通まで、つまり1から10まで協働するケースが多いそうだが、金谷氏は実は“ゼロから1”の段階を重視していると言う。

「最初の打ち合わせで、設備や現状の売上の内訳など細かくヒアリングします。新商品というのはなんでもいいわけではない。ある程度の規模の会社なら次の事業展開につながるようなものの方が良いですし、ご家族でやっているようなところでは、多少値が張っても安定してまわせる商品が必要だったりします」

　そうした事前の検証を十分にしないまま、つい“つくりやすいもの”をつくってしまうメーカーや店も多いというが、商品ができたあとに“今っぽいデザイン”でパッケージしても、それだけで売れるとは限らないのだ。

## ヒット商品より
## 事業が持続する状況を

　プロジェクトがキックオフすると、自社分析に続き「差別化のポイント」「売り先の検証」「ブランドコンセプトの確立」「商品ターゲットと使用イメージ」など細かく段階を踏みながら商品の開発・リリースまで導いていく。さらに発売後もイベント出展、販路の設計強化……とそのステップは続く。

「商品をつくったら、当然誰かがそれを売らなければいけませんよね。試しに自社のECサイトで売ってみるにしても、撮影は誰がやるのか。梱包は？発送作業は？都度外注するのも、そのために人を雇用するのも厳しい場合はどうするか、開発の時点で当然そこまで見据えていないといけない」

　売れてもそれを継続できなければ意味がない。そんな状況を防ぐには

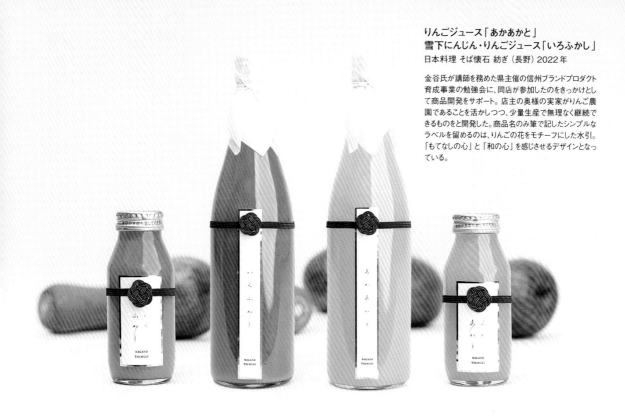

りんごジュース「あかあかと」
雪下にんじん・りんごジュース「いろふかし」
日本料理 そば懐石 紡ぎ（長野）2022年

金谷氏が講師を務めた県主催の信州ブランドプロダクト育成事業の勉強会に、同店が参加したのをきっかけとして商品開発をサポート。店主の奥様の実家がりんご農園であることを活かしつつ、少量生産で無理なく継続できるものをと開発した。商品名のみ筆で記したシンプルなラベルを留めるのは、りんごの花をモチーフにした水引。「もてなしの心」と「和の心」を感じさせるデザインとなっている。

初期段階から多角的な視点が必要で、セメントプロデュースデザインではプロデュース部とデザイン部という立場の異なる部署が連携しながらプランニングを行なっている。また企業側には、打ち合わせの場に経営者だけでなく複数の現場担当者の参加をお願いしているそうだ。

本書p.76で紹介している静岡のわさび専門店「カメヤ食品」の一連の商品群は、セメントプロデュースデザインが同社とタッグを組んで生まれたものだが、このときも現場の声が開発の方向性の決め手となった。

「依頼を受けた直後に新型コロナの流行が始まり、社長から一時はプロジェクト自体を取りやめる話もあったのですが、損失を取り戻すために敢えてチャレンジして商圏を広げたいという参加メンバーの営業担当の方々からの想いを受け、新商品や既存商品のリニューアルを進めていくことになりました。新商品「伊豆わさびピスタチオ」が発売1年で約26万個販売という結果を出せたのは、SNSでの拡散効果もありましたが、駅店舗の販路確保など、早い段階でのメンバーの皆さんの営業努力が大きかったと思います」

## 今、土産品に求められるもの

出張が多く、消費者の一人としても土産物店をよく利用するという金谷氏。
「この数年、バラ売りが増えてきていますよね。かつてのように、箱で買って会社中に配って……という機会が減りお土産の役割が変わってきている。そんななかで売り場を見渡すと、気づくこともあるんです。急いでいるときサッと買える場所に“高級手土産”がないなとか、チープに見えず、ひと目でその土地をアピールできる手頃な菓子が意外と少ないなとか」

昔も今も、常に競争が熾烈な土産業界。売れればすぐに類似品が出回り、あらゆる商品が出尽くした感もあるが、けれども「まだやれることはあるはず」と金谷氏は考える。

そのためにまずは自社が持つアドバンテージを見極め、それを軸に土産品を取り巻くあらゆるシーンを想定すること。そして、つくるのは商品一つでも、それをきっかけに地域や自社のあり方まで捉え直すような姿勢で臨むこと。そんな気持ちこそが売り場で買い手の心を掴む土産品を生むのだろう。

構成・文＝グラフィック社編集部

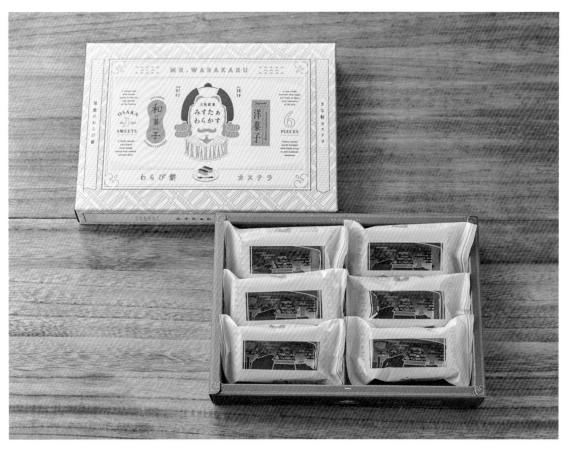

「大阪銘菓 みすたぁわらかす」
みどり製菓（大阪）2019年

カステラの上にわらび餅がのった和洋折衷スイーツ。発売後たちまち話題となり、大阪土産の新定番となった商品だ。セメントプロデュースデザインはその開発からパッケージデザイン、販促まで伴走した。まず、みどり製菓が持つ「機械ではできない職人の技」という強みをふまえ、試行錯誤を重ねながら菓子を開発。パッケージデザインでは「40代男性が大切な顧客に持っていける」……など購入シーンを具体的に想定しながらプランニングを行ない、大阪らしいクスッと笑えるモチーフを上品な雰囲気に仕上げた。

わらび餅を保護するフィルムには、大阪城や通天閣のイラストが描かれている。個包装は手を汚さないトレイタイプで土産にピッタリ。

侍のカツラ（和）を被った南蛮人（洋）の顔という、インパクトあるロゴ。"和洋折衷"を大阪ならではのユーモアで表現しつつ、白を基調としたすっきりしたデザインで、色が溢れる土産物売り場で逆に目を引く存在に。

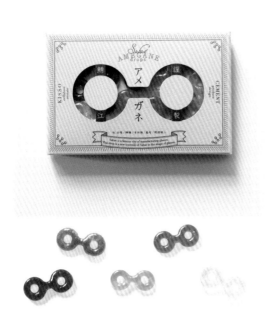

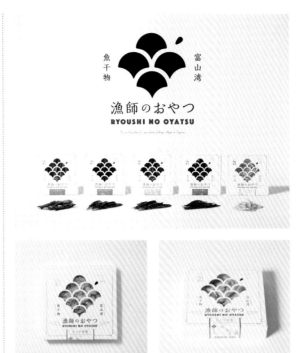

**「Sabae AMEGANE（アメガネ）」**
KISSO、朝倉製菓（福井）2016年

眼鏡の生産地として知られる福井県鯖江市ならではのかわいい菓子。地元の眼鏡素材商社、製菓メーカーと共に開発した。眼鏡型にくり抜かれたパッケージの窓から、同じく眼鏡型の5種のカラフルなキャンディが覗く。手頃な価格帯で、鯖江という街を伝える際の名刺代わりとなる手土産。

**「漁師のおやつ」** カネツル砂子商店（富山）2017年

富山湾の海産物加工会社として、110年以上の歴史を持つカネツル砂子商店。「漁師のおやつ」は、同店の素材の良さを存分に活かし、若い世代にも好まれる味を目指して開発されたおつまみブランド。贈り物としても喜ばれるようネーミングやデザインをつくり込み、新たな客層を獲得した。

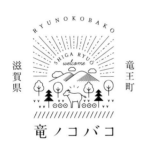

**地域ブランド「竜ノコバコ」** 滋賀県竜王町（滋賀）2020年

滋賀の南東に位置する竜王町は、米や野菜、果物などの特産物が豊富な町。その食の恵みを詰め込んだシリーズで、ネーミング、ロゴ、パッケージなど一連のブランディングを担当。ラベルには「鏡山」と「雪野山」に囲まれて育つ、竜王町発祥の近江牛や農産物が描かれている。

**「京都離宮」**
プレメーズ（京都）2022年

京都に誕生した、だし専門店「京都離宮」。その看板商品である「だし巻き」「出汁パック」のパッケージデザインと、店内ディスプレイをプロデュース。「だし巻き」のパッケージには、季節によって移り変わる京都伏見の名所風景をあしらい、だし文化と古都の魅力を伝えている。

# 本書の見方

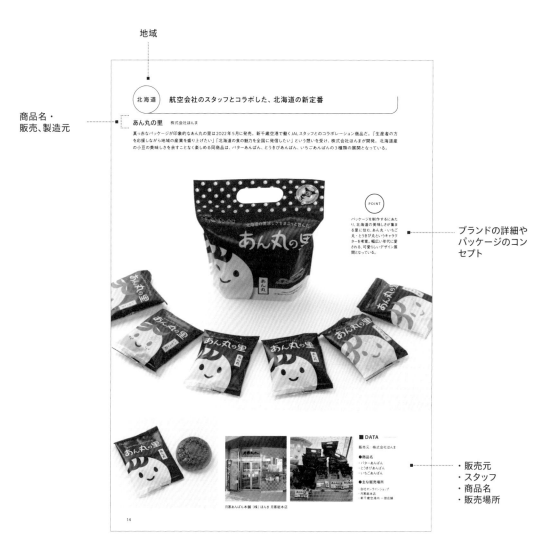

地域

商品名・
販売、製造元

ブランドの詳細や
パッケージのコンセプト

・販売元
・スタッフ
・商品名
・販売場所

---

●CREDIT

AD…アートディレクター　　　　Ph…フォトグラファー
D …デザイナー　　　　　　　　PR…プロデューサー
CD…クリエイティブディレクター　PL…プランナー
Dr…ディレクター　　　　　　　※代表的な略称です。
I…イラストレーター

※季節商品、限定商品など、販売を終了している商品があります。

和菓子
洋菓子
酒
お茶
果汁飲料
レトルト
缶詰…

# 北の大地をテーマに
# 老舗の商品を現代的にリブランディング

**ノースマン・生ノースマン**　千秋庵製菓株式会社

創業100年を超える千秋庵製菓の主力商品である「ノースマン」。パイ生地と北海道産小豆のあんを使用した元祖和洋折衷スイーツで、誕生から約半世紀もの間、土産菓子として親しまれてきた。今後100年を見据えて、2022年5月にパッケージデザインを刷新。デザインには、北国文化が感じられる織物や編み物をモチーフとして採用、当時つくられたロゴをそのまま生かして「北の大地に生きる人々のたくましい力を表現するブランド」として現代的にアップデートした。

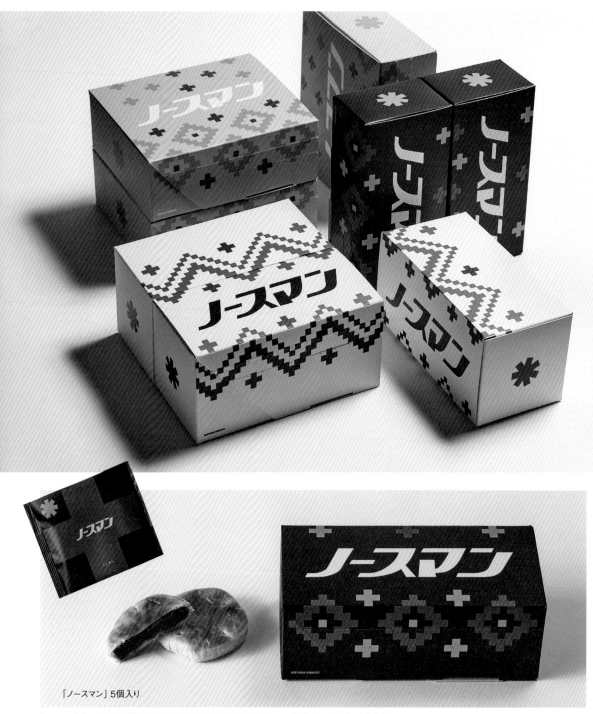

「ノースマン」5個入り

「ノースマン」は、パイ生地と北海道産小豆のあんを使用した元祖和洋折衷スイーツ。地元の人にも愛されてきた味だ。

ロゴタイプは「北の人」をイメージし、北
海道を代表する画家／デザイナーの
栗谷川健一さんにより約半世紀前につ
くられた。伸びやかな佇まいを強調する
ように、ロゴや模様を大胆に配置した
パッケージデザインとなっている。

「ノースマン」8個入り

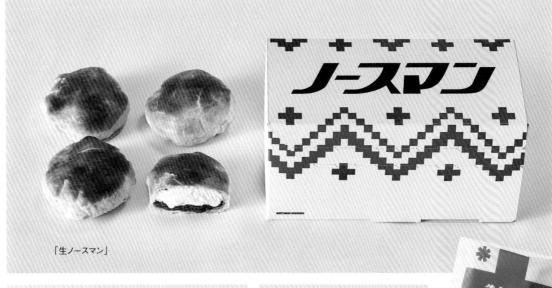

「生ノースマン」

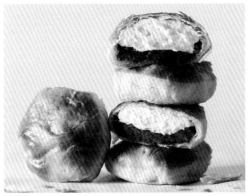

次世代にも美味しさを届け
るために、生菓子として誕
生したのが「生ノースマン」。
生クリームがたっぷりと入っ
ている。

## ■ DATA ·····················

販売元：千秋庵製菓株式会社
AD：貞清誠治、阿座上陽平
D：貞清誠治、杉浦良輔
Logo：栗谷川健一

● 商品名
・ノースマン
・生ノースマン

● 販売場所
・ノースマン大丸札幌店
・千秋庵新千歳空港店

ノースマン大丸札幌店

## 航空会社のスタッフとコラボした、北海道の新定番

### あん丸の里　株式会社ほんま

真っ赤なパッケージが印象的な「あん丸の里」は2022年5月に発売。新千歳空港で働くJALスタッフとのコラボレーション商品だ。「生産者の方を応援しながら地域の産業を盛り上げたい」「北海道の食の魅力を全国に発信したい」という思いを受け、株式会社ほんまが開発。北海道産の小豆の美味しさを余すことなく楽しめる同商品は、バターあんぱん、とうきびあんぱん、いちごあんぱんの3種類の展開となっている。

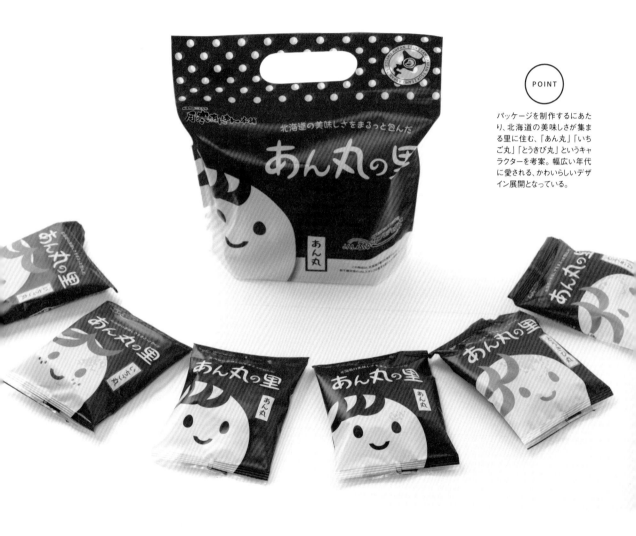

**POINT**

パッケージを制作するにあたり、北海道の美味しさが集まる里に住む、「あん丸」「いちご丸」「とうきび丸」というキャラクターを考案。幅広い年代に愛される、かわいらしいデザイン展開となっている。

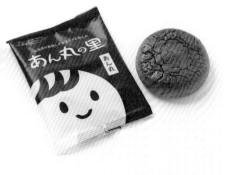

月寒あんぱん本舗（株）ほんま 月寒総本店

**■DATA** ·········

販売元：株式会社ほんま

**●商品名**
・バターあんぱん
・とうきびあんぱん
・いちごあんぱん

**●主な販売場所**
・自社オンラインショップ
・月寒総本店
・新千歳空港内 一部店舗
など

焼きとうもろこしのイラストがインパクト大で気軽さを演出

## Oh！焼とうきび チョコレートサンド　株式会社YOSHIMI

株式会社YOSHIMIの看板商品である「札幌おかきOh！焼とうきび」の香ばしい味わいを生かしたとうきびチョコレートを開発し、ラングドシャで包んだらどんなに美味しいだろうという思いで発売された。レストランが母体の同社だが、気取らない印象を表現したいという思いをパッケージデザインに込めている。手書きの商品名に合わせて、お菓子のイメージは線画のイラストで表現。シズル感を伝え、美味しそうにみえることにこだわった。

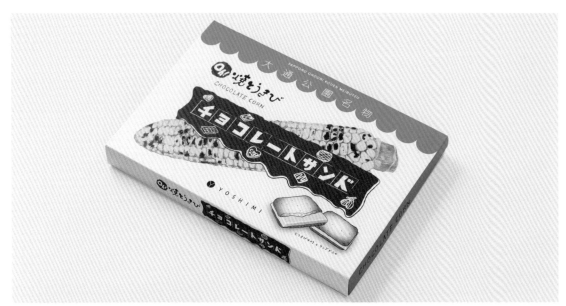

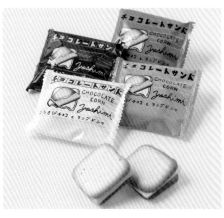

**POINT**

個包装は、4色のカラフルなカラーバリエーションで展開。楽しい雰囲気になる効果を演出している。

### ■ DATA

販売元：株式会社YOSHIMI
AD・D：野坂朋子（T.N.デザインオフィス）
D：株式会社新生
CD：勝山良美（株式会社YOSHIMI）
I：勝山良美（株式会社YOSHIMI）、野坂朋子（T.N.デザインオフィス）
進行管理：今江尚樹（株式会社新生）

● 商品名
・Oh！焼とうきび チョコレートサンド

● 主な販売場所
・道内の主要空港
・札幌駅
・道内の主要お土産店
・道内のホテル
・自社オンラインショップ など

北海道キッチンYOSHIMI　イオンモール岡崎店

# 機能美を備えた、日本最北の温泉郷の人気バター

## とよとみフレーバーバター　川島旅館

日本最北の温泉郷と言われる北海道・豊富温泉にある温泉旅館、川島旅館。豊富町は酪農が基幹産業の町であることから、川島旅館では牛乳と生クリームを使用したプリンやバターを販売。単なるバターではなく、さまざまなシーンで楽しんでもらえるようにと甘いものから和食に合うしょうゆ味など15種類のフレーバーを提供。旅館での朝食は、北海道のソウルフードであるバターしょうゆごはんを、さまざまなバターで楽しめる。その美味しさに手土産として購入する観光客が絶えない。

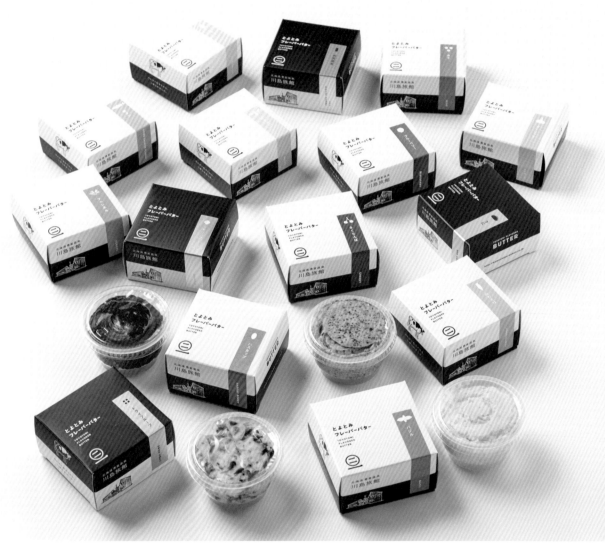

**POINT**

販売開始時のパッケージもコンパクトでかわいらしいデザインで好評だったが、持ち歩きに向かないことや、ショーケース陳列時に目立ちにくかったことから2019年にパッケージリニューアル。旅館のシンボルカラーである濃紺を軸に全体のブランドイメージを統一。元々使われていた川島旅館のロゴマークをベースに各ツールのデザインを展開した。

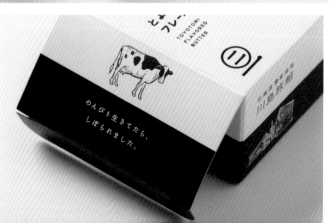

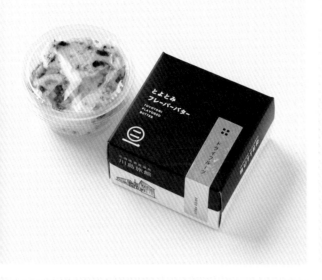

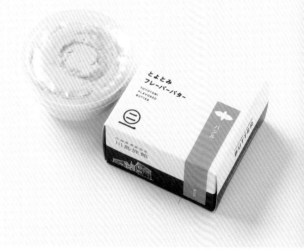

元々規格が違ったバターとプリンのパッケージを、同一のギフトボックスで販売できるようにリニューアル。バターの箱2個分で、プリンのケースと1個と同じサイズになるように設計し、ギフトボックスと紙袋を共用することで、資材の無駄を軽減。

見た目を美しくするだけのデザインリニューアルではなく、機能面も考慮した。パッケージング作業の手間が減るとその分の人件費が抑えられることや、資材の種類を減らすことで在庫リスクやコストを抑えられるなど、効率や使い勝手の機能美と、見た目などの造形美のバランスを両立することを目指した。

## ■ DATA ..........................................

販売元：川島旅館
デザイン会社：arica design inc.
AD・D：早坂宣哉
C：遠藤誠之
CD：小林仁志

### ●商品名
・とよとみフレーバーバター

### ●主な販売場所
・川島旅館売店
・きたキッチン（札幌）
・新千歳空港
・楽天市場
・komerco
・ANAショッピング など
※春、秋は首都圏を中心とした百貨店物産展などでも販売。

| 北海道 |
|---|

# 旭山動物園の動物たちを描いた
# 思わずジャケ買いしたくなるカップ酒

## ずZOOっと旭山セット　高砂酒造株式会社

思わずパケ買いしたくなる、かわいいカップ酒。ツンドラ（寒帯凍原の動物）・北海道（北の大地の動物）・サバンナ（熱帯草食の動物）の3つテーマで旭山動物園の動物たちが描かれている。明治32年創業の高砂酒造が、日本酒をもっと女性に親しんでもらいたいと開発を始めたのは2009年。印刷瓶を採用し、地元のデザイナーのあべみちこ氏に共同開発を依頼。発売後から話題を集め、たちまちロングセラー商品に。2021年、デザインをリニューアルしSNSでも話題沸騰。

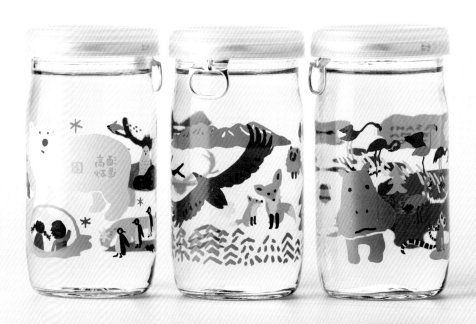

飲み終わった瓶はコップや容器として使ったり、再利用ができる。

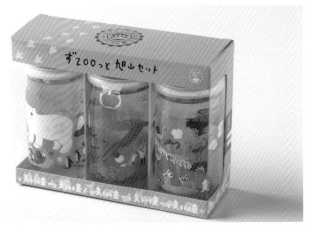

 **POINT**　瓶を回すと奥の面と重なり奥行きのある絵柄になったり、高砂酒造の文字が隠されていたりと遊び心をふんだんにちりばめている。

### ■ DATA

販売元：高砂酒造株式会社
I：あべみちこ（よつば舎）

●商品名
・ずZOOっと旭山セット

●主な販売場所
・全国の酒類販売店
・高砂酒造直売店
・自社オンラインショップ　など

青森

# 仕込み樽の縄モチーフと金銀カラーで贈答用にも最適な仕様に

## マルシチ 津軽焼肉のたれ　津軽味噌醤油株式会社

地元大鰐（おおわに）温泉の温泉熱を利用して発酵・熟成させた「マルシチ津軽味噌」を提供する青森県の「津軽味噌醤油」。2019年に青森県内の食材にこだわった発酵調味料をつくろうと開発された「津軽焼肉のたれ」は、「津軽味噌」や「マルシチ本醸造醤油」をベースに、青森県産りんごを使用したすりおろしりんご、青森県産にんにくを使用したすりおろしにんにく、りんご酢などを加えた味わい深い一品。焼肉の付けダレとしてはもちろん、揉みダレや、チャーハン、野菜炒めなどさまざまな料理のアクセントにおすすめだ。

POINT

みそ仕立て、しょうゆ仕立ての2種類に共通するイメージとして、仕込み樽の縄をデザインモチーフに取り入れた。フォント、色づかいに気を配り、スマートな容器でモダンな印象でありながら老舗の醸造蔵で造られた商品であることも表現。日常使いにもして欲しいという思いから、高級感が出過ぎないよう金箔銀箔は使わず、それぞれ金、銀の用紙に1色刷りで印刷コストを抑えるように心掛けた。

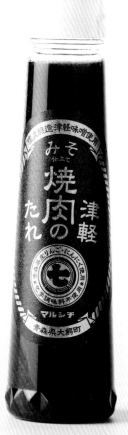

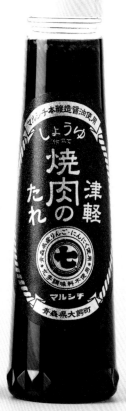

### ■ DATA

販売元：津軽味噌醤油株式会社
デザイン会社：デザイン工房エスパス
AD：木村正幸
D：山本亜希子

●商品名
・津軽焼肉のたれ みそ仕立て
・津軽焼肉のたれ しょうゆ仕立て

●主な販売場所
・青森県内の主要百貨店
・スーパー
・お土産店
・道の駅
・自社オンラインショップ など

## 全国区の祭りをモチーフに
## 愛嬌のある金魚の顔が人気をひとりじめ

金魚ねぶた　　上ボシ武内製飴所

パッケージの紺色と金魚の赤色のコントラストがレトロで印象的なお菓子。青森県産紅玉りんごをふんだんに使用したひとくち羊羹で、ほどよい酸味がアクセントだ。安政5年創業の上ボシ武内製飴所。毎年、青森祭「ねぶた」の時期になると、街中に「金魚ねぶた」と呼ばれる紙風船をぶら下げる風習があり、これを商品にできないかと考案したという。

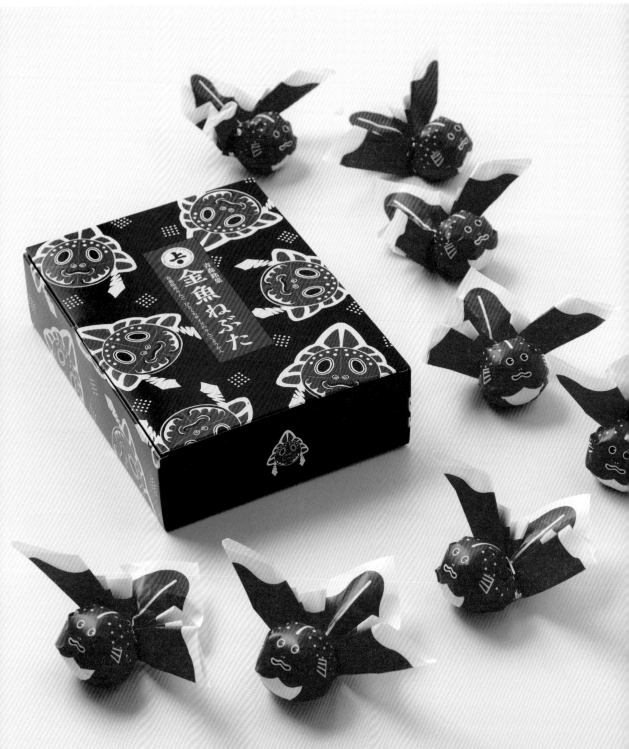

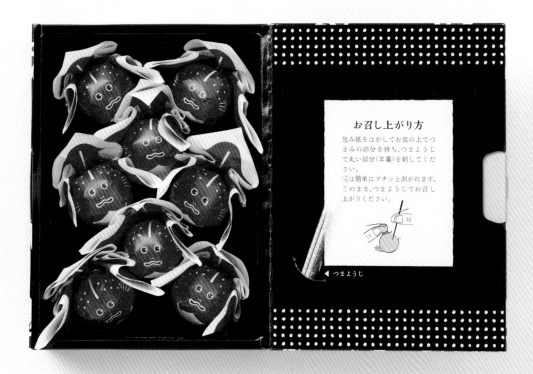

POINT　化粧箱を開けると、愛きょうのある顔の表情が特徴の真っ赤な金魚の包み紙が現れる。フタの裏側には、食べ方が記載され、爪楊枝が添えられている。

羊羹に爪楊枝を刺すと、皮がつるんとむけて中身が出てくる。

■ DATA ·················

販売元：上ボシ武内製飴所

●商品名
・金魚ねぶた

●主な販売場所
・自店舗
・青森空港
・新青森駅
・青森駅ビル
・青森観光物産アスパム など

上ボシ武内製飴所

# 盛岡のソウルフードを気軽に持ち帰れるかたちに

**あんバターサンドクッキー**　株式会社おとぎの里

生成りのベース色に、中央に商品のビジュアル。その傍にはあんなどの素材をイメージしたイラストが配置された、懐かしさを感じるパッケージデザイン。岩手の新たな名物をつくろうと、盛岡市民のソウルフード「福田パン」の不動の人気ナンバーワンである「あんバター」をモチーフにお菓子を企画した。柔らかいパンのイメージやあんとバターの味のバランスを崩さないように試作を重ね、遠方への持ち帰りが難しいコッペパンを焼き菓子に仕上げた。

POINT

1948年創業という福田パンの「昭和レトロで欧米風」なイメージを、デザインとパッケージの素材で表現。箱の素材は、サンダイヤホワイトにOPニス加工をほどこして、質感を出している。

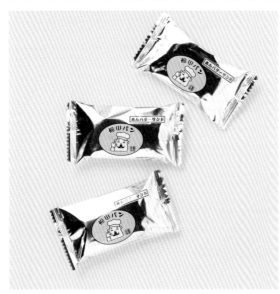

個包装にも、福田パンのおなじみのイラストが。

紫波SA上り売店

JR盛岡駅売店

---

■ DATA

販売元：株式会社おとぎの里

● 商品名
・あんバターサンドクッキー

● 主な販売場所
・東北自動車道岩手県内SA・PA
・JR盛岡駅
・JR花巻駅
・JR一ノ関駅 など

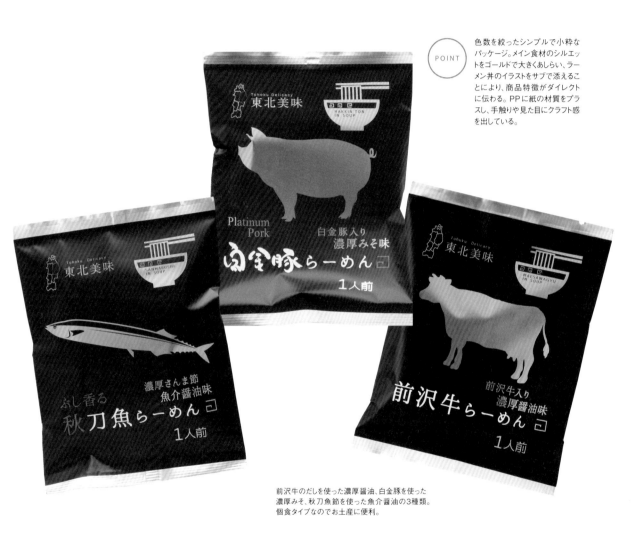

岩手

# 岩手の特産品でつくる、パッケージもお洒落なラーメン

## 岩手らーめん三昧　株式会社小山製麺

昭和35年に奥州・胆沢で創業して以来、麺づくり一筋の小山製麺が手掛けるご当地ラーメン。胆沢川系の良質な水と、岩手が誇るブランド牛の"前沢牛"や、ブランド豚の"白金豚"、三陸産の"秋刀魚節"を使ってつくられた、こだわりのスープとコシのある麺が絶妙に合い、ラーメン通も納得の旨さ。従来の土産品のような4、5食の箱入り仕様ではなく、個食タイプなので、お土産にも買い求めやすい。落ち着いたトーンにゴールドを効かせたシックな配色や、クラフト感のある質感など、ラーメン商品には珍しいお洒落なデザインも高ポイント。

POINT
色数を絞ったシンプルで小粋なパッケージ。メイン食材のシルエットをゴールドで大きくあしらい、ラーメン丼のイラストをサブで添えることにより、商品特徴がダイレクトに伝わる。PPに紙の材質をプラスし、手触りや見た目にクラフト感を出している。

前沢牛のだしを使った濃厚醤油、白金豚を使った濃厚みそ、秋刀魚節を使った魚介醤油の3種類。個食タイプなのでお土産に便利。

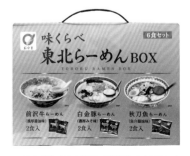

3つの味が楽しめる、自宅用にも贈答用にも人気のセット。

イオン江釣子店

■ DATA

販売元：株式会社小山製麺
D：株式会社小山製麺

●商品名
・岩手らーめん三昧（前沢牛らーめん、秋刀魚らーめん、白金豚らーめん）

●主な販売場所
・岩手県内の量販店 など

 岩手

# 自然豊かな三陸地域に惚れ込んだことから生まれたクラフトビール

**三陸ビール**　三陸ブルーイング・カンパニー合同会社

岩手県大船渡を拠点とする三陸ブルーイングのクラフトビールブランド。ベルジャンホワイト、セゾンなどベルギースタイルをメインとしつつ、IPA、スタウトなどもラインナップ。代表の南忠佑さんが結婚を機にはじめて訪れた自然豊かな三陸地域とそこに暮らす人たちに魅了されたことがきっかけに、地域の魅力を発信したいという思いで生まれたこのビールは三陸地域の沿岸で収穫された副原料を使用。料理とのペアリングを考慮した飲みやすくすっきりとした仕上がりだ。

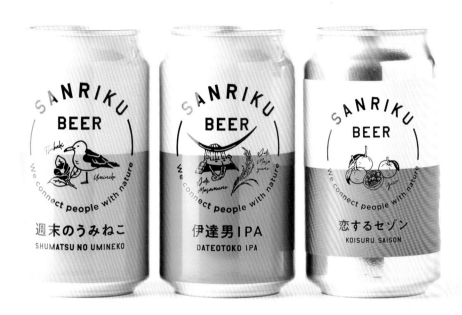

 POINT

商品のネーミングや原材料をわかりやすくイラストでアイコン化し、三陸ビールのキーカラーである蛍光イエローを主力商品の「週末のうみねこ」に使用。同シリーズにも蛍光カラーを使って競合との差別化を図り、目を引くように視認性を高めた。贈り物や自分へのプチご褒美として、週末のアウトドアやお家時間を三陸ビールでハッピーに過ごしてもらいたいと願い、パッケージのデザイン性やカラーリングなどにもこだわった。

「ガガニコジンジャーエール」

**■ DATA** .........................................

販売元：三陸ブルーイング・カンパニー
合同会社
デザイン会社：&Rainbow Inc.
CD：南 忠佑
AD：谷口佐智子
D：後藤瑛美
I：鷲尾友公（ガガニコジンジャーエール）

●商品名
・週末のうみねこ
・恋するセゾン
・伊達男IPA
・ガガニコジンジャーエール

●主な販売場所
・三陸沿岸の主要道の駅
・盛岡駅
・仙台駅
・仙台三越
・紀ノ國屋（東京）
・自社オンラインストア
など

## 「Ça va?（元気?）」の明るい掛け声を
## 岩手三陸から全国へ

### サヴァ缶5種5缶ギフトセット　岩手県産株式会社

東日本大震災で被害を受けた三陸からオリジナルブランドの加工品を全国に発信しようと、一般社団法人東の食の会、釜石市に工場を持つ岩手缶詰株式会社、岩手県産株式会社がタッグを組み企画開発。国産サバを使用したオリジナルの洋風缶詰として誕生した。「元気ですか?」を意味する「Ça va?（サヴァ）?」と「サバ」を掛けた、ダジャレを効かせたネーミングと、従来の缶詰製品にはないビビッドな色使いに、三陸のポジティブな姿勢とみなぎるパワーが感じられる。

POINT

ネーミングのダジャレを楽しく表現しつつも、中身の質の高さをしっかり伝え、長く愛されるタイムレスな商品を目指してデザイン。「Ça va（元気?）」のポジティブなメッセージに合わせ、味ごとにメリハリをつけた色展開がポイント。

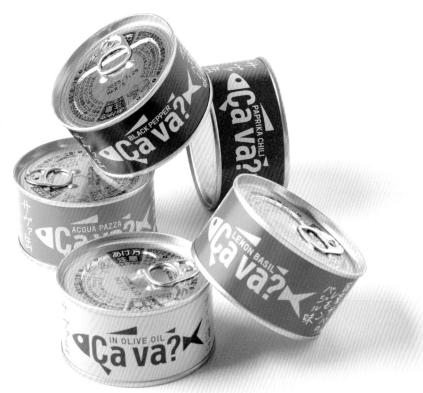

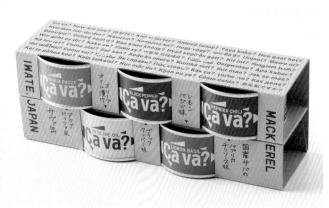

さまざまな料理にアレンジできる、5種類の味をアソートしたギフト缶セット。
紙パッケージの天面は「Ça va?」を世界各国の言葉で表現している。

### ■ DATA

販売元：岩手県産株式会社
デザイン会社：akaoni
AD・D：小板橋基希（akaoni）
CD：高橋大就（一般社団法人 東の食の会）

●商品名
・サヴァ缶5種5缶ギフトセット（二段箱）
（アクアパッツァ風、ブラックペッパー味、オリーブオイル漬け、レモンバジル味、パプリカチリソース味）

●販売場所
・特産品プラザ らら・いわて

# 仙台の牛タン専門店がつくる、具の9割が牛タンのリッチな調味料

## 牛タン仙台ラー油　株式会社陣中

TV番組で紹介され人気に火が付いた、牛タンをたっぷり贅沢に使用した食べるラー油。仙台に本社工場を構える牛タン専門店の陣中が、具材、ラー油共に、すべて手づくりしている。丁寧に処理して旨味を閉じ込めた牛タンと、独自調合のラー油との相乗効果で一度食べたら忘れられない味わいに。以前はガラス瓶のまま販売していたが、お土産品としてのニーズの高まりを受け、特別感のある紙パッケージを考案。丈夫な段ボール素材で瓶をしっかり保護しながら、商品の中身も見える六角柱の構造が秀逸。

POINT

お土産に1個ずつ手渡しできる、瓶の保護機能とデザイン性を兼ね備えた紙パッケージ。六角柱の面をうまく利用し、メッセージを記載する面積を確保しつつも、商品の中身が見えるデザインに。文字周りの45度で引かれた斜線は、商いの基本姿勢と言われるお辞儀の角度にちなんでいる。

フレーバーは4種類。ご飯や麺類はもちろん、パンや豆腐などとも相性が良く、アイデア次第でレパートリーが広がる。

### ■ DATA

販売元：株式会社陣中
企画制作：株式会社陣中

●商品名
・牛タン仙台ラー油（仙台ラー油、仙台ラー油辛口、仙台オリーブ辛油、生姜入り米油）

●販売場所
・仙台国際空港
・仙台駅
・自社オンラインショップ

27

## 遠方へのお土産にもうってつけ。常温保存可能なかまぼこ

### 旅するかまぼこ　三陸フィッシュペースト株式会社

宮城名物の笹かまぼこは、冷蔵保管が必須で賞味期限が短い点がお土産品としての長年の課題だったが、試行錯誤の末に誕生したのが、常温での長期保存を可能にしたこのかまぼこ。「旅するかまぼこ」のネーミングには、遠くまで一緒に持ち運んで欲しいという生産者の願いが込められている。常温保存するための加工に耐え得るには、上質な魚肉すり身でなければならないため、徹底して原料にこだわり、パッケージにも一工夫。魚のキャラクター「ととちゃん」がトレードマークの、子連れ客にも手にとりやすいデザインだ。

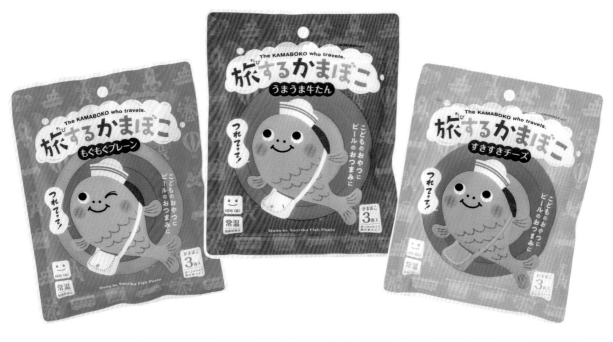

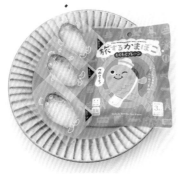 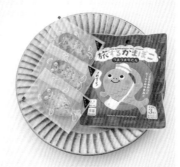 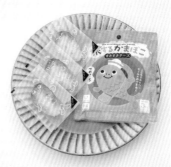

栄養たっぷりでこのかわいさ！魚本来の旨味を引き出したプレーンタイプ、魚肉との相性バッチリのチーズ味、ピリ辛風味の牛たん味があり、子どものおやつやおつまみに最適。

**POINT**

内装の個別パッケージはキャラクターの「ととちゃん」が10種類の表情を見せてくれる。陸に上がって旅をするため、エラ呼吸ではなく、鼻の穴がついているのがポイント。

### ■ DATA

販売元：三陸フィッシュペースト株式会社
デザイン会社：有限会社スマッシュ
I：橋本さと子
印刷：常盤化工株式会社

● 商品名

・旅するかまぼこ（うまうま牛たん、すきすきチーズ、もぐもぐプレーン）

● 主な販売場所

・仙台駅
・仙台空港
・宮城県内のお土産店、道の駅
・SA
・自社オンラインショップ　など

# こけしのご当地キャラと老舗製麺所が出合い、土産の新定番に

## 仙台弁こけしうーめん　きちみ製麺

個性的でかわいらしいビジュアルがSNSでも話題の宮城のご当地キャラ、「仙台弁こけし」。人気沸騰中のこのキャラと、明治30年創業の地元の老舗、きちみ製麺がコラボレーション。宮城県の特産品である「白石温麺（しろいしうーめん）」が新しいスタイルで生まれ変わった。めんつゆで食べる一般的な食べ方とは異なり、「肉味噌だれ」をからめて食べるという新提案で、宮城土産の新定番となっている。

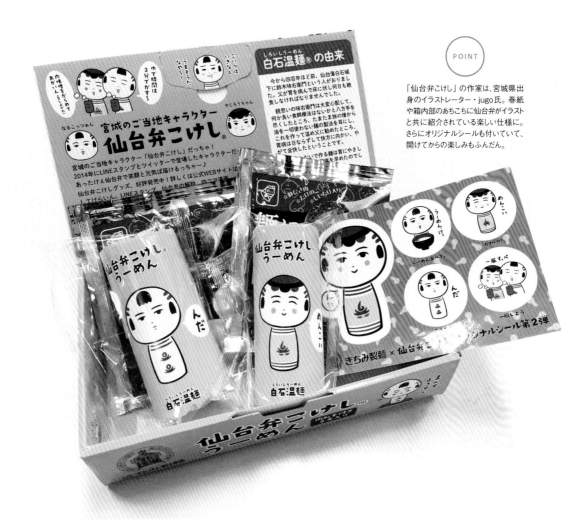

POINT

「仙台弁こけし」の作家は、宮城県出身のイラストレーター・jugo氏。巻紙や箱内部のあちこちに仙台弁がイラストと共に紹介されている楽しい仕様に。さらにオリジナルシールも付いていて、開けてからの楽しみもふんだん。

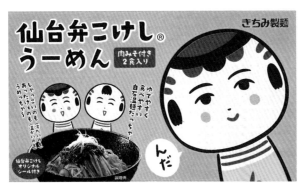

### ■ DATA

販売元：きちみ製麺
D：佐藤寛和（エントワデザイン株式会社）
I：jugo
PL：木村 敦（株式会社きちみ製麺）

● 商品名

・仙台弁こけしうーめん

● 主な販売場所

・仙台駅
・宮城県内の主要道の駅
・自社オンラインショップ
・Amazon など

# グラフィカルなイラストで、新しい「杜の都」土産の顔に

## 杜のゆべし　株式会社九重本舗玉澤

飴菓子「霜ばしら」でも有名な仙台の老舗和菓子店・九重本舗玉澤は、創業約350年。手土産として県内外で人気の「杜のゆべし」は、厳選された上質な餅米や胡桃を用いた風味豊かな餅菓子で、2022年6月16日の和菓子の日にデザインを一新した。ゆべしのモチーフをグラフィカルなイラストで表現し、老舗らしい上品な雰囲気の中にも新しさを感じさせるデザインに仕上げている。

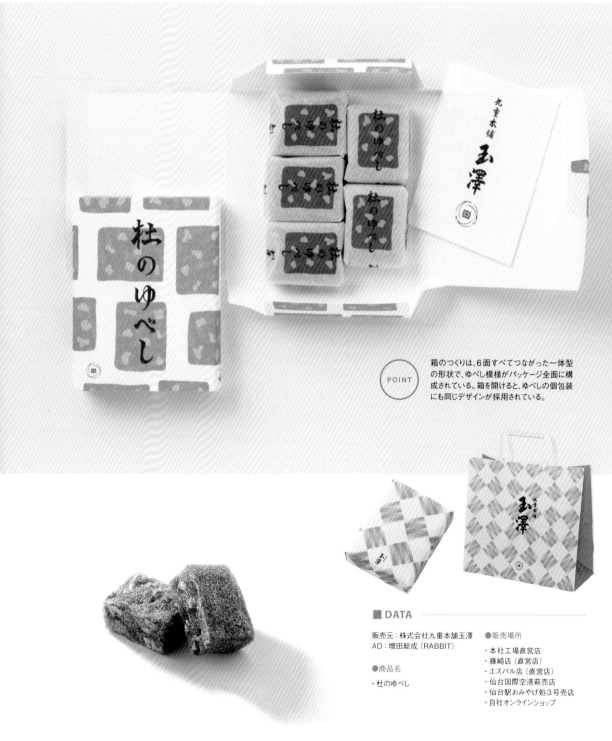

POINT　箱のつくりは、6面すべてつながった一体型の形状で、ゆべし模様がパッケージ全面に構成されている。箱を開けると、ゆべしの個包装にも同じデザインが採用されている。

■ DATA

販売元：株式会社九重本舗玉澤
AD：増田総成（RABBIT）

●商品名
・杜のゆべし

●販売場所
・本社工場直営店
・藤崎店（直営店）
・エスパル店（直営店）
・仙台国際空港萩売店
・仙台駅おみやげ処3号売店
・自社オンラインショップ

# 誰もが知る風習をキャラクター化し、店頭の話題をさらう

## なまはげのおくりもの　お菓子のにこり

「一目で秋田のお土産とわかる新しい商品を開発したい」という店主の思いから生まれた、お米のサブレ。モチーフに選んだのは、全国的にも知られる秋田の風習 「なまはげ」。年の変わる節目に訪れる悪事を諫め、災いを祓いにやってくる来訪神だ。一見恐ろしいイメージだが、それをあえてユニークなイラストで表現した。原材料も秋田産にこだわり、大潟村産米粉を使用している。

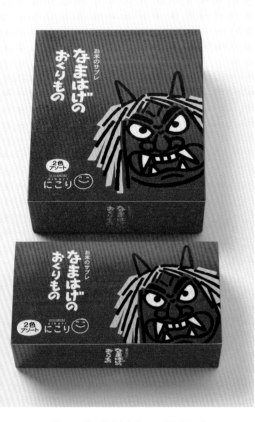

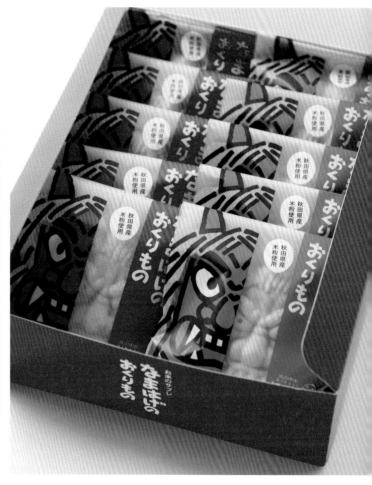

POINT　個包装の赤はプレーン、青は塩キャラメル味。サクッとした軽い食感が特徴だ。個包装を開けると、リアリティがある表情のなまはげの最中が出てくる。

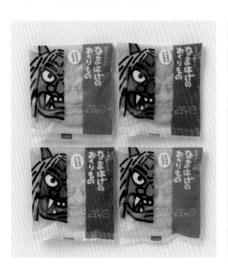

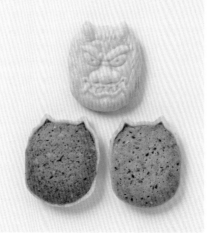

### ■ DATA

販売元：お菓子のにこり

●商品名
・なまはげのおくりもの
（4個入り、10個入り）

●主な販売場所
・自店舗
・秋田空港
・秋田駅
・秋田県物産振興会
・都内アンテナショップ（2カ所）
など

# 立体感があるパッケージが秋田犬のキャラクターを引き立てる

**もふどら** 　有限会社蕗月堂

かわいい秋田犬のイラストが一際目を引くパッケージが特徴。横手で三代続く老舗和菓子店がつくる人気商品だ。新しいどらやきを開発途中に、蒸すタイプのどらやきを試作した際、もふもふの食感や質感が偶然出たことがきっかけで秋田犬をモチーフにしたお土産として考案したという。秋田犬の気品や力強さ、やさしさや忠誠心を全面に出したいとキャラクターの表情にこだわった。

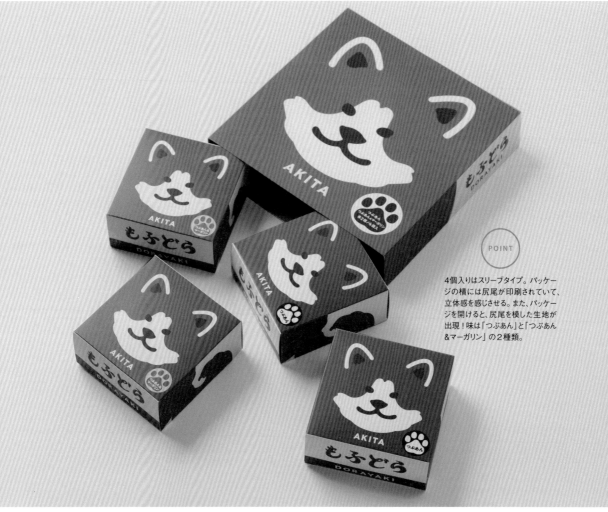

**POINT**

4個入りはスリーブタイプ。パッケージの横には尻尾が印刷されていて、立体感を感じさせる。また、パッケージを開けると、尻尾を模した生地が出現！味は「つぶあん」と「つぶあん&マーガリン」の2種類。

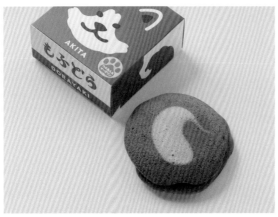

## ■ DATA

製造元：有限会社蕗月堂

●商品名
・もふどら

●主な販売場所
・秋田空港
・秋田駅トピコ
・秋田県産プラザ
・秋田県内の主要道の駅
・東武百貨店池袋店
・スクランブルスクエア14F ハチふる
・あきた美彩館
・秋田ふるさと館
・自社オンラインショップ　など

# 既存商品と一線を画すインパクトのあるデザイン

## きりたんぽカップスープ　株式会社ツバサ

秋田県で商品開発や小売、マーケティングなどクリエイティブなビジネスを行なっているツバサのオリジナル商品「きりたんぽカップスープ」は、肉厚きりたんぽを温めてお湯を注ぐだけで簡単調理ができる人気商品。スープは、日本三大地鶏の比内地鶏のガラを使用。比内地鶏醤油味、海鮮ブイヤベース味、スパイシーカレー味にははるさめ、ピリ辛チゲ味にはワンタンが入り、4種類の味を楽しめる。お土産やお昼ごはんのお供に、いつでもどこでもきりたんぽが食べられるとあって秋田土産に大人気。

**POINT**

食品メーカーとして後発であるツバサのきりたんぽ商品をいかに目に止まる商品にするかを意識し、既存商品と差別化を図れるようなインパクトのあるデザインを目指した。比内地鶏ときりたんぽのイラストをミックスさせた、どこか懐かしいレトロな雰囲気が特徴。

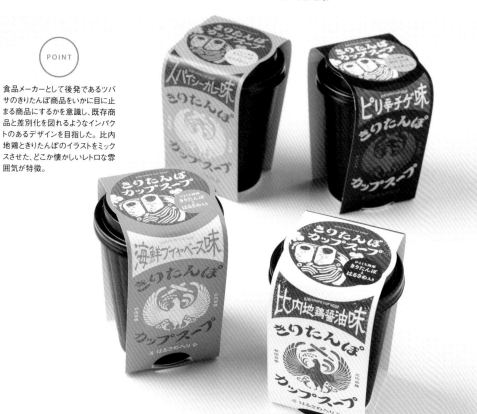

※通常の商品はネギは入りません。

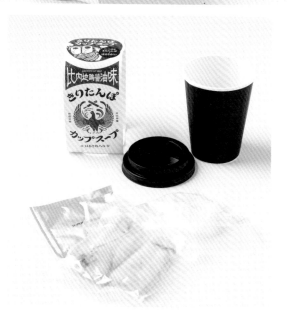

### ■ DATA

販売元：株式会社ツバサ

●商品名
・きりたんぽカップスープ比内地鶏醤油味
・きりたんぽカップスープ海鮮ブイヤベース味
・きりたんぽカップスープスパイシーカレー味
・きりたんぽカップスープピリ辛チゲ味

●主な販売場所
・秋田空港
・大館能代空港
・秋田駅
・仙台駅
・秋田県内の道の駅
・日本百貨店
・秋田美彩館
・俺のグランマーケット
・のもの　など

## 素朴な美味しさとポップなイラストで、山形の新たな名物に

### 山形小麦ラスク　　有限会社白いくも

地元の人気菓子店、菓子工房白いくもの系列ブランド「山形ラスク研究所」が開発したラスク。お土産として、気温の変化に強く、日持ちがすることに重点を置いて開発された。小麦粉は県内産のゆきちを使用するなど、地元のさまざまな食材と合わせて8種類のフレーバーを展開している。パッケージでは、それぞれのフレーバーをポップなイラストでわかりやすく表現。大胆に配置することで、目を引くデザインに仕上げている。

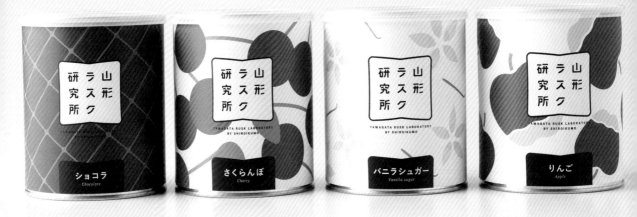

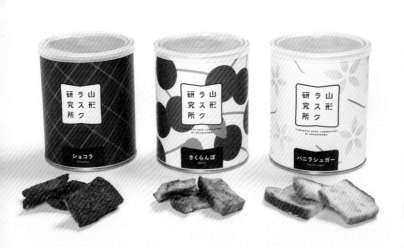

缶の裏側には、イラストを用いて原材料をわかりやすく表記。

POINT　焼きたての風味を損なわないよう、アルミ製の缶を使用。口に入れた瞬間に広がる味・香り・食感などの個性を表現することをデザインにおいて心掛けたという。

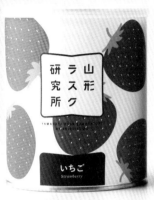
いちご
Strawberry

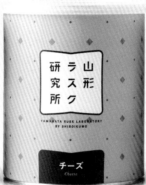
チーズ
Cheese

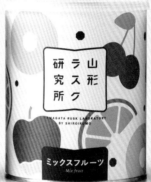
ミックスフルーツ
Mix fruit

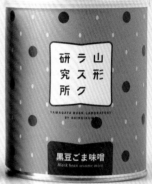
黒豆ごま味噌
Black bean sesame miso

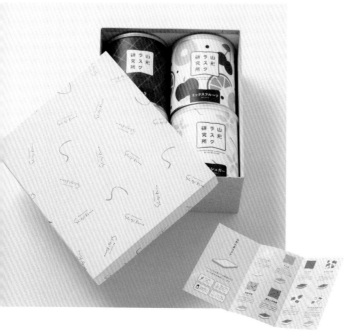

## ■ DATA

販売元：有限会社白いくも
デザイン会社：株式会社エーディーバンク
D：元木 綾

●商品名
・山形小麦ラスク

●販売場所
・白いくも 本店
・白いくも バイパス店
・白いくも 米沢公園通店
・エスパル山形
・天童道の駅サンピュア
・やまぎん県民ホール
　YAMAGATA0035
・自社オンラインショップ

# 山形のフルーツのやさしい甘さをかわいらしいイラストで表現

## ランラン♪・山形くだものサイダー　山形食品株式会社

西洋なしの加工工場として誕生した創業90年の飲料製造会社、山形食品。「生産者の力になりたい」「山形県産果実の評価を向上させたい」そんな思いから自社ブランド「サン&リブ」を通して素材のありのままの美味しさを届けている。「ランラン♪」は、人気商品の果汁100%ジュースとは別シリーズで、手軽に飲める山形土産を開発しようと考えて誕生。「山形くだものサイダー」は山形県産の果汁の美味しさを味わえるご当地サイダーを開発しようと考えてつくられた。いずれも果物本来の味わいが口の中でやさしく広がる。

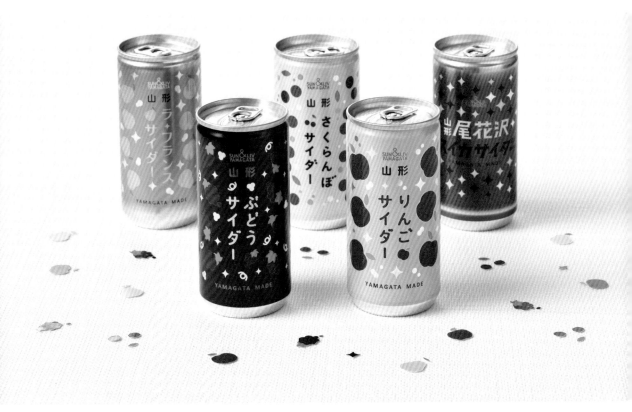

POINT

「山形くだものサイダー」
ひと目で果物の種類がわかる色合いと、炭酸の泡と一緒に果物の美味しさが、しゅわしゅわキラキラと弾ける様子を表現。

### ■ DATA

販売元：山形食品株式会社
デザイン会社：株式会社ダイコン
AD・D：中山ダイスケ（株式会社ダイコン）

●商品名
・ランラン♪ラ・フランス
・ランラン♪ブドウ
・山形ラ・フランスサイダー
・山形さくらんぼサイダー
・山形尾花沢スイカサイダー
・山形ぶどうサイダー
・山形りんごサイダー

●販売場所
・山形県内JA直売所
・自社オンラインショップ

POINT

「ランラン♪」
ラララ〜♪と口ずさむ鼻歌が聞こえてきそうな、明るくかわいらしいテイストのパッケージ。たわわに実った果物の収穫を喜ぶ動物たちが、色鉛筆を使用したやさしいタッチのイラストで描かれている。

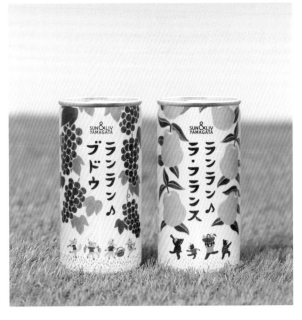

**栃木**

# ほのかに香るコーヒーと
# 独自配合のスパイスが決め手のクラフトコーラ

**ニッコーラ**　日光珈琲

「巷で流行っているクラフトコーラを、日光珈琲の焙煎士がつくったらどうなるか？」がテーマ。日頃さまざまな種類のコーヒー豆を扱い、その特性を活かしながら調合してブレンドコーヒーを完成させる焙煎士の作業と、クラフトコーラ製造工程の親和性に着目して開発された。研究を重ねて原料を厳選し、コーヒーをベースに栃木県大田原産の唐辛子や柚子、生姜、ガラムマサラなどを独自ブレンド。飲みやすい爽やかな味わいに、ほどよい刺激とコクが調和する日光珈琲ならではの商品に仕上がっている。

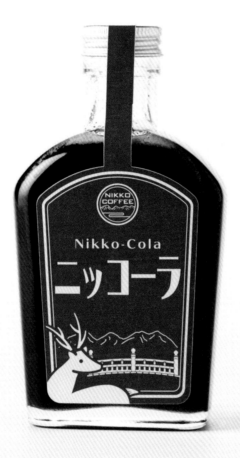

POINT

「ニッコーラ」の商品名に合わせ、ラベルは鹿や神橋、日光連山など、日光の名物や名所をモチーフにデザイン。世界遺産「日光の神社」を構成する文化財の神橋や、コーラの持つイメージから、朱に寄せた赤をキーカラーに据え、レトロかわいいボトルに仕立てた。ラベルはミラーコート紙にグロスPP加工を施し、水滴対策や衛生面も考慮。

グラスに氷とニッコーラ大さじ2杯を入れ、炭酸や牛乳などお好みの飲み物で割ればできあがり。

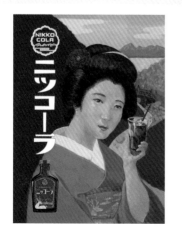

**■ DATA** ⋯⋯⋯⋯

販売元：有限会社風間総合サービス
D・I：井上 淳

●商品名

・ニッコーラ

●販売場所

・自店舗
・自社オンラインショップ

茶寮 日りん

# 「パンダ」×「納豆」という意外な組み合わせが目を引く

**茨城パンダ納豆**　有限会社菊水食品

茨城県日立市の納豆メーカー「ひたちの納豆屋 菊水食品」が販売している、パッケージにジャイアントパンダをデザインした「茨城パンダ納豆」。県と同市が、かみね動物園（日立市）にジャイアントパンダを誘致する活動を進めていることから、民間レベルでも応援する試みとして開発。国産大豆100%、化学調味料不使用のタレが入ったパンダ納豆は納豆本来の旨味を残しつつ、においを抑えたまろやかさが特徴。

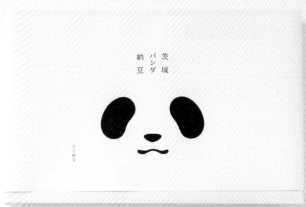

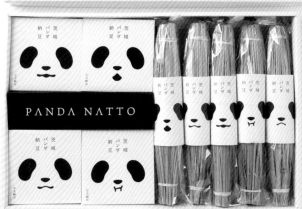

**POINT**

茨城パンダ納豆のパッケージに描かれているパンダの目は納豆の原材料である"大豆"のかたちがモチーフ。表情違いの口元がなんとも愛らしい。昔ながらの煮沸消毒した天然の藁（わら）で納豆を包んだ、わらつと納豆も同様に5種類のパンダデザインに包まれている。

## 「茨城パンダ納豆 どらい」

真空フライで加工した「茨城パンダ納豆どらい」。しょうゆ味、ピリ辛味、うす塩味、プレーンと4種展開。日持ちがするのでお土産にも最適。

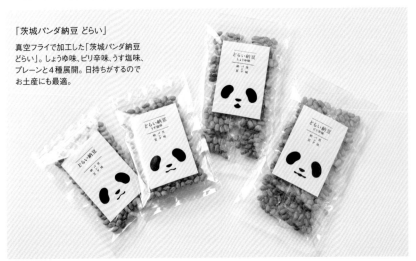

### ■ DATA

販売元：有限会社菊水食品

●商品名
・茨城パンダ納豆 ギフトセット（しかく40g×4個、わらつと60g×5個）
・茨城パンダ納豆 どらい（しょうゆ味、ピリ辛味、うす塩味、プレーン）

●販売場所
・菊水食品直売所
・JR日立駅「ぷらっとひたち」
・日立市かみね動物園（どらいのみ）
・IBARAKI sense（茨城県アンテナショップ）
・自社オンラインショップ

# ひたちなか市の名物焼きそばを、自宅用にパッケージ

## 那珂湊焼きそば　　有限会社わたなべ製麺所

「那珂湊焼きそば」は、60年近く前からひたちなか市の漁師や住民に愛されてきた茨城県民のソウルフード。本商品は、わたなべ製麺所の先代が東日本大震災後の町おこしのために炊き出しやイベントで提供していた那珂湊焼きそばを、お土産にすることで那珂湊の魅力を県内外に広く発信したいと商品化した。創業当時から変わらない手延べ製法でつくられ、油を最低限しか使わないため、熟練の職人が蒸し上がりから一気に手作業でほぐし仕上げている。具材に負けない存在感がある太麺の、コシのあるもちもちの食感を楽しめる。

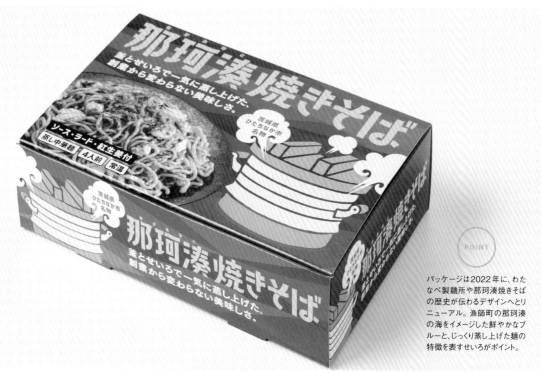

POINT

パッケージは2022年に、わたなべ製麺所や那珂湊焼きそばの歴史が伝わるデザインへとリニューアル。漁師町の那珂湊の海をイメージした鮮やかなブルーと、じっくり蒸し上げた麺の特徴を表すせいろがポイント。

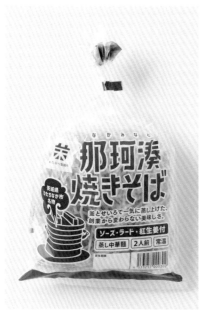

一般的な焼きそばとは異なり、もっちりプリプリの太麺。茹でる際にスープや出汁を吸わせると、一層美味しく仕上がる。

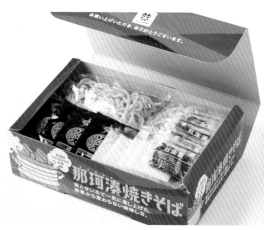

### ■ DATA

販売元：有限会社わたなべ製麺所
デザイン会社：文化メディアワークス
AD：佐藤正和
I・PL：佐藤歩美

● 商品名

・那珂湊焼きそば

● 主な販売場所

・IBARAKI sense
（茨城県アンテナショップ）
・那珂湊駅
・大洗まいわい市場
・自社ECサイト など

栃木

# 地元に伝わる健康祈願の縁起物をかわいいお菓子に

### 黄ぶなっこ最中　　株式会社たまき

黄ぶなは「かつて疫病が流行した際、偶然釣り上げた黄色いフナを食べたところ治った……」という伝承に由来する、宇都宮の無病息災のシンボル。張り子など郷土玩具のモチーフとして知られているが、それをアレンジしてかわいい土産菓子に仕立てた。最中のかたちは、店主が木彫りの特技を活かして製作。素朴で温かみを感じさせる唯一無二のフォルムとなっている。自然の甘さにこだわった味も魅力。

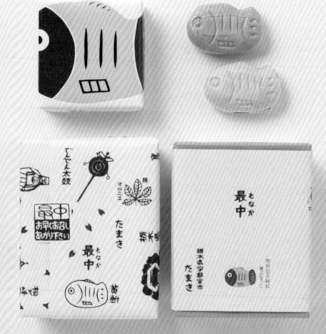

プチギフトは、黄ぶなの
イラストを大きく配置。

POINT

包装紙は、栃木県と宇都宮市の歴史と文化を木版画で散りばめたビジュアル。色は最中皮のイメージをバックに、版画はあんの色をイメージしている。10個入りの外箱は、両面白ボールの化粧箱（糊貼り）で上品さを追求。

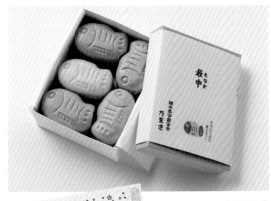

商品の中には小さなカードが。宝船七福神、立雛、兜など20数種のカラー木版画紙片から、季節を選んで添えている。

■ DATA

販売元：株式会社たまき
AD：田巻雅子
D・I：田巻秀樹
PL：若林智子

● 商品名
・黄ぶなっこ最中

● 販売場所
・自店舗
・和食了寛
・東武宇都宮百貨店
・とちびより（JR宇都宮駅パセオとちぎ
　グランマルシェ内）
・自社オンラインショップ

群馬

# 「湯もみキャラクター」が大人気。
# 歴史的名湯の活性化の一助に

**草津温泉プリン**　草津温泉プリン

2018年、草津温泉の魅力を全国に発信することを目的に、プリン専門店がオープン。湯もみをイメージした温度管理と製法にこだわった商品が開発された。味の展開は、「湯畑プリン」「湯もみプリン」「夜の湯畑プリン」の3種。原料には地元の榛名牛乳を使用。プリンの瓶とフタに描かれた、湯もみ板を持った女の子のイメージキャラクターが愛らしく、一際目を引く。

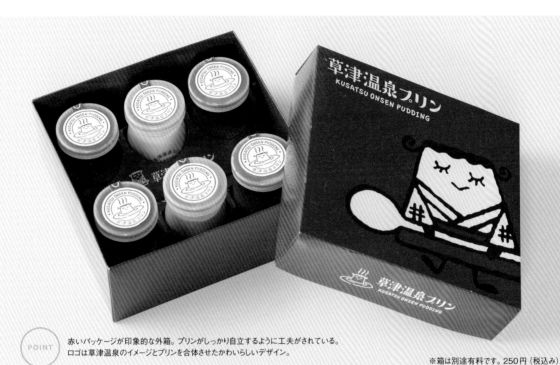

POINT　赤いパッケージが印象的な外箱。プリンがしっかり自立するように工夫がされている。
ロゴは草津温泉のイメージとプリンを合体させたかわいらしいデザイン。

※箱は別途有料です。250円（税込み）

草津温泉の湯畑をイメージした「湯畑プリン」（中）はエメラルドグリーンのジュレ。「夜の湯畑プリン」（右）の青いジュレはレモンポーションを入れると青から紫に変化する様は湯畑の夜のライトスポットをイメージしている。

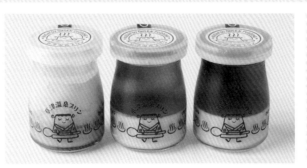

湯もみ板をイメージした焼き印を施した、オリジナルの木製スプーン。

■ DATA

販売元：草津温泉プリン

●商品名
・湯畑プリン
・湯もみプリン
・夜の湯畑プリン

●販売場所
・草津温泉プリン

# 那須牛乳のホエイから生まれたお菓子

ブラウンチーズブラザー　　株式会社 GOOD NEWS

パッケージに箔押しされたユニークな牛のキャラクターが印象的。開発したのは、那須に拠点を置く株式会社 GOOD NEWS で、食をテーマに社会課題を解決することを目的としている。「ブラウンチーズブラザー」は、2022 年 7 月に発売。牛乳からチーズをつくる過程で大量に出るホエイ（乳清）を、美味しく活用したいと開発された。同社の人気商品「バターのいとこ」と共に、栃木土産の新定番となっている。

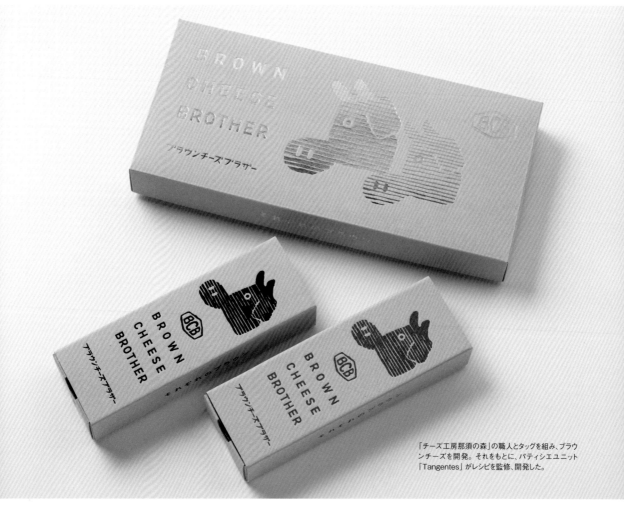

「チーズ工房那須の森」の職人とタッグを組み、ブラウンチーズを開発。それをもとに、パティシエユニット「Tangentes」がレシピを監修、開発した。

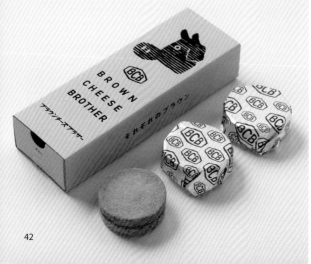

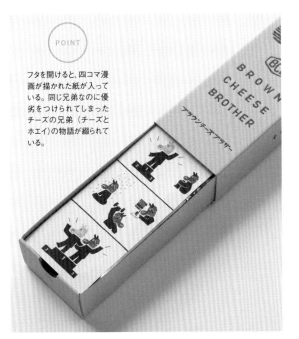

⊙ POINT

フタを開けると、四コマ漫画が描かれた紙が入っている。同じ兄弟なのに優劣をつけられてしまったチーズの兄弟（チーズとホエイ）の物語が綴られている。

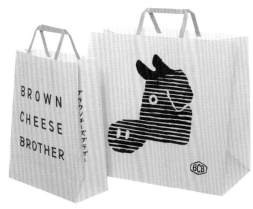

ショッパーの全面にも、大きくキャラクターがあしらわれている。

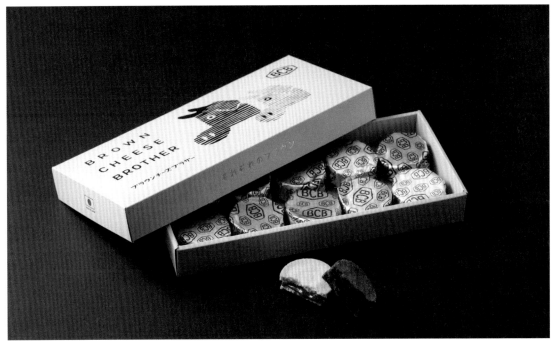

■ DATA

販売元：株式会社 GOOD NEWS
デザイン会社：株式会社 ALNICO DESIGN
CD：宮本吾一（GOOD NEWS）
D：平塚大輔（ALNICO DESIGN）

●商品名

・ブラウンチーズブラザー
プレーン／チョコ（各3個入り）
・ブラウンチーズブラザー BROTHER BOX
（2種セット各5個入り）

●販売場所

・BROWN CHEESE BROTHER 那須店
（GOOD NEWS NEIGHBORS内直営店）
・GOOD NEWS TOKYO エキュート品川店

BROWN CHEESE BROTHER 那須店

GOOD NEWS TOKYO エキュート品川店

# 統一したデザインで商品展開することで話題性と認知度をアップ

**関東・栃木レモンシリーズ**　株式会社永井園

黄色いレモンのデザインでおなじみ。今や栃木県のみならず、全国で愛されている「関東・栃木レモン」（通称：レモン牛乳）。栃木乳業監修により、地元民にとって懐かしの味がさまざまな商品に展開されている。レモン牛乳をテーマに、斬新な商品をつくりたいという開発者の思いのもと、2017年にレモンカレーを開発。その後も多くの企業とコラボレーションしながら商品展開を増やしている。

POINT 「関東・栃木レモン」と同じデザインで展開。一目でレモン牛乳の商品だとわかる。統一感が出るため売り場でも目立つ存在に。

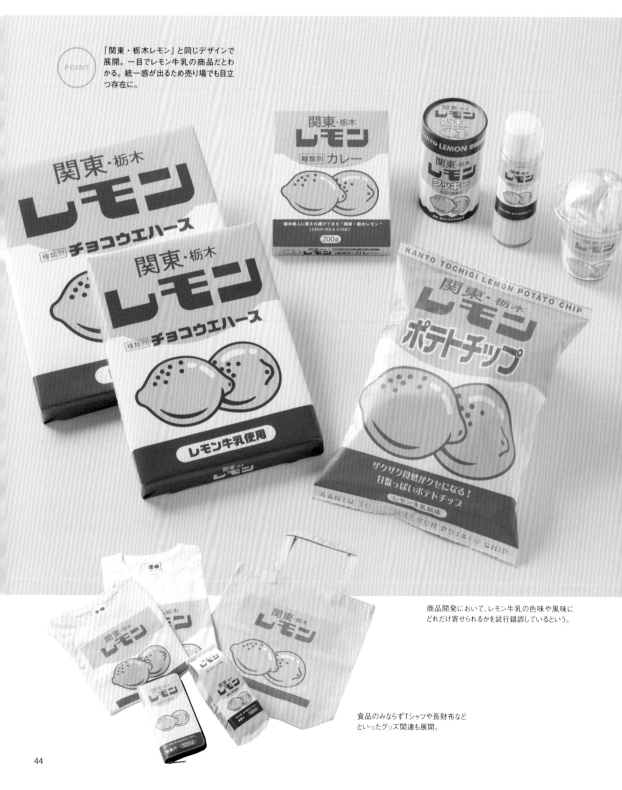

商品開発において、レモン牛乳の色味や風味にどれだけ寄せられるかを試行錯誤しているという。

食品のみならずTシャツや長財布などといったグッズ関連も展開。

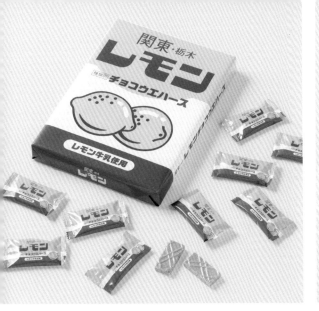

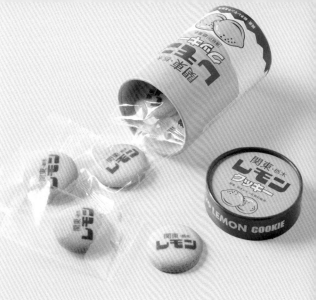

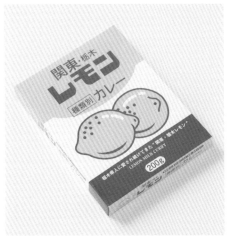

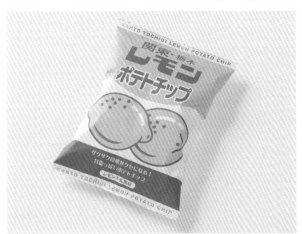

■ DATA

販売元：株式会社永井園

●商品名
・関東・栃木レモンクッキー
・関東・栃木レモンチョコウエハース
・関東・栃木レモンドレッシング
・関東・栃木レモンカレー
・関東・栃木レモンポテトチップ
・関東・栃木レモンマシュマロ

●主な販売場所
・さんりお屋
・永井百貨店
・栃木県内の道の駅
・JR宇都宮駅内のお土産店
・東北自動車道SA・PA
・県内観光地 など
※一部を除く

さんりお屋

永井百貨店

永井百貨店店内

群馬

## インパクト大のラベルデザインで
## 嬬恋のイベントを後押し

叫ばれビールソウルフルテイスト（男）・叫ばれビールハートフルテイスト（女）　　嬬恋高原ブルワリー

キャベツの産地・群馬県嬬恋村で毎年開催されているイベント「キャベツ畑の中心で妻に愛を叫ぶ」。全国から愛妻家が集まり、日頃言えない感謝の気持ちを叫ぶもので、このイベントに寄り添った商品をと考案された。ラベルの色は、嬬恋キャベツを意識したグリーンと愛妻を意識したピンクで演出。遊び心があるユニークな名前とパッケージのイラストが、イベントの楽しさを物語っている。

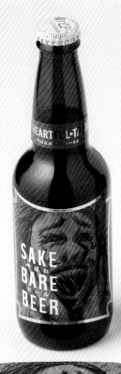
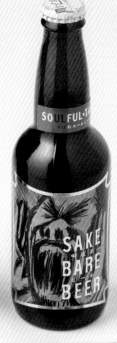

POINT

「叫び」と「泣き」を炸裂させたイメージをイラストでダイナミックに表現。「SAKE」「BARE」「BEER」と3段並んだロゴがリズム感を演出している。

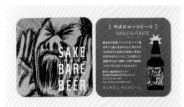

### ■ DATA

販売元：嬬恋高原ブルワリー
デザイン会社：株式会社 ASTRAKAHN
AD・D・CD：洲崎賢治
I：友田 威
PL：山内章弘、山本一樹

●商品名
・叫ばれビールソウルフルテイスト（男）
・叫ばれビールハートフルテイスト（女）

●主な販売場所
・群馬県嬬恋村内の酒屋、旅館 など

# 小豚のキャラクターが牧場とお客様をつなぐ

## SAIBOKU ハム・ソーセージ・ウインナー　株式会社埼玉種畜牧場

「食」で人々の幸せに貢献するという思いから1946年埼玉県日高市に創業したサイボク。小さな牧場からスタートし、現在では種豚の育種改良、肉豚の生産、自社工場での食肉の製造・加工、販売まで一貫体制による商品づくりを行なっている。自社のブランド豚「ゴールデンポーク」「スーパーゴールデンポーク」を原料にしたハム、ソーセージ、ウインナーは安心・安全・新鮮にこだわり、余計な添加物は使わず、豚肉本来の美味しさを追求している。

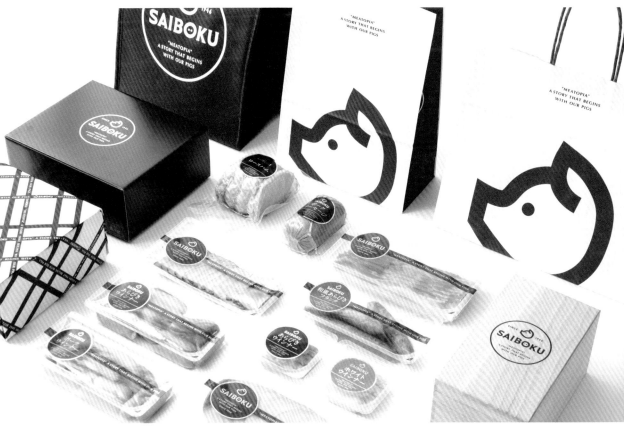

パッケージは、ハム、ソーセージ、ウインナーなど、多様な商品の種類に対応するため、ラベルシステムを採用。カテゴリや味の種類によって色分けしている。また、トレイや包装紙に展開している赤いリボンのモチーフは、サイボクとお客様をつなぐ絆を表現。「日本パッケージデザイン大賞2019」VI・BI部門入選。

POINT

子豚の横顔のブランドロゴは、パッケージやブランドのキャラクターに展開。サイボクが運営する豚のテーマパークの人気キャラクターとして県内外からの来場客に愛されている。

### ■ DATA

販売元：株式会社埼玉種畜牧場
ブランディング会社：株式会社エイトブランディングデザイン
ブランディングデザイン：西澤明洋、清瀧いずみ

●商品名
・SAIBOKU ハム・ソーセージ・ウインナー 等

●主な販売場所
・埼玉県内および都内の直営店舗
・百貨店
・自社オンラインショップ など

# ほっこりした色合いとまるいモチーフで埼"玉"感をアップ

**玉もなか** 株式会社ジェイコム埼玉・東日本

2020年11月、埼玉県所沢市にオープンにした「LOVE埼玉パーク」は、「埼玉」に特化したコンセプトショップ。オープンにあわせて、埼玉銘菓の仲間に入れるようなお菓子をつくろうと開発されたのが「玉もなか」だ。埼玉の"玉"と埼玉県民のまぁるい心を表しており、その名のとおり、小さな球体の最中。パッケージには埼玉の文字やあんのイラストなど、丸を印象的に使用。親しみの中にも、直感的に「埼玉」のお土産であることがわかるデザインとなっている。

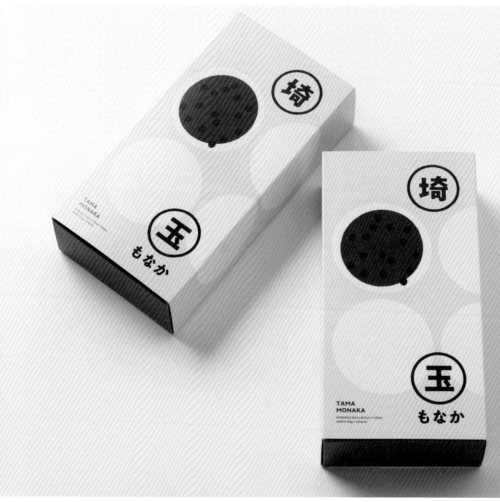

パッケージの側面は、海外の観光客にも楽しんでもらえるよう、英語で表記をする工夫も。

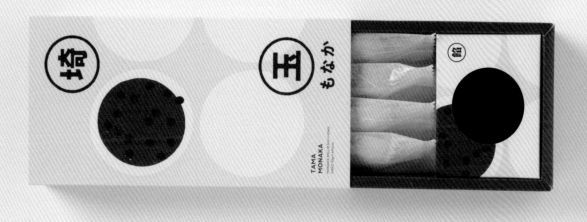

皮とあんがひとつずつパッケージされ別に入っている。重量のあるあんと、軽くて壊れやすい最中が箱の中で壊れない機能性を備えた設計だ。

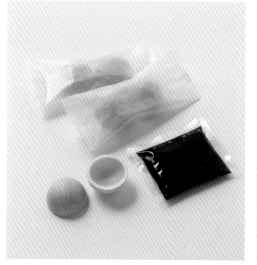

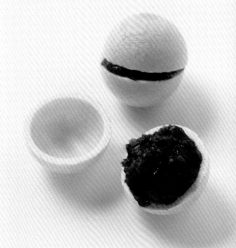

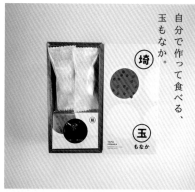

自分で作って食べる、玉もなか。

埼玉を代表する銘菓になるべく生まれた「玉もなか」。埼玉の玉をイメージした球体の可愛らしいもなかに、好きなだけあんこを詰めていただきます。

皮とあんこが分かれているのでさくさく食感が楽しめます。

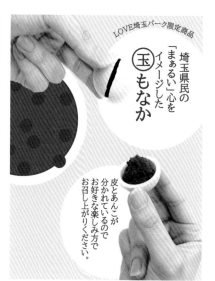

LOVE埼玉パーク限定商品

埼玉県民の「まぁるい」心をイメージした「玉もなか」

皮とあんこが分かれているのでお好きな楽しみ方でお召し上がりください。

■ DATA

販売元：株式会社ジェイコム埼玉・東日本
デザイン会社：株式会社ナニラニ
AD：久田幸弘
D：大隅愛子
PL：田頭倫子

●商品名

・玉もなか

●販売場所

・LOVE埼玉パーク Presented by J:COM
（ところざわサクラタウン）

東京

## 箔押しされたメロンが限定土産の高級感を際立たせる

### メロンたまご　銀座たまや

国産赤肉メロンのジューシーな果肉を感じる濃厚な味わいが特徴。東京土産として絶大な人気を誇る「ごまたまご」を販売している"銀座たまや"ブランドから2020年7月に発売された。メロンのイメージをそのままに、パッケージイラストのメロンの網目部分には、高級感のあるゴールドの箔押しが用いられている。背景色の鮮やかなオレンジとメロンのグリーンのコントラストが一際目を引くデザイン。

POINT

お菓子のフォルムは、たまご型のお菓子「ごまたまご」と合わせた展開。個包装もパッケージと同じデザインで展開されており、お菓子の世界観を印象づけている。

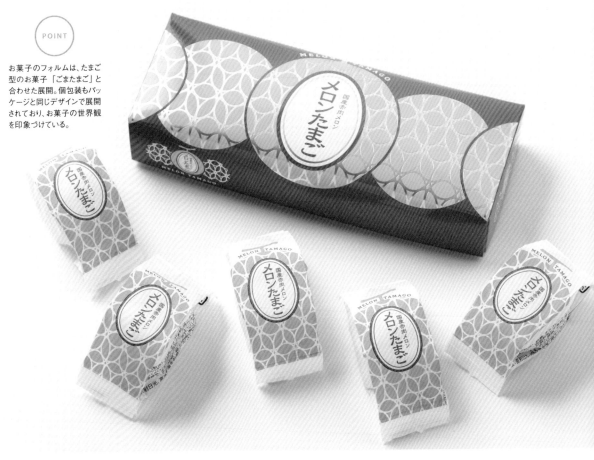

メロンの果肉のような断面にもこだわっている。

### ■ DATA

販売元：株式会社東京玉子本舗
デザイン会社：株式会社ミックブレインセンター
AD：横山牧子
D：五冨利七海

●商品名
・メロンたまご

●販売場所
・EXPASA海老名下りSASTAR1（海老名SA下）
※時季により販売箇所は変わる場合があります。

# お菓子の仕掛けも楽しい上野の新名物

## 上野パンダファミリーおさんぽバウム　株式会社スパート（上野案内所）

何層にも重ねられたバウムクーヘンに描かれたかわいいパンダ。フチの型抜きをしながら食べる楽しいお菓子だ。上野動物園のジャイアント
パンダ「シャンシャン」が5歳、双子の「シャオシャオ＆レイレイ」が1歳になったことを記念して2022年6月に発売された。バウムの絵柄が
数種類あり、どの絵柄が入っているのかは開けてみるまでわからないという仕掛けも楽しい。

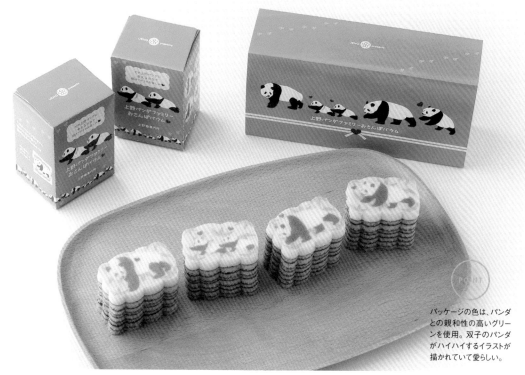

POINT

パッケージの色は、パンダ
との親和性の高いグリー
ンを使用。双子のパンダ
がハイハイするイラストが
描かれていて愛らしい。

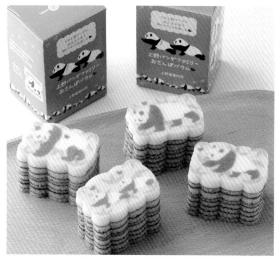

## ■ DATA

販売元：株式会社スパート（上野案内所）

● 商品名

・上野パンダファミリーおさんぽバウム（プレーン味）

● 販売場所

・上野案内所（松坂屋上野店内）
・自社オンラインショップ「江戸東京一」

# パッケージもお菓子も、いちごをまるごと表現

## 恋するいちご・初恋糖　株式会社静風

栃木県真岡市は、いちごの出荷量日本一を誇る生産地。地元密着型の企業、静風が栃木産「とちおとめ」を地域活性化の一助にしたいと開発されたのが、「恋するいちご」と「初恋糖」だ。栃木県産のとちおとめを100%使用し、いちご本来の風味が感じられる商品に。いちごをイメージした真っ赤なパッケージが、お菓子の内容を際立たせている。

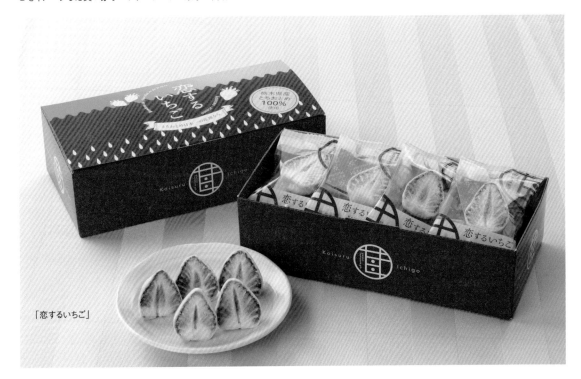

「恋するいちご」

POINT　上：いちごのかたちをそのまま活かした「恋するいちご」。外箱と個包装には、いちごの漢字をモチーフにしたロゴが印刷されている。
右下：「初恋糖」は使い切りやすい小ぶりのサイズのガラス瓶を使用し、中身が見える仕様に。

特選いちごを使用した「恋するいちごプレミアムシリーズ」のパッケージはシンプルな仕様に。

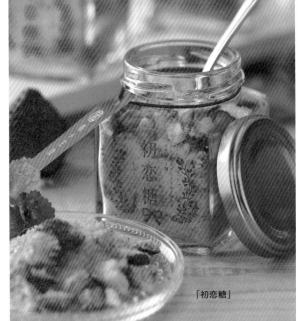

「初恋糖」

### ■ DATA

販売元：株式会社静風
D：伊藤雅美

●商品名
・恋するいちご
・初恋糖

●主な販売場所
・栃木県内の道の駅
・JR宇都宮駅
・自社オンラインショップ など

# 雪国新潟のほっこり癒されるクリスマス菓子を通年で販売

## 白銀サンタ　ガトウ専科

シルバーの背景に赤い帽子を被った雪だるまのパッケージが愛らしい「白銀サンタ」は、雪国新潟の名物として、クリスマスシーズン以外でも通年購入できると話題。ころんとしたかたちがかわいくて癒されると女性に大人気のお菓子だ。新潟で洋菓子を製造・販売するガトウ専科が、地元を代表するお菓子をつくりたいと考案。生地にも新潟県産の米粉を使用するなど、食材にもこだわっている。

 POINT

お菓子のテーマは「雪だるまになったサンタさん」。個包装は、中身の雪だるまに赤い三角帽子をかぶっているようなデザイン。ふっくらした生地が2層になって、ミニチュア版の雪だるまのよう。

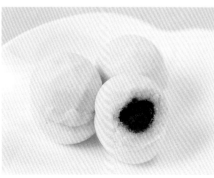

サンタになった、雪だるま。
ホワイトチョコレートに、ふっくらクッキーのボディ。
サンタのハートはスイートなフランボワーズピューレ。

Shirogane Santa

## ■ DATA

販売元：ガトウ専科

●商品名

・白銀サンタ
（6個入り、8個入り、12個入り）

●販売場所

・ガトウ専科 各店舗

# 伝統菓子をポップなデザインで刷新し販路を広げる

## 浮き星　hickory03travelers

一見、金平糖のようにも見える、あられに砂糖蜜をかけた新潟の郷土菓子。かつては「ゆか里」という名で市民に親しまれていたが、現在つくっているのは「明治屋」1軒のみという。そこで、デザインを通して地域活性化を図る地元のクリエイター集団「ヒッコリースリートラベラーズ」が協力し、気軽なお土産として多くの人に親しんでもらおうと、新たなネーミングからパッケージまで考案。販路を広げることに成功した。

POINT

缶や外箱に描かれたちょっと癖があるかわいいイラストが魅力。缶の色や柄でフレーバーが異なる。

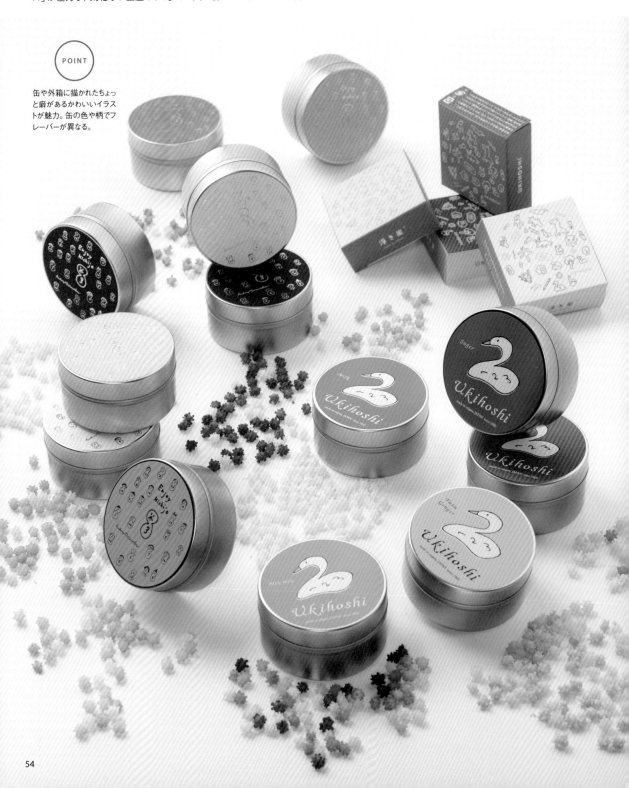

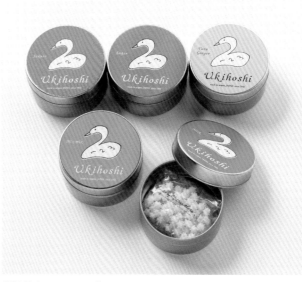

「浮き星 缶 雪だるまシリーズ」　箔押し加工が施されている。

「浮き星 缶 deux シリーズ」

「浮き星 ペーパーボックスシリーズ」

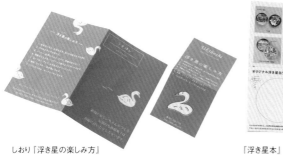

しおり『浮き星の楽しみ方』

『浮き星本』

ショッパー

■ DATA ·······································

販売元：hickory03travelers
（ヒッコリースリートラベラーズ）
デザイン会社・D：hickory03travelers、
合同会社アレコレ
AD・I：迫 一成

● 商品名
・浮き星 缶 雪だるま
・浮き星 缶 deux
・浮き星 箱 ペーパーボックス

● 主な販売場所
・喫茶 UKIHOSHI
・hickory03travelers
・hickory03travelers オンラインショップ
・ぽんしゅ館コンプレックス（新潟県）
・ぽんしゅ館長岡駅店（長岡駅）
・ぽんしゅ館越後湯沢駅店（越後湯沢駅）
・中川政七商店
・雑貨店
・県内スーパー、自社オンラインショップ　など

## ご当地B級グルメをインパクトあるパッケージで土産展開

### バスセンターのカレー風味せんべい・バスセンターのカレー風味柿の種　　　新潟交通商事株式会社

新潟のご当地グルメのひとつ、「バスセンターのカレー」(正式名称：万代シテイバスセンター構内にある「万代そば」の「カレーライス」)。1973年に創業してから、地元民や観光客から親しまれている名物だ。お土産用のレトルトカレーとして売り出されると、たちまち人気商品に。さらに、栗山米菓とコラボレーションして「バスセンターのカレー風味せんべい」が誕生した。スパイシーな味付けと軽い食感が魅力。お土産用レトルトの商品デザインをそのままパッケージに反映した。見た目のインパクトも強烈な商品だ。

POINT

カレーライスのビジュアルと力強いフォントが、一際目立つパッケージデザイン。

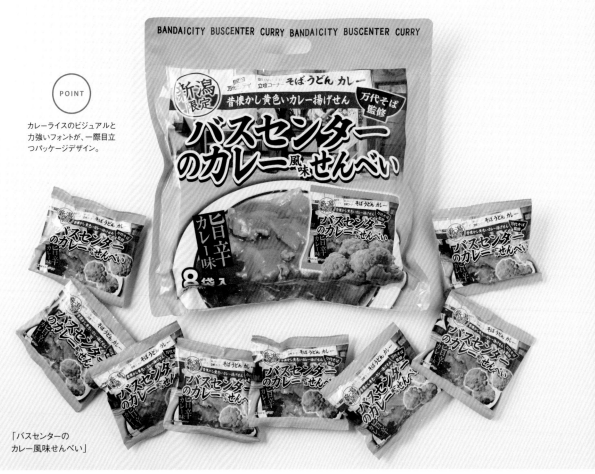

「バスセンターの
カレー風味せんべい」

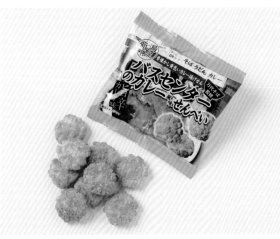

袋の裏側には、バスセンターのカレーライスの紹介が。

**「バスセンターのカレー風味
柿の種」**

2021年、新潟の名物カレー
「バスセンターのカレー」と「元
祖柿の種」浪花屋製菓の共同
で開発した商品。パッケージは、
金箔を用いた高級感のある佇
まい。被せフタをスライドさせる
と、バスセンターのカレーの紹介
が記載されている。

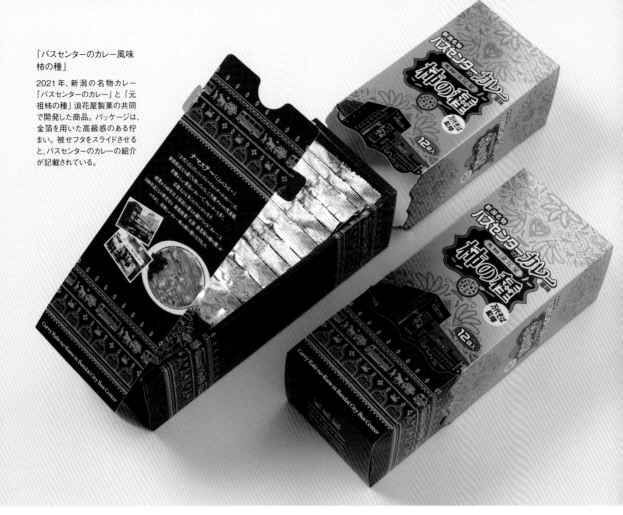

POINT

全体的に箔押しされており、
高級感を感じる外箱。カジュ
アルなスナックの柿の種との
ギャップも魅力だ。

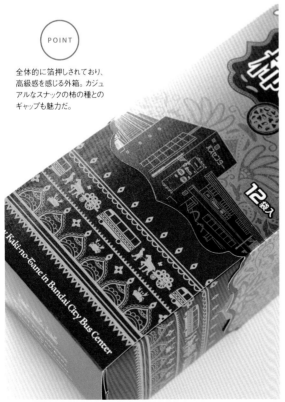

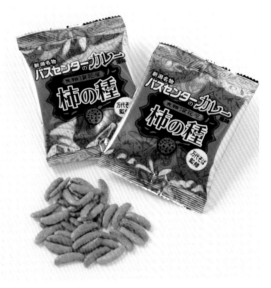

■ **DATA** ................................................

販売元：新潟交通商事株式会社

●商品名
・バスセンターのカレー風味せんべい
・バスセンターのカレー風味柿の種

●主な販売場所
・万代そば
・新潟空港
・新潟県内の主要駅
・新潟県内の主要道の駅
　など

57

**富山** 散りばめられた富山のかわいいモチーフが楽しさをプラス

## 富山白えびチーズぱり　株式会社あいの風

富山名産の白えびパウダーを練り込み、チーズを挟んだお煎餅。パリッとした食感に濃いチーズクリームが癖になる美味しさだ。クラフト調のパッケージには、富山の立山連峰や富山湾、かわいいタッチの白えびやチーズが描かれ、メインカラーのオレンジ色と相まって、ポップな印象に。煎餅＝和テイストを覆し、ターゲット層を若い女性にまで広げた。

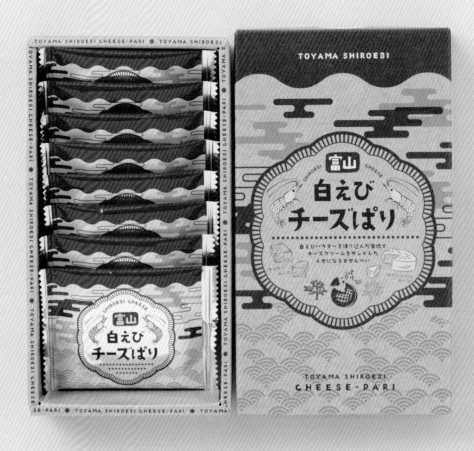

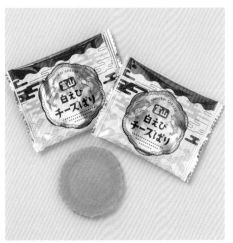

フタを開けると、身箱のフチにローマ字で商品名が。また、お菓子をとった底面にも、かわいいイラストが描かれている。

**■ DATA**

販売元：株式会社あいの風
D：朝倉古都美（石田紙器株式会社デザイン設計課）

●商品名
・富山白えびチーズぱり

●販売場所
・富山駅
・有磯海下りSA
・小矢部上りSA
・楽天市場

## あえてシンプルなデザインにすることで
## 売り場での注目率をUP

**能登牛パイ**　てらおか風舎

創業明治37年から100年続く寺岡畜産が営むレストランのてらおか風舎が、能登牛の美味しさを手軽に楽しんで欲しいと開発。肉の旨味が詰まったザクっとした食感。味のベースには店舗で使用されているステーキソースが使われている。2020年にパッケージをリニューアル。ブランド牛でありながら、土産品としてカジュアルに手に取れるシンプルなデザインが特徴だ。

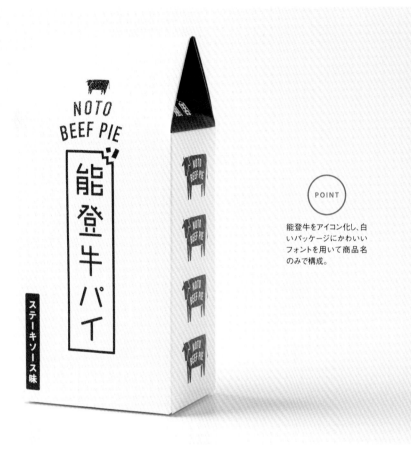

**POINT**

能登牛をアイコン化し、白いパッケージにかわいいフォントを用いて商品名のみで構成。

リニューアルの際、ミニサイズを開発し、幅広い年代にアプローチできるようにリプロダクト。

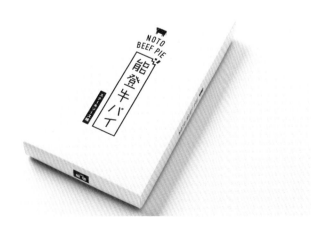

■ **DATA** ....................

販売元：てらおか風舎
デザイン会社：ペロ＆ボスコ Co.,Ltd.
AD・I：モリモトシンゴ

●商品名

・能登牛パイ

●主な販売場所

・石川県内のお土産店
・道の駅
・自店舗 など

## 八幡さまのキャラクターがかわいい縁起物の土産菓子

石川

### あいそらしモナカ 八幡さま　金沢うら田

「あいそらしい」とは、金沢の方言で「かわいらしい」という意味。モチーフとなっている「加賀八幡起上り」は、地元で古くから縁起物として親しまれてきた張り子の人形だ。コロナ禍の2021年、お菓子を通して少しでも人々に元気と勇気を与えたい、心和むひと時を感じてもらいたいという店主の思いから、開発された。箱を開けると最中とあんが別々にセットされており、自分でつくるキットとなっている。

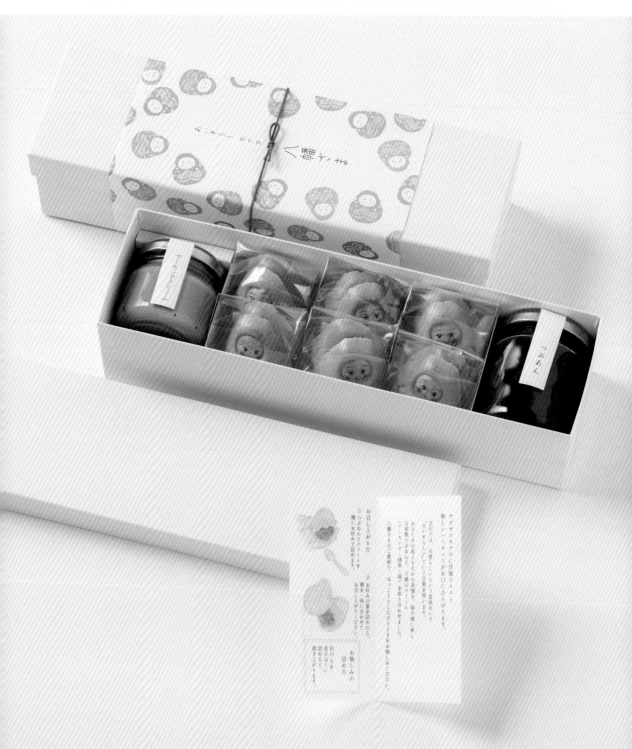

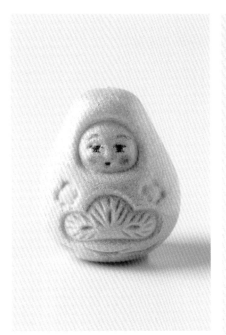

ほんのりピンクの頬がかわいらしい。あんの詰め方でゆらゆら起き上がらせることができる。

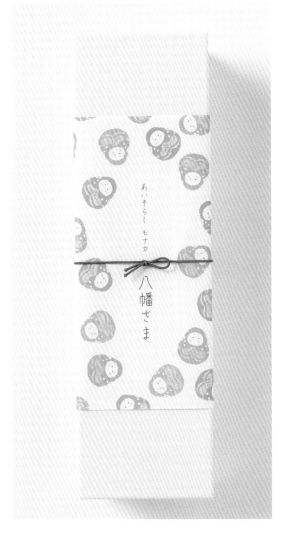

POINT

外箱には八幡さまの愛らしいイラストがラッピングされている。3色の八幡さまは味を表し、黄色はアーモンド、赤はいちご、緑は抹茶を意味している。

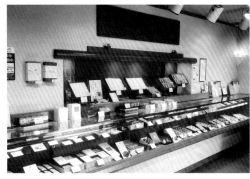

泉野店

■ DATA ..................

販売元：金沢うら田

●商品名
・あいそらしモナカ 八幡さま

●販売場所
・金沢うら田

圧倒的に愛らしいデザインで、たちまち人気の金沢土産に

**金澤文鳥** 清香室町

地元和菓子店が2021年から展開するシリーズ。「おいしいものに誘われて金沢に住み着いた、旅する文鳥」というコンセプトで、文鳥をかたどったかわいらしいパッケージが特徴だ。箱を留める帯にあしらわれた「鳥」という文字が、よく見るとくちばしが付いた鳥のようなかたちになっているなど、細部にまで凝ったデザイン。全体に和の雰囲気がありつつ、上品さを感じる仕様になっている。

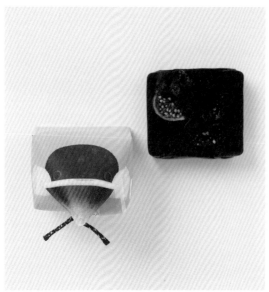

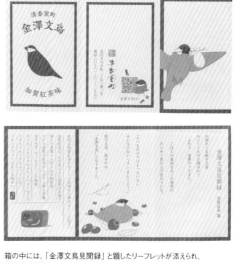

箱の中には、「金澤文鳥見聞録」と題したリーフレットが添えられ、物語感を演出。

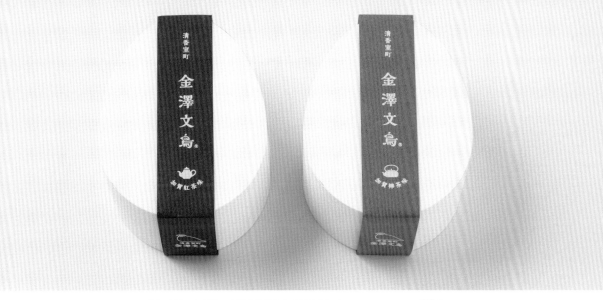

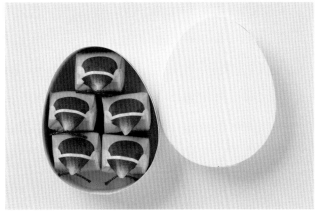

新フレーバー「加賀棒茶味」はナッツとコラボレーションした羊羹。文鳥の色も味にちなんで薄茶色で展開。

帯を外すと、真っ白の箱の天面に、文鳥のエンボス加工がほどこされている。

POINT 鳥の羽が持つ柔らかい雰囲気を出すため、和紙テイストの包紙で柔らかい風合いを演出している。くちばし部分はグラデーションで、より文鳥らしく見える工夫も。

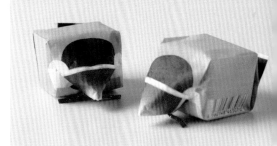

■DATA

販売元：清香室町
製作会社：松原紙器製作所

●商品名
・金澤文鳥 加賀紅茶味
・金澤文鳥 加賀棒茶味

●販売場所
・清香室町 本店
・清香室町 金沢駅百番街店
・清香室町 香林坊大和店

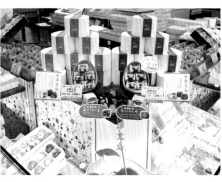

金沢駅百番街店

# 地元の女子高生がデザイナー、地域創生に貢献するサバ缶

## 強健サバ缶 アマニ油入り　福井缶詰株式会社

「強健サバ缶」は、地元小浜市の代表する商品をつくろうと、創業80年の老舗メーカー、福井缶詰とニップンがコラボレーションして生まれた商品だ。サバとアマニ油で、たっぷりのオメガ3脂肪酸が摂取できることが特徴。デザイン原案は、福井県立若狭高等学校の女子高生が担当。アマニの種子を手に持った「サバァマニ男爵」をメインキャラクターにコラージュしたユニークなビジュアルで話題に。

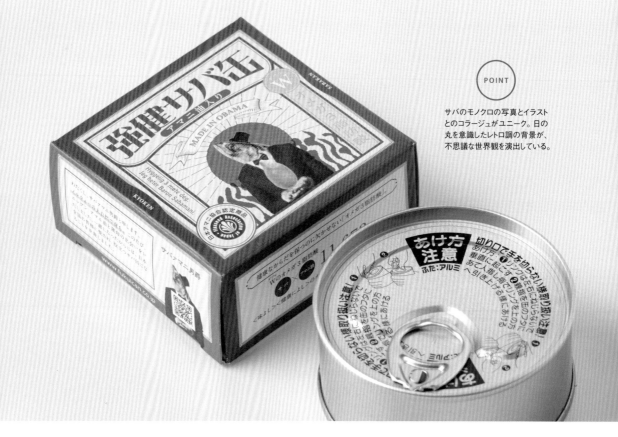

**POINT**

サバのモノクロの写真とイラストとのコラージュがユニーク。日の丸を意識したレトロ調の背景が、不思議な世界観を演出している。

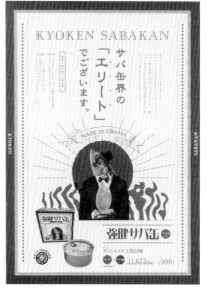

### ■ DATA

販売元：福井缶詰株式会社

●商品名
・強健サバ缶 アマニ油入り

●主な販売場所
・福井県小浜市の道の駅
・お土産店
・福井県アンテナショップ
・自社オンラインショップ
・関西郵便局の店頭販売（2023年3月まで予定）
・ふるさと納税返礼品 など

# 富士山の自然をデザインと味に落とし込む

## 富士桜スモークナッツシリーズ　美好商会

ナッツ・ドライフルーツ専門店「my present.」のオリジナル商品。母体である食品原材料の卸売会社、美好商会が創業70周年を迎えた際に、同社の得意分野であるナッツを活かし、「美味しくて地域貢献できる商品をつくりたい」と考えて開発。世界遺産・富士山北麓に自生する「富士桜」の間伐材を100%使用し、チップに加工。味の特徴は強めのスモーク。ナッツの特徴に合わせ、それぞれ燻製方法を変えている。

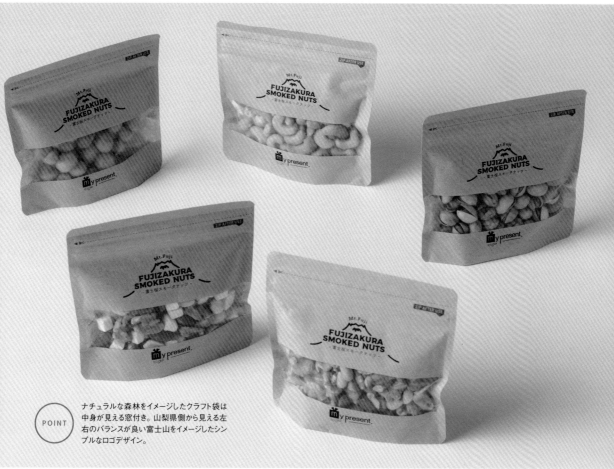

**POINT**　ナチュラルな森林をイメージしたクラフト袋は中身が見える窓付き。山梨県側から見える左右のバランスが良い富士山をイメージしたシンプルなロゴデザイン。

最後の一口まで美味しく食べられるようにと、ナッツの鮮度を保つチャック付き。
売り上げの一部を富士山の清掃活動等を行なう「富士山基金」に寄付している。

### ■ DATA

販売元：美好商会
デザイン会社：コペンフラップ
AD：緒形郁美（コペンフラップ）
D：小尾侑里（my present.）

● 商品名
・富士桜スモークナッツミックス
・チーズ入り富士桜スモークナッツミックス
・富士桜スモークマカダミア
・富士桜スモークカシューナッツ
・富士桜スモークピスタチオ

● 販売場所
・山梨県甲府市城東にある直営店「my present.」
・自社オンラインショップ

# 人気ご当地パンの昭和レトロな雰囲気が味わえる

## 牛乳パン風味シリーズ　　株式会社長登屋

長野県のソウルフードである「かねまるパン店」の牛乳パンとコーヒー牛乳パンと愛知県の菓子食品の製造、卸売、小売の事業を展開する長登屋がコラボレーションした「牛乳パン風味シリーズ」。2019年に長野県の新たな定番土産となる商品を開発しようと考えて制作されたこのシリーズは、現在累計売上150,000個を突破。パッケージデザインのイラストは、実際の「牛乳パン」と同じイラストを使用。かねまるパン店の初代店主の妻が、小さい頃の息子（現店主）さんをモデルに描いたもの。

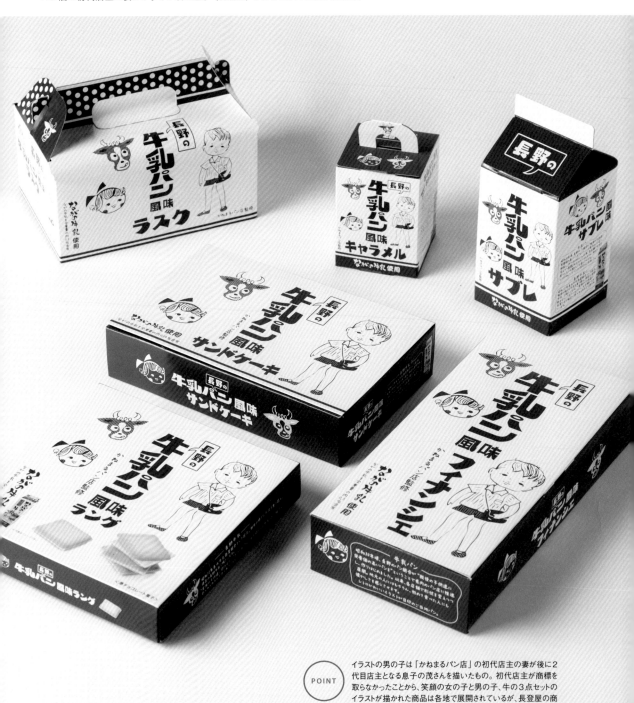

**POINT**
イラストの男の子は「かねまるパン店」の初代店主の妻が後に2代目店主となる息子の茂さんを描いたもの。初代店主が商標を取らなかったことから、笑顔の女の子と男の子、牛の3点セットのイラストが描かれた商品は各地で展開されているが、長登屋の商品ラインナップは随一。昭和レトロなイラストの雰囲気を活かしたほっこりデザインのパッケージはどれも手に取りたくなるかわいさ。

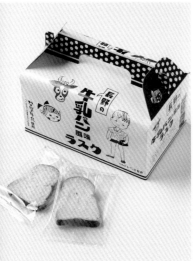
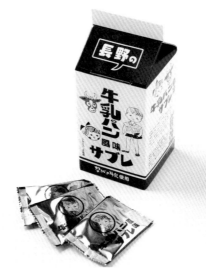
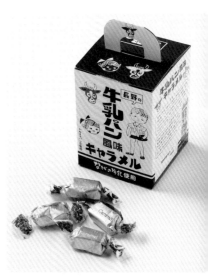
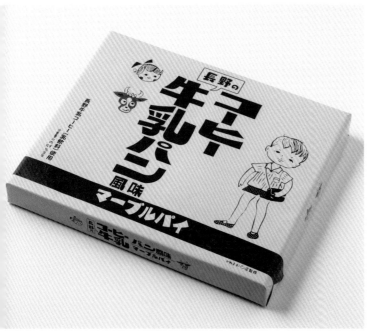

■ DATA

販売元：株式会社長登屋

●商品名

・牛乳パン風味サブレ
・牛乳パン風味キャラメル
・牛乳パン風味ラスク
・牛乳パン風味サンドケーキ
・牛乳パン風味フィナンシェ
・牛乳パン風味ラングドシャ
・コーヒー牛乳パン風味ショコラパイ

●主な販売場所

・長野県内のSA、PA
・道の駅 など

# 7色のマカロンが散りばめられた長野のポップなスイーツ

## スパイス・マカロン　根元 八幡屋礒五郎

日本三大七味のひとつとも言われる、長野の名物でありお土産の定番「八幡屋礒五郎」。若い世代にも唐辛子の素材を身近に感じて欲しいという思いから商品化したKongenSweetsシリーズの「スパイス・マカロン」は、唐辛子、麻種、紫蘇、生姜、山椒、胡麻、陳皮の7つのスパイスの味わいが楽しめる。2010年の発売当時は中のバタークリームに素材の味を練りこんでいたが、2019年から生地に素材の味を練りこみ、味わいを改良。

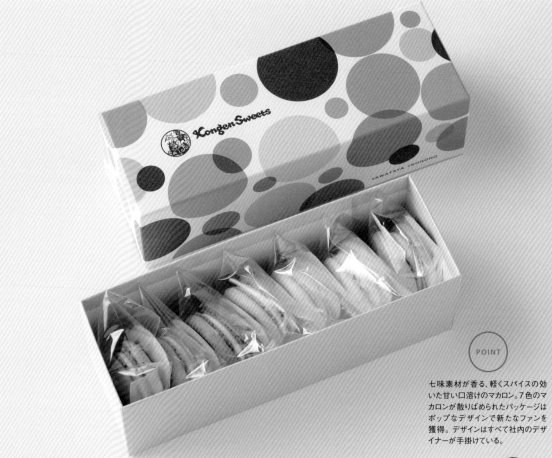

POINT

七味素材が香る、軽くスパイスの効いた甘い口溶けのマカロン。7色のマカロンが散りばめられたパッケージはポップなデザインで新たなファンを獲得。デザインはすべて社内のデザイナーが手掛けている。

### ■ DATA

販売元：根元 八幡屋礒五郎

●商品名
・スパイス・マカロン

●販売場所
・直営店（本店、長野駅MIDORI店）
・自社オンラインショップ

## 岐阜 老舗の銘茶を、飛騨のお守り"さるぼぼ"のティーバッグに

### さるぼぼほ〜っとてぃ〜 株式会社スカイワールド

「さるぼぼ」とは飛騨の言葉で猿の赤ちゃんのこと。災いが"さる"、猿のように子沢山になるという、家内安全や良縁、子宝祈願のお守りとして古くから親しまれてきた。そのさるぼぼをモチーフに、明治13年創業の老舗「野畑茶舗」店主が厳選した緑茶と紅茶を詰めたティーバッグ。愛嬌のあるユニークなデザインと香り高い豊かな味わいで、人気の飛騨土産だ。企画プロデュースは、地域創生を掲げ、飛騨高山の優れた技術や商品を紹介・流通する複合商業施設「右衛門横町」を運営するスカイワールドが手掛けている。

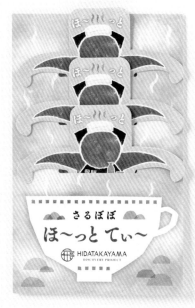 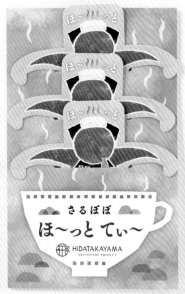

飛騨高山の老舗「野畑茶舗」のお茶が、手軽なティーバッグに。ピンクのパッケージは紅茶、グリーンは緑茶。

POINT

温泉ならぬお茶に浸かりながら、日本酒を楽しんでいるさるぼぼの姿が笑いを誘うタグデザイン。ほ〜っとくつろぐ声が聞こえてきそうだ。

### ■ DATA

販売元：株式会社スカイワールド
デザイン会社：株式会社ゴーアヘッドワークス
D・I：清水真規子
PR：株式会社スカイワールド
Skyworld, Inc. CEO：榎坂純一

●商品名
・さるぼぼほ〜っとてぃ〜（紅茶、緑茶）

●販売場所
・右衛門横町

右衛門横町

# お茶通にも喜ばれる、飛騨の老舗茶舗オリジナルの和紅茶

## 飛騨紅茶・さるぼぼタグティー　　株式会社なべしま銘茶

飛騨高山に5代続く老舗の深蒸し茶専門店・なべしま銘茶が、8年かけて生み出したオリジナルの和紅茶。奥飛騨温泉郷の湯けむりで発酵を促した、まろやかな甘みとほどよい渋味は、摘み取り時期で異なる味わいも魅力。春摘みの一番茶「ファーストフラッシュ」はストレートで、夏の終わりに摘んだ二番茶「セカンドフラッシュ」はミルクティーで楽しみたい。さるぼぼのタグがかわいいタグティーも、発売以来、手頃な飛騨土産として人気。

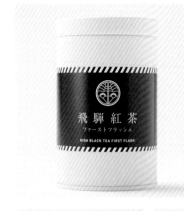 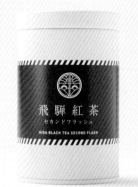 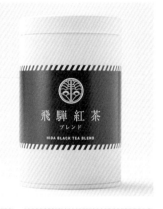

「飛騨紅茶」

**POINT**

「飛騨紅茶」「さるぼぼタグティー」共にパッケージは、店舗ディレクションを担当した堀口和也がトータルで手掛けている。贈答用におすすめのシンプルで上品なデザイン。

### ■ DATA

販売元：株式会社なべしま銘茶
D：堀口和也

●商品名
・飛騨紅茶（ファーストフラッシュ、セカンドフラッシュ、ブレンド、琥珀の月／各リーフタイプ・ティーバッグ）
・さるぼぼタグティー

●主な販売場所
・自店舗
・高山市内の主要道の駅
・高山市内のお土産店 など

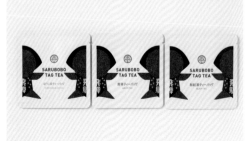 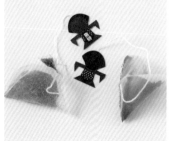

「さるぼぼタグティー」
さるぼぼを真っ二つに割って配した、洗練されたデザイン。ティーバッグのタグは店主自ら発案。

# 純度100%の柿のみつを際立たせる佇まい

**柿みつ**　合同会社三藤

「柿みつ」は、岐阜県産の富有柿だけを使った純度100%のみつ。岐阜県を拠点とする合同会社三藤が規格外の柿を有効利用したいとの思いから開発した商品だ。濁りのない、みつづくりにこだわり、砂糖や水、添加物を一切使用していないのが特徴。柿をモチーフにしたラベルが、みつの自然な色味を際立たせている。

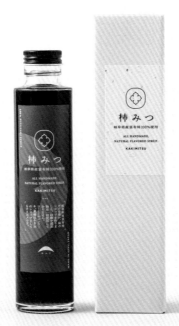

**POINT**

ラベルデザインの配色は、わかりやすくグリーンとオレンジを使用。柿のイメージをそのまま伝えている。また、やさしいフォント使いが品質の良さを表現している。外箱のラベルは、和の雰囲気を感じる和紙の仕様となっている。

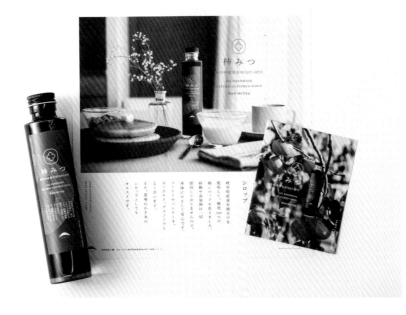

**■ DATA**

販売元：合同会社三藤
デザイン会社：THROUGH
D：大津 厳

●商品名

・柿みつ

●販売場所

・道の駅 パレットピアおおの
・THE GIFTS SHOP
・自社オンラインショップ

## 温泉街を元気にする、昭和レトロなプリン＆ドリンク

### 湯上り三兄弟・熱海プリン・風呂まーじゅプリン　株式会社フジノネ

熱海を盛り上げたいと開発された「熱海プリン」シリーズ。「風呂まーじゅプリン」は、卵を使用せずマスカルポーネチーズを使ったプリン。
「温泉＝お風呂」ということで、チーズを意味する「フロマージュ」と「風呂」をかけて、熱海にちなんだプリンとして2017年に発売された。
湯上りの定番ドリンク「コーヒー牛乳」「フルーツ牛乳」「いちご牛乳」をイメージした「湯上り三兄弟」は、「熱海プリンカフェ2nd」限定商品。

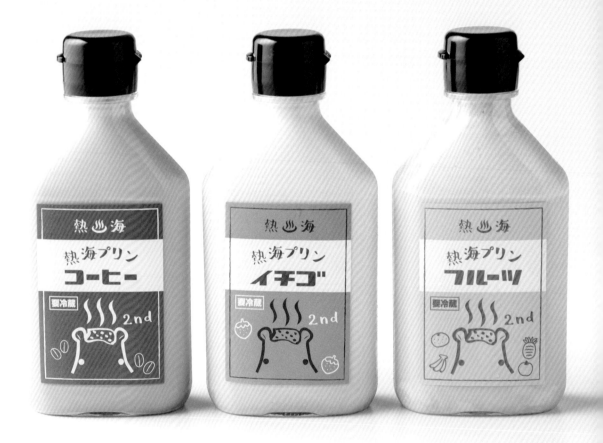

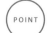

「湯上り三兄弟」
湯上りに飲むコーヒー牛乳やフルーツ牛乳を連想するパッケージ。懐かしさを演出しながらもあえてボトルはスリムなペットボトルで仕上げている。

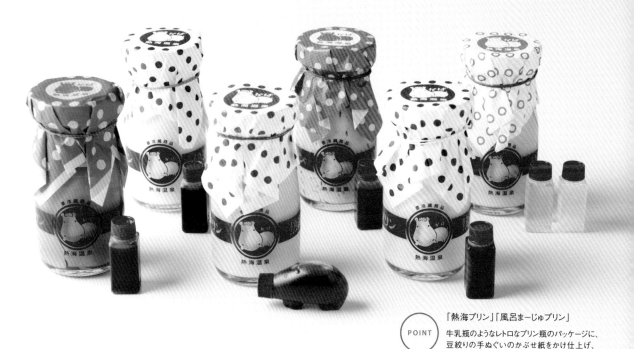

○ POINT

「熱海プリン」「風呂まーじゅプリン」

牛乳瓶のようなレトロなプリン瓶のパッケージに、
豆絞りの手ぬぐいのかぶせ紙をかけ仕上げ、
温泉やお風呂をかわいらしく表現。

■ **DATA**

販売元：株式会社フジノネ

●商品名
・熱海プリン
・風呂まーじゅプリン
・湯上り三兄弟

●販売場所
〈熱海プリン、風呂まーじゅプリン〉
・熱海プリン店舗全店（市内4店舗）
〈湯上り三兄弟〉
・熱海プリンカフェ2nd（イートイン限定）

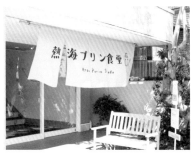

ドライブイン熱海プリン食堂

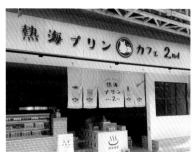

熱海プリンカフェ 2nd

熱海プリン 1号店

# 観光客や緑茶初心者でもわかりやすく整理した"緑茶愛"に注目

## SHIMADA Green Ci-Tea JAPAN No.1-7
面白企画創造集団・トコナツ歩兵団

「SHIMADA Green Ci-Tea JAPAN」は、「島田市緑茶化計画 - 地球上でもっとも緑茶を愛する街 -」をPRする商品をつくろうと、島田市・島田市茶業振興協会の3支部の青年部・JAおおいがわ・トコナツ歩兵団が協働で開発したオリジナル緑茶ブランド。製造工程の違いによる4種（No.1浅蒸し×火香弱／No.2浅蒸し×火香強／No.3深蒸し×火香弱／No.4深蒸し×火香強）と、製造過程で出る「出物」（でもの）を使用した3種（No.5芽／No.6茎／No.7粉）があり、味と香り、水色（すいしょく）の違いを楽しめるデザインを目指した。

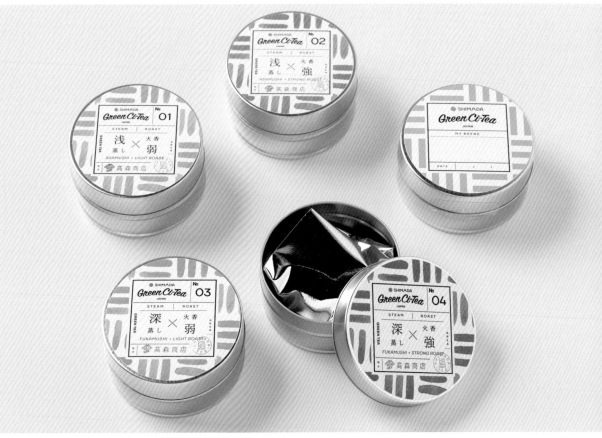

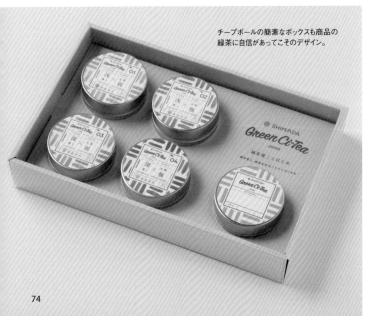

チープボールの簡素なボックスも商品の
緑茶に自信があってこそのデザイン。

 POINT

パッケージはそれぞれの違いをかわいく際立たせるため、テキスタイルデザイナーのKAYO AOYAMA氏に依頼し、水彩で表現してもらった。また、シティプロモーションを兼ねた商品として市内の3つのエリア（島田、金谷、川根）の茶葉をスタンプで区別し、アピールできる仕掛けに。

島田市緑茶化計画のメインビジュアルの
イラストは若林 夏氏によるもの。

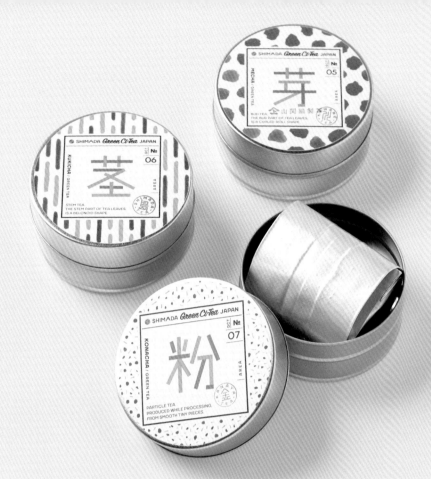

丸い銀の缶は、茶業関係者が緑茶のサンプルをやりとりする
ためによく使用している「見本缶」をセレクト。

## ■ DATA

製造元：参画する島田市内の茶商さん
CL：島田市広報課
PR：渡部祐介（トコナツ歩兵団）
AD・D：前川ゆういち&あきこ（トコナツ歩兵団）
I：KAYO AOYAMA
協力：島田市観光協会、島田市内の茶商の皆さん

●商品名
・SHIMADA Green Ci-Tea JAPAN（No.1-7）

●主な販売場所
・蓬莱橋897.4茶屋
・TOURIST INFORMATION おおいなび
　（KADODE OOIGAWA内）
・島田市内の下記のお茶屋さんほか
・白瀧製茶
・マルナカ 中村茶商
・マルサン 中野園
・山関園製茶
・朝日園
・石川製茶
・マルゴ 一言（ひとこと）茶店
・MOJ / MATCHA MORE
・お茶のさすき園
・まるさ佐京園 など

TOURIST INFORMATION おおいなび（KADODE OOIGAWA内）

蓬莱橋897.4（やくなし）茶屋

# 多岐にわたる商品群をターゲットに合わせてデザイン一新

## ドレッシング・わさび醤油たれ ほか　カメヤ食品株式会社

従来の主力商品のターゲット層が団塊の世代であったため、観光土産の未来市場での生き残りをかけ、若年層や女性向けの商品開発を決意。2019年からデザインプロデュース会社「セメントプロデュースデザイン」とタッグを組み、新販路向け商品、既存商品のリニューアル、海外向け商品、本店のみ販売する限定商品……など、多岐にわたる商品群をターゲットに合わせたデザイントーンで展開している。

POINT　カメヤブランドの底上げを目指し、各商品カテゴリーで訴求したいターゲットに合わせたデザイントーンを整理して展開。そうすることで、若年層、中年層、海外などターゲットごとに適した世界観を認知してもらうことができると考えた。

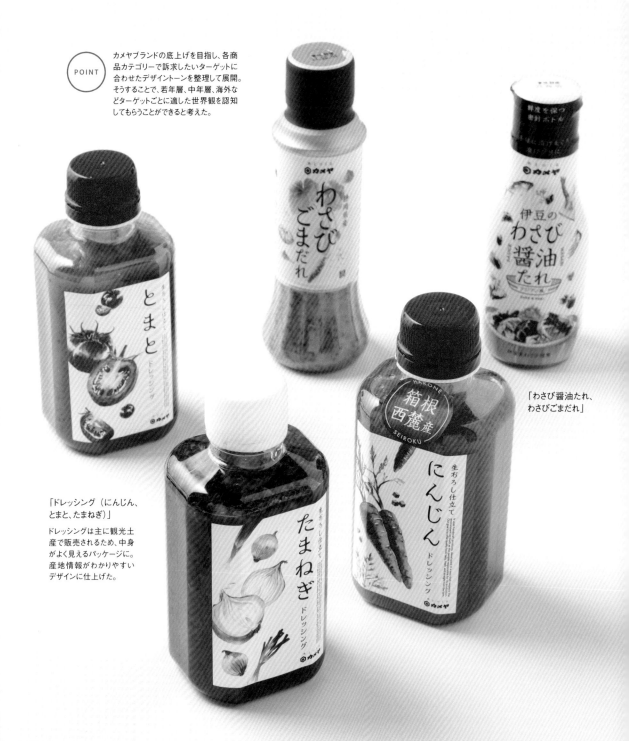

「わさび醤油たれ、わさびごまだれ」

「ドレッシング（にんじん、とまと、たまねぎ）」

ドレッシングは主に観光土産で販売されるため、中身がよく見えるパッケージに。産地情報がわかりやすいデザインに仕上げた。

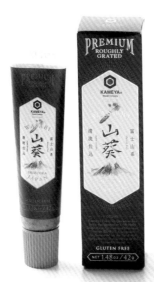
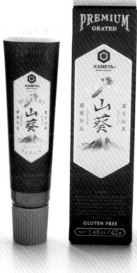

「PREMIUM GRATED WASABI、PREMIUM ROUHLY GRATED WASABI、WASABI SALT（海外輸出用）」

日本のわさびは高値で販売されるため、海外向けの商品はそれに負けない老舗感や日本らしさ、高級感を訴求できるデザインで展開。

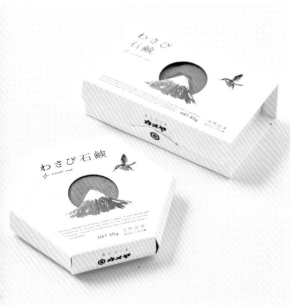

「わさび石鹸」

「伊豆わさびピスタチオ、伊豆わさびちーず」

KIOSKなどで「伊豆のわさび」を味わえる商品。出張や、旅行中の若年層でも買いやすく食べやすいように、老舗感を押し出すのではなく、カジュアルで旅情感を感じるデザインに。

カメヤ本店

■ DATA

販売元：カメヤ食品株式会社
デザイン会社：CEMENT PRODUCE DESIGN
AD・D：志水 明
D・I：丸山あゆみ

●商品名
・伊豆わさびちーず
・伊豆わさびピスタチオ
・わさび石鹸（50g）
・わさび石鹸（85g）

・にんじんドレッシング
・たまねぎドレッシング
・とまとドレッシング
・わさび醤油たれ
・わさびごまだれ
・PREMIUM GRATED WASABI（※海外輸出用）
・PREMIUM ROUHLY GRATED WASABI（※海外輸出用）
・WASABI SALT（※海外輸出用）

●主な販売場所
・静岡県
・山梨県
・神奈川県の観光地
・SA・PA
・道の駅
・静岡空港
・羽田空港
・自社オンラインショップ など
（伊豆わさびちーず、伊豆わさびピスタチオは東京駅から大阪までの駅店でも販売）

# 人気ご当地キャラクター「うなも」の温かみのあるイラストも人気

## うなぎいものクッキーサンド　うなぎいも協同組合

浜名湖のうなぎと遠州浜のさつまいもがコラボレーションして2011年に誕生した新たな浜松限定ブランド「うなぎいも」。頭がさつまいも、体がうなぎでできたオリジナルキャラクターは「うなも」と命名。この「うなぎいも」を使ったプリンやタルト、どら焼き、サブレなどが地元のお菓子屋でお土産として展開されている。2022年7月に発売された「うなぎいものクッキーサンド」は、気軽にワンハンドで食べられるスイーツとして開発された。

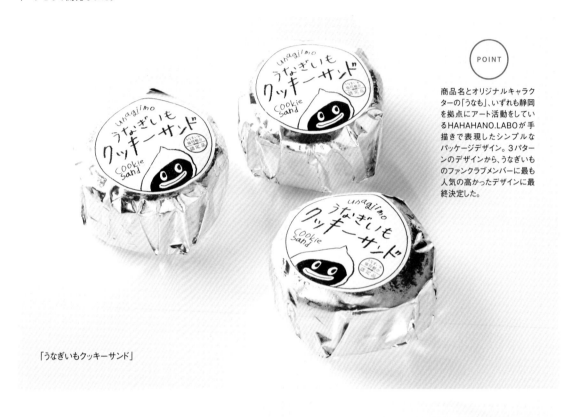

POINT

商品名とオリジナルキャラクターの「うなも」、いずれも静岡を拠点にアート活動をしているHAHAHANO.LABOが手描きで表現したシンプルなパッケージデザイン。3パターンのデザインから、うなぎいものファンクラブメンバーに最も人気の高かったデザインに最終決定した。

「うなぎいもクッキーサンド」

「うなぎいもぷりん」

### ■ DATA

販売元：うなぎいも協同組合
デザイン会社：HAHAHANO.LABO
D：二宮奈緒子
I：二宮 幹

● 商品名

・うなぎいものクッキーサンド

● 販売場所

・浜名湖SA
・うなぎいもストア浜松駅店
・うなぎいもストア inTOKYO
・うなぎいもストア通販

静岡 | **レトロな情感と独特の発砲感に、全国にファンが急増**

## 熱海ラムネ　伊豆半島合同会社

日本の夏の風物詩として長年親しまれてきたラムネ。近年、廃れつつあるその文化を守りたいと、伊豆半島地域の創生・活性化・支援を行なう伊豆半島合同会社が企画・販売。元祖ビー玉ラムネの技術の活用した、転がるビー玉の音やシュワシュワののど越しが懐かしい、正統派のラムネだ。甘過ぎず、ベタつかない飲みやすい味なので、子どもも年配者も美味しく飲める。シンプルでありながら、熱海の情緒を余すところなく表現したレトロなボトルのデザインも注目を呼び、人気急上昇中。

海中から温泉が吹き上がり、海が熱かったことにその名を由来すると言われる「熱海」にちなみ、赤と青をテーマカラーにデザイン。レトロな商品ロゴと、背景にあしらわれた波打つ海とカモメの絵が、街の雰囲気にしっくりなじむ。

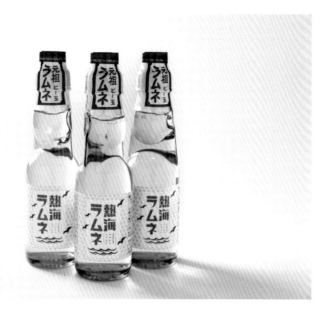

海・花火・浴衣・温泉文化が根づいた熱海の夏にぴったりの、清涼感溢れるレトロムードのラムネ。旅の思い出や街歩きのお供に。

### ■ DATA

販売元：伊豆半島合同会社
企画制作プロデューサー：布施和広
企画制作ディレクター：飛田春奈

●商品名
・熱海ラムネ

●主な販売場所
・熱海ミニ横丁内
・熱海市内のお土産店 など

咲見町一番街

# おなじみの名古屋土産を「つくる」という新しい切り口で

**ういろのこな**　株式会社大須ういろ

1947年に愛知県名古屋市で創業した大須ういろ。2022年7月に発売された「ういろのこな」は、自宅で蒸したてのういろが食べられるようにと開発されたお土産。商品開発の背景には、ういろの原材料が米粉と砂糖であること、蒸し菓子であること、お米を使っているがゆえに温度変化に敏感であることなどをもっと広く知ってもらいたいという思いから発想。味には白、抹茶、黒、きな粉があり、白はお湯をコーヒーや紅茶に変更することでさまざまなアレンジが楽しめる。

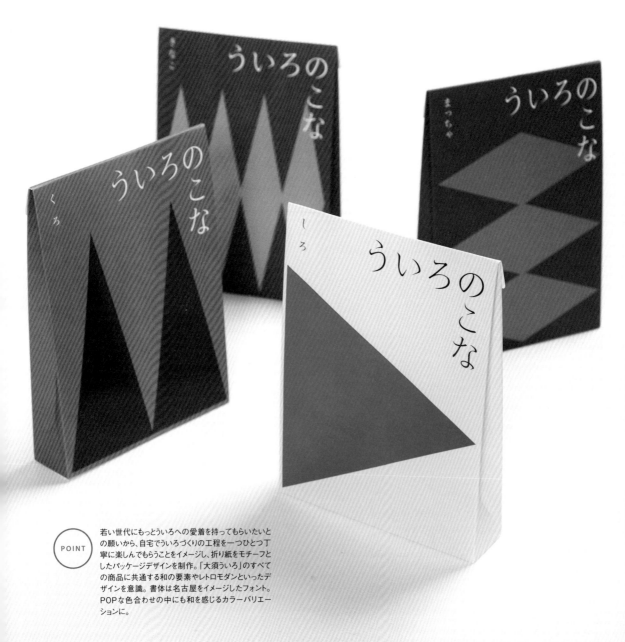

**POINT**　若い世代にもっとういろへの愛着を持ってもらいたいとの願いから、自宅でういろづくりの工程を一つひとつ丁寧に楽しんでもらうことをイメージし、折り紙をモチーフとしたパッケージデザインを制作。「大須ういろ」のすべての商品に共通する和の要素やレトロモダンといったデザインを意識。書体は名古屋をイメージしたフォント。POPな色合わせの中にも和を感じるカラーバリエーションに。

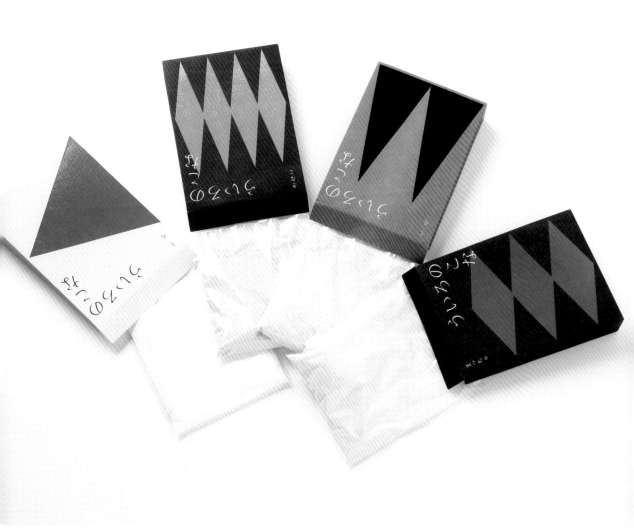

おうちでつくる　ういろのこ
な

オリジナルの美味（い）ういろができたら、『おういろのこな』をつけて
Instagramに投稿してください、大須ういろのスペシャルシェフとして
あなたの作ったういろが商品化されるかも！

じぶんで
つくる

とたのしいね

●製造者／株式会社大須ういろ 〒459-8009 名古屋市緑区浦水山 2-1619 〔お客様窓口／TEL052-626-3000〕

■ DATA ......................................

販売元：株式会社大須ういろ
AD：eri murayama
D：keishi oyama

●商品名

・ういろのこな

●販売場所

・直営店（大須ういろ本店、大須う
いろ大須北店、大須ういろ本部店）
・自社オンラインショップ

# 大人心をくすぐるポイントを追求した老舗ラムネメーカーの新商品

## THE RAMUNE LOVERS　カクダイ製菓株式会社

2021年の「ジェイアール名古屋タカシマヤ」開業20周年を記念した食品売り場の大規模リニューアル時に、地元・名古屋の企業を代表してカクダイ製菓が新規ブランドを立ち上げ初出店。同社のロングセラー「クッピーラムネ」はさまざまな企業とコラボレーションしてきたが、新ブランドの立ち上げはラムネ菓子の可能性を広げる大きなチャレンジと考え、新商品を開発した。口に入れるとほろほろほどける雪のような口どけの「生ラムネ」と、ラムネとチョコレートを組み合わせた心地よい嚙みごたえと濃厚な味わいを楽しめる「ラムネドルチェ」を展開。

**POINT**　ラムネの持つどこか懐かしい雰囲気を残しながらも、現在も未来も感じさせるようなアイコニックなイラストを求めてイラストレーターのさぶ氏に依頼。"カワイイ"だけでなく、抜け感とハッピー感のある表現で思わず手に取りたくなるパッケージに。フレーバーごとに、テイストのイメージを盛り込んだ動物キャラクターのイラストが描かれている。新たな名古屋土産としてSNSでも話題に。

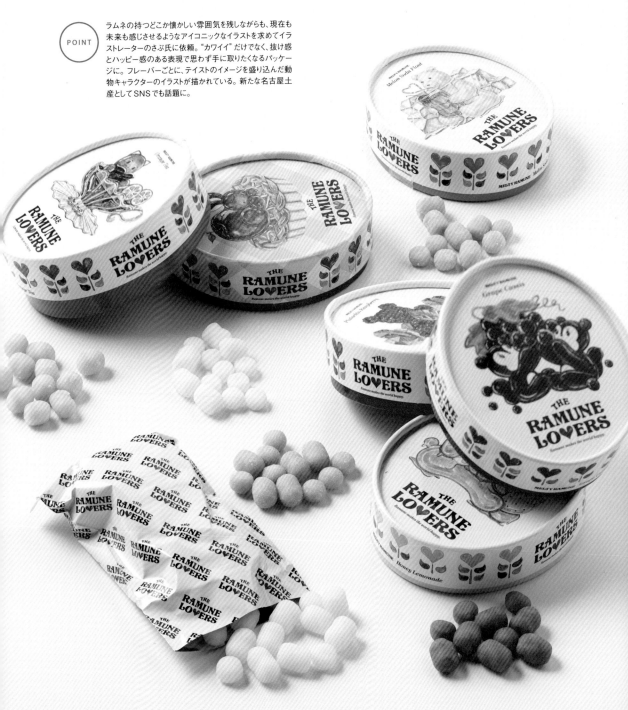

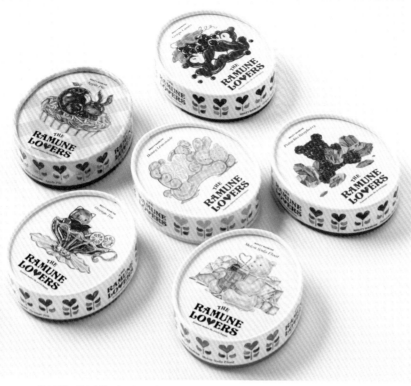

雪のような口どけ、素材の味を活かした高級感あふれるテイスト、ラムネが持つ爽やかさを活かした後味の残し方、
お菓子そのものの佇まいなど、すべてにおいて「大人の心をくすぐることができる」ポイントを追求。

ペーパー缶に印刷さ
れた懐かしいイラスト
を引き立てるため、
UVOPニスを用いて
光沢のある質感に。
ラムネドルチェの「ティ
ラミス」と「抹茶」には、
特色の銅を用いてさり
げなく金色に見える
工夫が施されている。

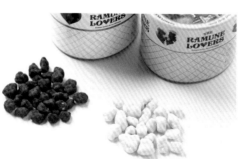

## ■ DATA

販売元：カクダイ製菓株式会社
プロデュース会社：株式会社チチ
AD・D：藤木雅彦（株式会社チチ）
I：さぶ

●商品名

＜生ラムネ＞
・ハニーレモネード
・メロンクリームソーダ
・グレープカシス
・オレンジティー
・ピスタチオラズベリー
・アップルパイ

＜ラムネドルチェ＞
・ティラミス
・和栗モンブラン

＜アソートボックス＞
・アソート小
・アソート大
※フレーバーのラインアップは季節
に合わせて変動します

●販売場所
・ジェイアール名古屋タカシマヤ

# 「プレゼントしたい」を目指したこだわりのパッケージ

## 八幸八の粕酢　　株式会社大和屋守口漬総本家

愛知県名古屋市で守口漬・奈良漬を中心に漬物を販売している、大和屋守口漬総本家。2019年には漬物、魚という専門領域だけでなくもっと発酵食品を身近に感じて欲しいという思いから「八幸八（はっこうや）」を立ち上げた。大和屋の漬ける技術の中で培った酒粕を用い、尾張三河地区でつくられていたお酢の技術と組み合わせ、粕酢を開発。梅、柚、檸檬の果汁に粕酢を加え飲むお酢として販売。

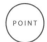

POINT

最もこだわったのはロゴマークのクオリティ。版画のようなテイストのシルク印刷で仕上げ、発酵食品の手づくり感を表現。初期段階ではブランド名は「八幸屋」だったが、マークを作成中に「八幸八」にした方がロゴのおさまりがいいという理由で変更したという裏話も。赤い丸は酒が発酵する時に起きる泡をイメージ。赤と白をキーカラーとし、ボトルキャップを隠す紙とシールをそれぞれ色分けして商品識別している。日本パッケージデザイン大賞2021 銅賞受賞。

## ■ DATA

販売元：株式会社大和屋守口漬総本家
デザイン会社：ピースグラフィックス
CD・AD：平井秀和
D：平井秀和、瀬川真矢
ネーミング：瀬川真矢

●商品名
・八幸八の粕酢
　梅粕酢
　ぽん酢
　柚粕酢
　檸檬粕酢

●販売場所
・大和屋本店
・大和屋守口漬総本家自社オンラインショップ

プレゼントしたくなる粕酢を目指すこと、また環境に配慮しプラ使用を減らすためボトルはガラスビンを採用。ミルクガラスのボトルにしたかったが予算が合わなかったため、透明ボトルを白く塗るというこだわりにも注目だ。

## 愛知

### リアルな写真とクラフト紙の素材感の対比で
### 名古屋名物をアピール

## みそ煮込うどん　株式会社大須ういろ

1947年に愛知県名古屋市で創業した大須ういろ。以前から販売していた「みそ煮込うどん」を「きしめん」や夏限定の「冷やしきしめん」と共に、麺類の幅や食感、つゆを見直すタイミングで2021年にパッケージもリニューアル。2022年には、さらに粉にもこだわり愛知県産「きぬあかり」を使用した生麺に変更。絹のように美しい明るさを持つ麺ができる小麦として開発された「きぬあかり」は、つるつるもちもちとした最高の食感だ。

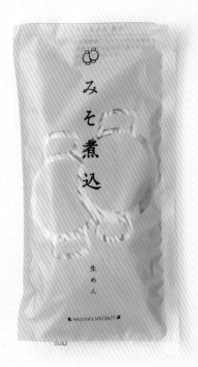

POINT

それまでの "いかにもお土産物" というデザインを刷新し、素朴でレトロなイメージを残しつつモダンに。新しい世界観をつくることで、若い世代にも響く、次世代の手土産を意識した。写真か絵が入っていないと売れないという麺類のジンクスを、どうシンプルにモダンにするかという課題に挑んだデザイン。リアルで鮮明な写真と、クラフト紙の素材感の対比で表現した。クラフト紙を使用したのは、商品イメージの素朴さやシンプルさと合わせるため。色は、味噌を連想する色づかいでまとめている。中を開けると商品を食べるシーンの栞になっており、裏面は調理例を紹介。商品に馴染みがなくても迷わず調理できる工夫がほどこされている。

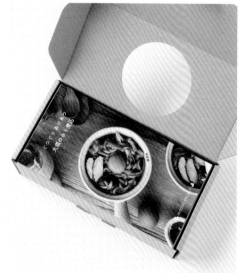

## ■ DATA

販売元：株式会社大須ういろ
AD：eri murayama
D：澤田剛秀（studio point）

●商品名

・みそ煮込うどん 4食入

●販売場所

・直営店（大須ういろ本店、大須ういろ大須北店、大須ういろ本部店）
・自社オンラインショップ

## 地元特産物のイメージを一新する、楽しいデザイン

**のりもも**　株式会社百福

古くから海苔の生産地として知られる三重県。創業60年の海苔屋「福井」では、2021年から新ブランド「のりもも」をスタート。「海苔の楽しさ、魅力を伝える」「よいものを欲しい人にきちんと届ける」「仲間を増やし、生産する方がこの先もつくり続けられる仕組みをつくる」の3つをビジョンに掲げ、商品を開発している。キーカラーをピンクに設定した楽しいデザインで、従来の海苔のイメージを刷新。多くのファンを獲得することに成功した。

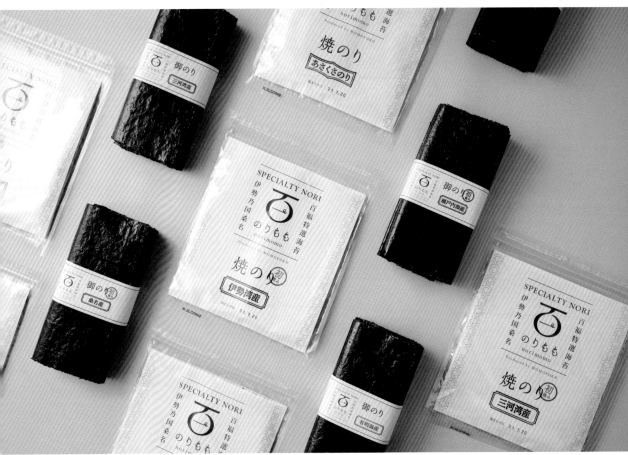

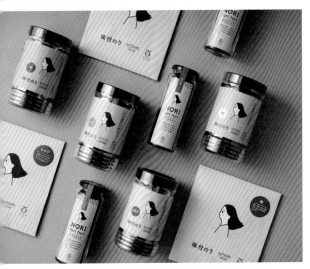

「ベーシック」
「ベーシック」は用途に応じたラインナップ。
太巻やおにぎりなど、使い方をアイコニックなイラストで表現。

POINT

ブランドラインを「スペシャリティ」「ベーシック」「カジュアル」の3つに分けて展開。「スペシャリティ」は、選りすぐりの海苔を使用。ロゴを全面に打ち出し、本物志向を意識したデザインに。

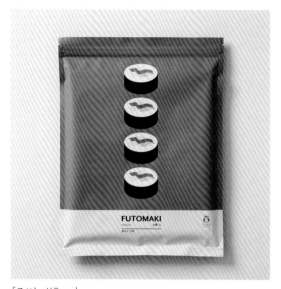

「スペシャリティー」
過剰包装しない、リサイクル素材等を積極的に使うなど、
環境にも配慮した取り組みを行なっている。

「カジュアル」
「カジュアル」は新たな楽しみ方を提案するシリーズ。
キャラクターの「ももこ」さんがシンボリックに描かれて印象的。

## ▊ DATA

販売元：株式会社百福
制作会社：株式会社RW

●商品名
・のりもも「スペシャリティ」
・のりもも「ベーシック」
・のりもも「カジュアル」

●主な販売場所
・のりももVISON店
・のりもも桑名店
・鈴鹿モビリティランド（三重県）
・六本松蔦屋書店（福岡）
・三重テラス（東京）
・アクアイグニス阿久比PA／大府PA（愛知）
・京都おうち平安神宮店（京都）
・自社オンラインショップ など

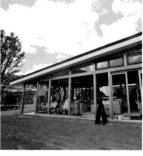

VISON 店

## レトロを感じさせるデザインで、食材への安心感と美味しさを表現

**びわコーラ**　株式会社イーマックス・サプライ 食産耕房

2022年4月に生まれた「びわコーラ」。はちみつや唐辛子、近江米に加え、伝説の果物「むべ」など、地元の食材を中心につくったクラフトコーラシロップだ。開発したのは、「滋賀県に眠る、まだ知られていない食材を通して魅力を発信したい」がコンセプトの食産耕房で、1本ずつ手づくりで製造されている。ラベルには、水や山など滋賀の豊かな自然を、シンボリックなイラストで展開。レトロを感じさせるシンメトリーなデザインで、安心感と美味しさへの自信を表現している。

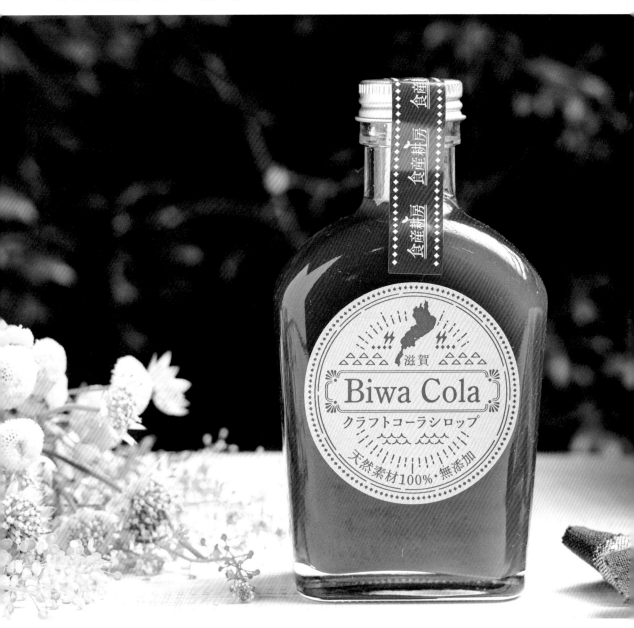

**POINT** 自然の風合いを演出するため、クラフト素材を使用。色むらやインクの滲みもアクセントになっている。

■ **DATA**

販売元：株式会社イーマックス・サプライ 食産耕房
デザイン会社：株式会社プランジェクトナカデ
D：岩出麻記

●商品名

・びわコーラ

●主な販売場所

・竜王アウトレット内テナント湖の駅
・道の駅妹子の郷
・近鉄百貨店（草津店）
・自社オンラインショップ など

滋賀

# 茶産地が一体となり立ち上げた
# 産地を活性化するブランド

## 土山一晩ほうじ　　滋賀県茶業会議所

日本茶発祥の地と呼ばれる滋賀県近江にある茶産地、「土山」。産地の認知度向上を目指し、茶農家と茶匠が一体となって開発したのが「土山一晩ほうじ」だ。最大の特長は、微発酵させた茶葉を焙じることで生まれる華やかで香ばしい香り。つくり手それぞれに味わいの個性が異なるのも大きな魅力。店頭での視認性を考慮し、ブランドカラーは焙煎する炎をイメージした赤色で統一されている。

POINT

ロゴマークは太陽と三日月が
モチーフ。「一晩寝かせて」つ
くるという製造工程をデザイン
に表している。

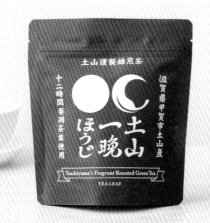

箱型のパッケージはブランドロゴの正方形の形状をそのまま活かしたデザインで、
店頭での陳列のしやすさも考慮されている。

### ■ DATA

販売元：滋賀県茶業会議所
ブランディング会社：株式会社エイトブランディングデザイン
ブランディングデザイン：西澤明洋、清瀧いずみ

●商品名
・土山一晩ほうじ

●主な販売場所
・甲賀農業協同組合の直売所
・オンラインストア
・滋賀県内の道の駅
・主要スーパー
・百貨店
・都内アンテナショップ など

# モチモチ食感がたまらない！カラフルな乙女のための京菓子

## 京西陣菓匠宗禅 串わらび　　京西陣菓匠宗禅有限会社

以前は冷凍で販売をしていた「串わらび」だが、「日持ちがしてお土産としても購入しやすい本物のわらび餅が欲しい」という声に応えて開発・販売された、常温保存可能な「串わらび」。本わらび粉ともち粉・酵素の絶妙な配合と独自の手もみ急速冷凍製法でモチモチの食感と味わいが実現。素材も抹茶・ほうじ茶は希少な京都和束町の茶葉を使ったものやクーベルチュールチョコ、京都水尾柚子などこだわりのラインナップだ。

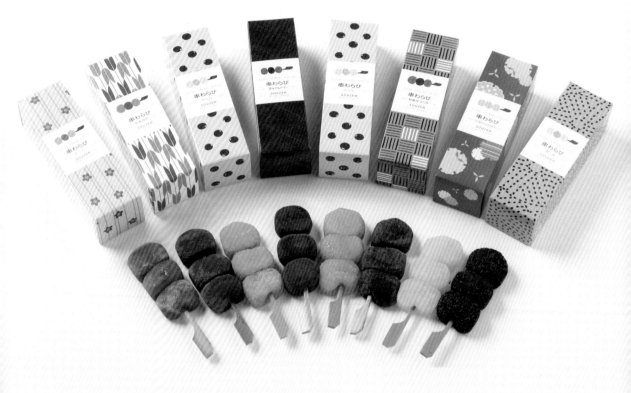

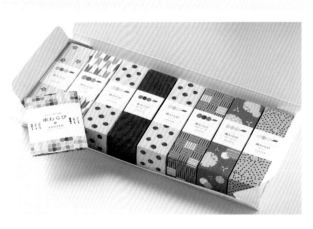

## ■ DATA

販売元：京西陣菓匠宗禅有限会社
AD：Souzen Yamamoto

●商品名
・串わらび

●主な販売場所
・関西・伊丹空港
・京都駅
・新大阪駅
・SA（近畿圏内、名神・新名神）
・百貨店 など

# 観光客にターゲットを絞り一目でわかる京都感を演出

## ショコラぼうろ&そばぼうろアソート　　平和製菓株式会社

1950年創業のそばぼうろ製造メーカー、平和製菓が従来の製品にひと手間加え、今までにない新しい「ぼうろ」を目指して開発したブランド「Tsuroku」。若い世代に向けて開発したのはチョコレートをぼうろに染み込ませた新感覚の味わいで、抹茶やほうじ茶、アールグレイのほか季節限定でパウダー付きぼうろを発売するなどラインナップも豊富。新たな京都銘菓として発売すぐに観光客に大人気となった。

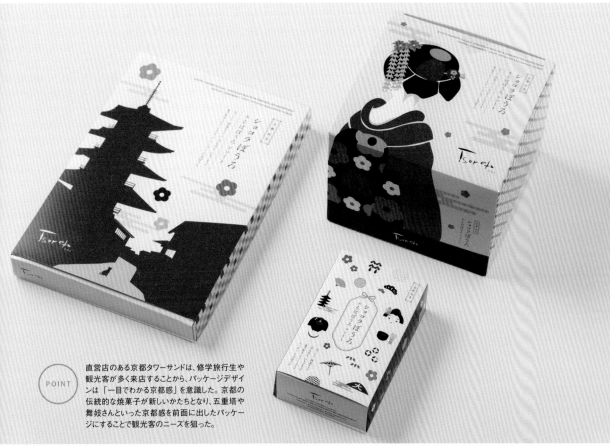

**POINT**　直営店のある京都タワーサンドは、修学旅行生や観光客が多く来店することから、パッケージデザインは「一目でわかる京都感」を意識した。京都の伝統的な焼菓子が新しいかたちとなり、五重塔や舞妓さんといった京都感を前面に出したパッケージにすることで観光客のニーズを狙った。

## ■ DATA

販売元：平和製菓株式会社
デザイン会社：株式会社中川紙宗
AD：Souzen Yamamoto

●商品名
・ショコラぼうろ&そばぼうろアソート（8枚入）（20枚入）（48枚入）

●主な販売場所
・Tsuroku 京都タワーサンド店
・自社オンラインショップ
・京都市内のお土産店 など

## 抹茶の鮮やかな色合いのパッケージが上品な
## 京都老舗の新定番

### 祇園辻利 POLCOCON　株式会社祇園辻利

1860年創業の京都・祇園辻利が発売した「さくほろクッキー POLCOCON（ぽるここん）」。材料に卵を一切使用せず、ほろほろと口の中で崩れる軽やかな食べ心地が特長の洋菓子「ポルボロン」（スペイン語）と、ひとくちサイズの大きさから「繭」を意味する「COCON（ココン）」（フランス語）を掛け合わせたネーミングで登場。濃厚で香り高い風味豊かな抹茶粉糖がまぶされて、さくほろ食感が後を引く。

POINT

ほろっと崩れるやさしい食感や、しっかりと香る宇治抹茶の味わいが特徴的なことから、重なり合うお茶の葉のイラストでお菓子のシルエットを描き、温もりを感じられる手書き文字とナチュラルな配色で構成・表現。食べ終えた後も小物入れなどとして置いておきたくなるように紙管を使ったパッケージデザインに。ロゴデザインは商品形状や、ころっとした気軽なお菓子であることから、愛らしい造形を意識。上質さも伝わるよう、ラインピッチは一定の細さに設定している。

カジュアルな印象ながらも洗練されたパッケージで手土産にもぴったり。時代のニーズに合わせ、ブールドネージュとしては珍しく1個ずつ個包装として販売している。抹茶の風味を保つため、個包装はアルミ製を採用。

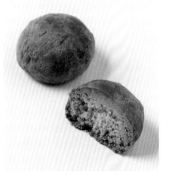

**■ DATA**

販売元：株式会社祇園辻利
D：園田拳斗（祇園辻利）

**●商品名**
・POLCOCON

**●販売場所**
・祇園辻利 祇園本店
・祇園辻利 京都駅八条口店
・祇園辻利 東京スカイツリータウン・ソラマチ店
・茶寮都路里 京都伊勢丹店
・茶寮都路里 大丸東京店
・祇園辻利公式オンラインショップ

## レトロタッチな大阪名物・ミックスジュースのイラストが目印

### 大阪ミックスジュースサンドクッキー　　株式会社寿香寿庵

関西の菓子メーカー、寿香寿庵が「大阪を代表するお土産をつくりたい」という思いから、大阪のソウルドリンクである「ミックスジュース」をベースにしたサンドクッキーを発売。エアチョコにオレンジピール、りんごのフリーズドライを加えたミックスジュース風味のまろやかなチョコをさっくりと香ばしいクッキーでサンド。大阪のミックスジュースを彷彿させる、濃厚ながらもまた次が食べたくなる爽やかな後味がポイント。

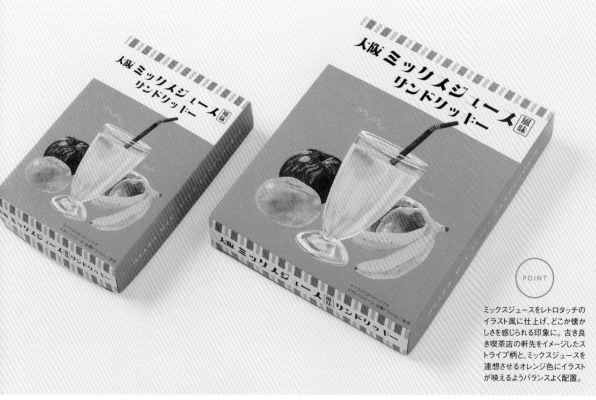

POINT

ミックスジュースをレトロタッチのイラスト風に仕上げ、どこか懐かしさを感じられる印象に。古き良き喫茶店の軒先をイメージしたストライプ柄と、ミックスジュースを連想させるオレンジ色にイラストが映えるようバランスよく配置。

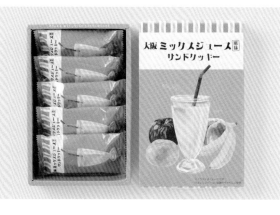

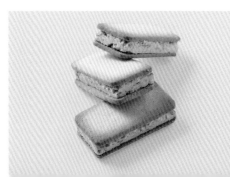

### ■ DATA

販売元：株式会社寿香寿庵
I：藤井美帆

●商品名
・大阪ミックスジュースサンドクッキー

●主な販売場所
・アントレマルシェ エキマルシェ新大阪店
・アントレマルシェ新大阪中央口店
・お土産街道アルデ新大阪店 など
※売場が変更になる可能性があります。

# 地元企業のロングセラー文具を
# ユニークなコラボでかわいいお菓子に

## フエキ×パインアメ・クッピーラムネ・あまおう果汁入りいちごのど飴　株式会社ヘソプロダクション

不易糊工業のキュートな容器でお馴染みの「フエキどうぶつのり」が、ロングセラーキャンディ、パイン株式会社の「パインアメ」や「いちごのど飴」、カクダイ製菓の「クッピーラムネ」とコラボレーション。商品プロデュースを手掛けたのは大阪のヘソプロダクション。カラフルなフエキくんの帽子を外すと、甘酸っぱくてジューシーなパインアメやラムネがどっさり。

©FUEKINORI KOGYO/EFFORT

POINT　当初は外箱には入れずに裸で販売を予定していたが、透明パッケージに入れることで「かわいさ」が際立つことに気付き、オリジナルのパッケージを制作。また、昔ながらのロゴデザインを活用し、中のフエキくんに焦点が当たるようシンプルでレトロポップなデザインに仕上げた。

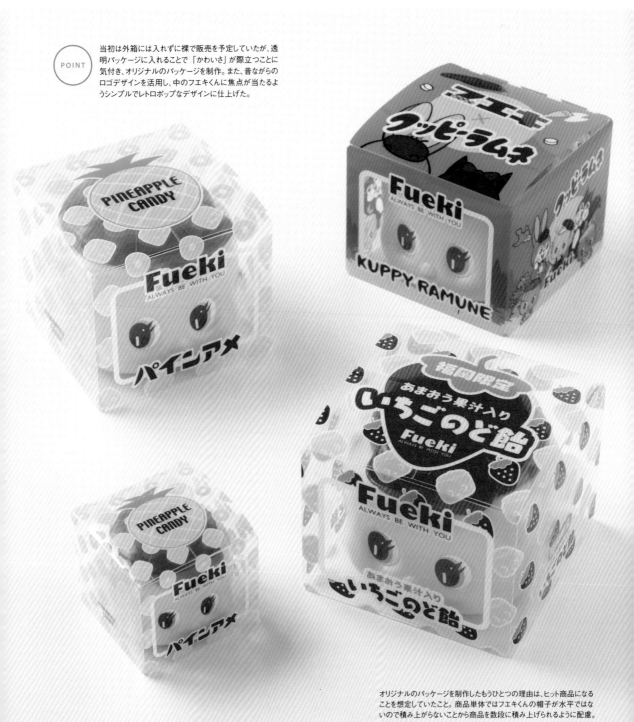

オリジナルのパッケージを制作したもうひとつの理由は、ヒット商品になることを想定していたこと。商品単体ではフエキくんの帽子が水平ではないので積み上がらないことから商品を数段に積み上げられるように配慮。

## ▓ DATA

販売元：株式会社ヘソプロダクション
デザイン会社：株式会社ヘソプロダクション
ション
CD：鈴村直也
D：もりもとたくろう
PR：稲本ミノル

●商品名

・フエキ×パインアメ レギュラーサイズ／
フエキ×パインアメ ビッグサイズ
・フエキ×クッピーラムネ ビッグサイズ
・フエキ×あまおう果汁入りいちご
のど飴 ビッグサイズ

●主な販売場所

〈フエキ×パインアメ〉
「フエキショップ -Fueki shop-」（心斎
橋パルコ内）ほか関西を中心に主要駅
構内やSA、空港等の土産店舗、バラ
エティショップ など
〈フエキ×あまおう果汁入りいちごのど飴
ビッグサイズ〉
「フエキショップ -Fueki shop-」ほか、お
みやげ本舗博多、博多駅、小倉駅の駅
ナカ店舗 など
〈フエキ×クッピーラムネ〉
「フエキショップ -Fueki shop-」（心斎
橋パルコ内）ほか、東海エリアの駅構
内・土産店舗 など

## 「大阪から福と笑顔を発信したい！」ハッピー感満載のちょろけんシリーズ

**なにわちょろけん シリーズ**　株式会社一創堂

「古くから大阪にあるユニークな文化を発掘し、大阪らしい新たな魅力を発信したい」という思いから、かつて門付け芸としてなにわの人々に愛された「ちょろけん」をモチーフにキャラクター化した「なにわちょろけん」菓子シリーズ。大阪弁のちょける（おどける、ふざけるの意味）の語源とも言われている元祖ゆるキャラ「ちょろけん」の愛らしさはもちろん、中身の美味しさもあってファンが続出。「ちょろけんぴ」は大阪の土佐稲荷神社奉納菓子でもある。

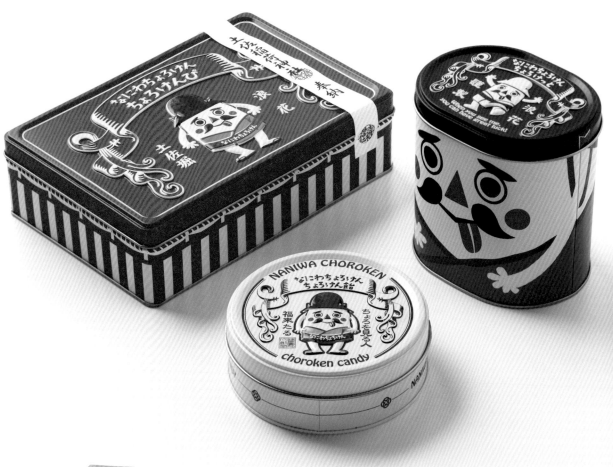

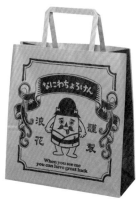

**■DATA**

販売元：株式会社一創堂
CD・AD・I・PR：野杁達郎

●商品名
・なにわちょろけん ちょろけんぴ
・なにわちょろけん ちょろけっと
・なにわちょろけん ちょろけん飴

●販売場所
・伊丹空港
・関西国際空港
・新大阪駅
・大阪駅
・自社オンラインショップ

「ちょろけんぴ」

「諸国之台所」と呼ばれた大阪は江戸時代、土佐からもたくさんの名産が運び込まれ、今も「土佐堀」という地名が残っている。この歴史にちなみ土佐（高知）の芋けんぴとコラボレーション。パッケージ缶は大阪らしい赤に紅白幕をあしらった。

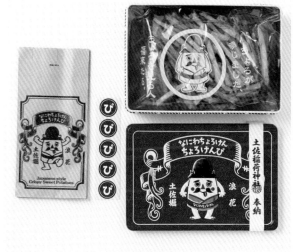

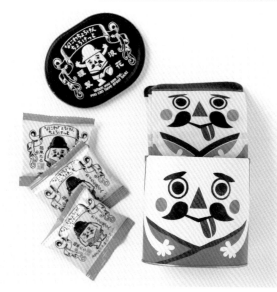

「ちょろけっと」

大阪で100年の老舗、「あたり前田のクラッカー」でおなじみの前田製菓で焼き上げたほろ甘いビスケット。お福分けジッパーバッグ付き。パッケージ缶は大きく「ちょろけん」をレイアウトし、インパクトあるデザインに。

「ちょろけん飴」

「飴ちゃん」を配る文化がある大阪にちなみ、福来たる「ちょろけん」の顔を模した組み飴とお福分け用の袋が入っている。パッケージ缶は縁起の良い水引きをイメージしたデザインにすることで、お土産や贈り物にも最適な仕様に。

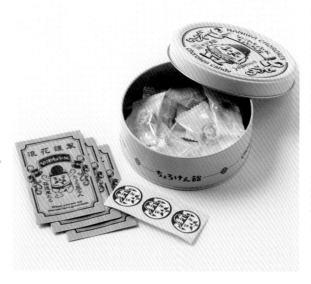

## ぱんだのイラストで注目度高めのスイートな芋のお菓子

### 蜜ぽてと・飴ぽてと・お芋チップス　らんらん

ほっこり癒されるパンダのイラストがかわいい「氷とお芋の専門店」らんらん。明治42年創業の氷問屋が母体で、かき氷とお芋にこだわった店舗として長く愛されてきた。雑誌やテレビに紹介されることも多く、ふわふわのかき氷とお芋のスイーツを目当てに全国から多くのファンが訪れる人気店だ。2020年に移転・リニューアルオープンに伴い、パッケージを一新。パンダと余白の効いたレイアウトで親しみやすさの中に品を感じるデザインで展開している。

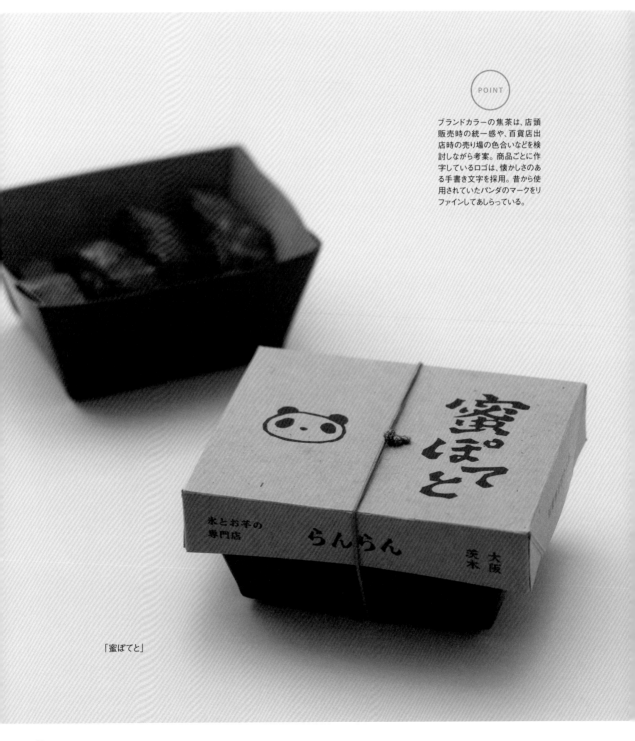

POINT

ブランドカラーの焦茶は、店頭販売時の統一感や、百貨店出店時の売り場の色合いなどを検討しながら考案。商品ごとに作字しているロゴは、懐かしさのある手書き文字を採用。昔から使用されていたパンダのマークをリファインしてあしらっている。

「蜜ぽてと」

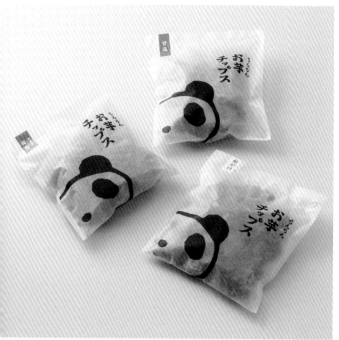

「お芋チップス」

「飴ぽてと」

■ DATA ...............

販売元：氷とお芋の専門店 らんらん
制作会社：paragram
AD：赤井佑輔
D：渡会芽生
Ph：貝淵亜季

●商品名
・蜜ぽてと
・飴ぽてと
・お芋チップス

●販売場所
・自店舗
・阪急百貨店
・自社オンラインショップ

# 大阪

## 縁起の良い梅結びモチーフをあしらった新たな大阪土産

### 大阪梅菓「CHOYA 梅結」 チョーヤフーズ株式会社

梅酒でおなじみのチョーヤが、「人を結び、ご縁を結ぶ、実を結ぶ、贈り物」をコンセプトとして水引の結び方である梅結びをモチーフに新たな大阪土産として開発。北海道産大手亡豆を使用したしっとりした食感と華やかな香りが特徴の白あんと、完熟南高梅の爽やかな酸味と果実感を味わえる特製梅ジャムを、素朴な風味で懐かしさ漂う生地で包み込んだ、3層仕立ての梅の和菓子。一口食べるとやさしい甘さの中に梅のほのかな酸っぱさを感じる新感覚の味わい。

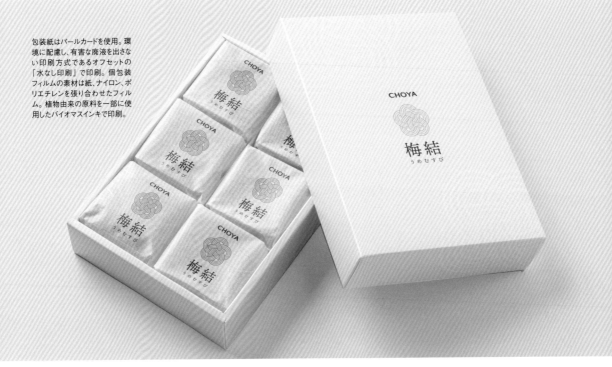

包装紙はパールカードを使用。環境に配慮し、有害な廃液を出さない印刷方式であるオフセットの「水なし印刷」で印刷。個包装フィルムの素材は紙、ナイロン、ポリエチレンを張り合わせたフィルム。植物由来の原料を一部に使用したバイオマスインキで印刷。

**POINT**

「梅」と「和」を想起するイメージで、贈り物に華を添える水引の中でも基本の結びとされ、日本古来の縁起物「松竹梅」から縁起が良いとされている"梅結び"のモチーフをパッケージに使用。梅結びは、結び目がしっかりとして簡単にほどくことができないことから、固く結ばれた絆という意味が込められている。「貴方のご縁が結ばれますよう、貴方の願いが叶いますよう」という思いを込めた。

**■ DATA**

販売元：チョーヤフーズ株式会社

●商品名
・大阪梅菓「CHOYA 梅結」

●主な販売場所
・JR新大阪駅（新幹線改札内コンコース）「ギフトキヨスク」「グランドキヨスク」
・大阪国際空港（伊丹空港）北ターミナル2F「旅・SORA」
・関西国際空港2Fドメスティック「関西旅日記」など

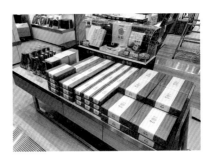

関西旅日記

# 「淡路島なるとオレンジ」の魅力を広く伝えたい
# という情熱をパッケージに凝縮

## 淡路島ビスケット 島ビスケ　株式会社うずのくに南あわじ

兵庫県淡路島の観光施設「ショップうずのくに」や「うずの丘大鳴門橋記念館」を運営する会社の社員が、「売上上位3位に入る新商品を開発しよう！」とプロジェクトを発足させ誕生した「島ビスケ」。約300年前に淡路島で発見され、現在絶滅危機に直面している固有種「淡路島なるとオレンジ」の魅力を伝える一品となった。爽やかな酸味とほろ苦さが特徴。

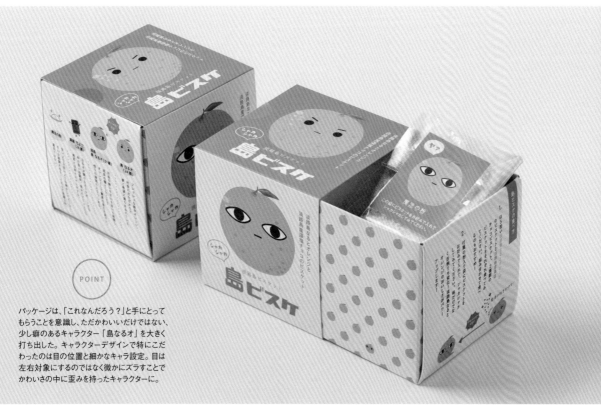

**POINT**

パッケージは、「これなんだろう？」と手にとってもらうことを意識し、ただかわいいだけではない、少し癖のあるキャラクター「島なるオ」を大きく打ち出した。キャラクターデザインで特にこだわったのは目の位置と細かなキャラ設定。目は左右対象にするのではなく微かにズラすことでかわいさの中に歪みを持ったキャラクターに。

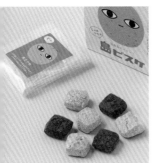

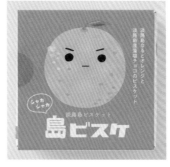

「島ビスケ」は淡路島産の藻塩プレミアムを使用した塩チョコビスケットの組み合わせや、付属の「魔法の粉」を振りかけて味の変化を楽しむこともできる。その「味の変化」や淡路島なるとオレンジの魅力である「ほろ苦さ」をキャラクター設定に反映することで、楽しんで読みすすめてもらえる外箱を目指した。内箱には隠れ「島なるオ」を忍ばせるなど、遊び心を随所に取り入れている。

## ■ DATA

販売元：株式会社うずのくに南あわじ
商品開発チーム：宮地勇次、倉田祐貴、川上小百合、笹田和樹、柿谷竜也、筒井翔兵
総合デザイン担当：川上小百合

●商品名
・淡路島ビスケット 島ビスケ

●販売場所
・道の駅うずしお
・うずの丘大鳴門橋記念館
・通販サイトうずのくに

ショップうずのくに 道の駅うずしお店

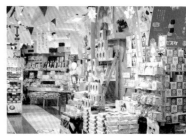

ショップうずのくに うずの丘店

## 神戸牛の旨さを細部にわたる高いデザインクオリティで表現

### 神戸牛のグリル缶詰・神戸ビーフのカレー缶詰・THE JERKY8　　株式会社ブロケード

兵庫県神戸市にあるイートインも楽しめる精肉店、Nickが神戸牛の美味しさを広く伝えるべく開発した「神戸牛のグリル缶詰」と「神戸ビーフのカレー缶詰」。いずれも無添加でありながら賞味期限が長く、神戸の手土産として大人気の商品。また、熟成肉の「JERKY」は、店主が但馬玄という肉と出会い、あまりの美味しさに驚き、その旨味を追求して誕生したというこだわりの一品。肉の旨さを最大限に引き出すことだけを考えた、オリジナルジャーキーの原材料は肉と海塩のみ。

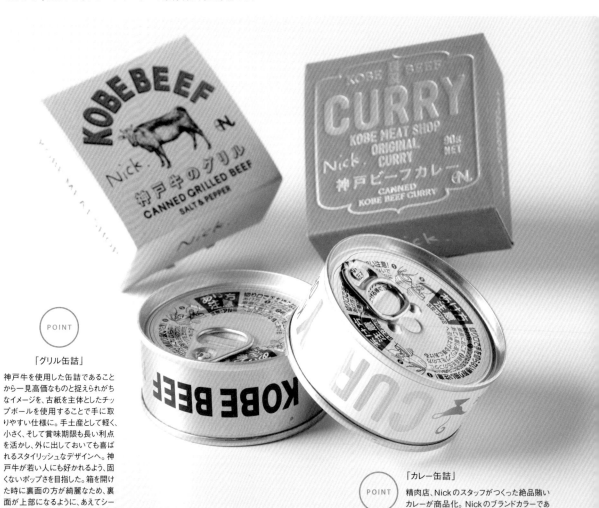

**POINT**

「グリル缶詰」

神戸牛を使用した缶詰であることから一見高価なものと捉えられがちなイメージを、古紙を主体としたチップボールを使用することで手に取りやすい仕様に。手土産として軽く、小さく、そして賞味期限も長い利点を活かし、外に出しておいても喜ばれるスタイリッシュなデザインへ。神戸牛が若い人にも好かれるよう、固くないポップさを目指した。箱を開けた時に裏面の方が綺麗なため、裏面が上部になるように、あえてシールを逆に貼っている。

**POINT**

「カレー缶詰」

精肉店、Nickのスタッフがつくった絶品賄いカレーが商品化。Nickのブランドカラーであるブルーを基調に色ライナーを使用。謹製という言葉を使用し、前面ゴールドの箔押し加工にすることで重厚感を持たせた。

Nick

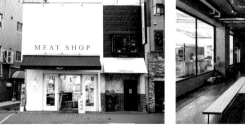

NICK JERKY

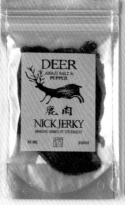

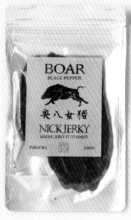
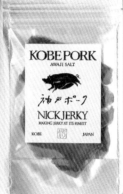
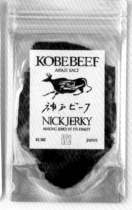

 **POINT**

「JERKY8」

2万年前、クロマニヨン人によって描かれた壁画の一部をモチーフとしてシンボルマークを作成。書体、イラストはすべて躍動感に満ちた壁画感を演出すべく木版画で制作。今や添加物が王道のJERKYのイメージを覆し、肉の旨味が最大限に生み出される動物を強く表現。

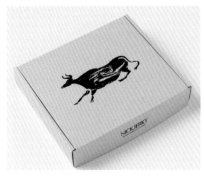

軽量のJERKYに合わせた軽く薄いGフルートダンボールを使用したギフトボックス。

箱を開けると最初に出てくるのはオテフキ。JERKYは手で食べるものであることから考えられたニクい演出。

**■ DATA**  ·············

販売元：株式会社ブロケード
CD：錦 昭光
AD・I・PL：錦 じゅん

●商品名
・神戸牛のグリル缶詰
・神戸ビーフのカレー缶詰
・THE JERKY8

●主な販売場所
・Nick
・NICKJERKY
・神戸空港
・自社オンラインショップ など

# 奈良の果物・大和茶を使ったチョコ×ラムネの絶妙なハーモニー

## Lilionte(リリオンテ) 株式会社ケーツーコミュニケーション

2018年に、「あたらしいお菓子のカタチ、いとをかし」をコンセプトに創業した「リリオンテ」。看板商品の「ショコネ」「リリショコネ」は、あすかルビーや大和抹茶など地元奈良のフルーツやお茶を使ったフレーバーチョコで、昔懐かしいラムネ菓子を包み込んだ新食感スイーツ。サクッと噛むと口の中でシュワッとほどけ、素材の豊かな香りとラムネの甘酸っぱさが広がる。奈良の名所や風物詩のイラストがキュートな手のひらサイズのボックスは、持ち運びやすく軽いので、お土産やプチギフトにぴったり。

POINT 奈良のランドマークやアイコンが、ポップに品よくあしらわれたキューブボックス。食べ終わった後は小物入れなどに利用すれば、奈良の思い出がよみがえり、二度楽しめる。

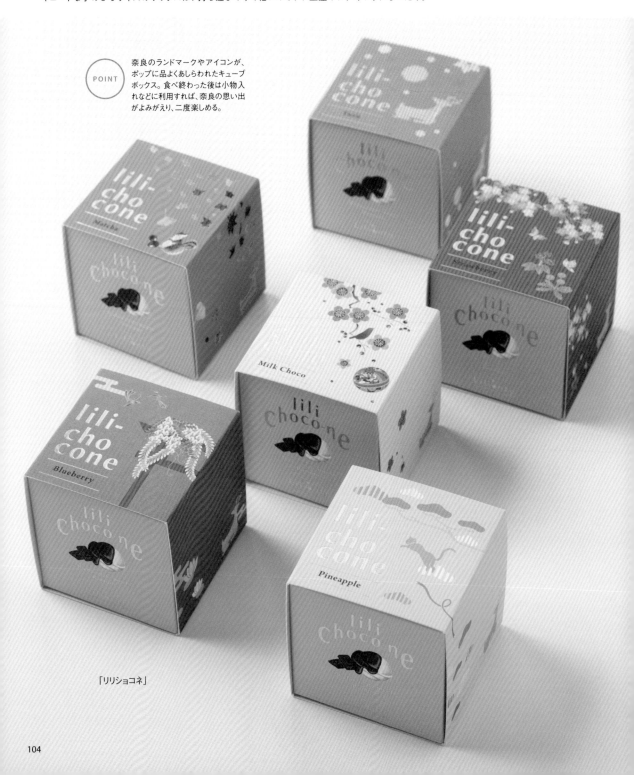

「リリショコネ」

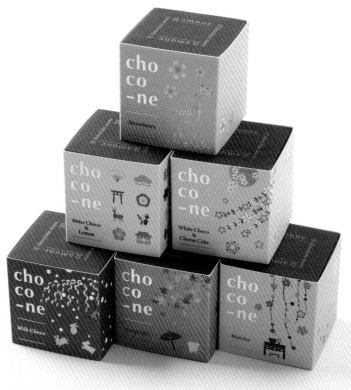

「ショコネ」

キューブパッケージは、外箱と内箱の2層構造。和のラムネと洋のチョコレートを組み合わせたお菓子にちなみ、外箱は和風、内箱は洋風テイストでデザインされている。

好きなフレーバーが選べるギフトボックス。

### ▋ DATA ⋯⋯⋯⋯⋯⋯⋯⋯⋯⋯⋯⋯⋯⋯⋯⋯⋯⋯

販売元：株式会社ケーツーコミュニケーション
AD：Yukko（Lilionte）
D：蓮蔵直美
CD：Yusuke Kayamori（Lilionte）

●商品名

・ショコネ（ラムネ×口どけチョコ）
・リリショコネ（ラムネ×パリパリチョコ）
・ショコネクランチ（ラムネショコラ×サクサクフレーク＆ベリー）

●主な販売場所

・近鉄奈良駅
・JR奈良駅
・奈良公園周辺など奈良県内のお土産店やホテル
・自社オンラインショップ など
※バレンタインやホワイトデーの冬時期は全国の百貨店などで
POP-UPも行なっている

「ショコネクランチ」

2種類のチョコレートの中に、小粒のラムネやサクサクのフレーク、ベリーなどを詰め込んだ「ショコネクランチ」。

# 一粒の飴に、奈良の文化と伝統食材の魅力を凝縮

## なら Bonbon　ドネー ドゥ ガトー

大和野菜やお茶など奈良に伝わる伝統的な食材や、奈良時代から根付く発酵技術を生かしてつくられた飴。自然の風味や美味しさを追求し、着色料などの添加物は使わず、すべて自然の味と色で仕上げている。奈良時代に伝来した蹴鞠（けまり）の文化が、その後、女の子の玩具として手毬に派生したことにヒントを得、飴は1個1個線をつけて手毬風に。ころんとかわいい色とかたちがガラス瓶に映え、季節によって種類が変わるので、選ぶ楽しさもひとしお。ラベルやボックスのスリーブには植物や動物などの正倉院紋様があしらわれ、ポップな雰囲気の中にも格式が漂う。

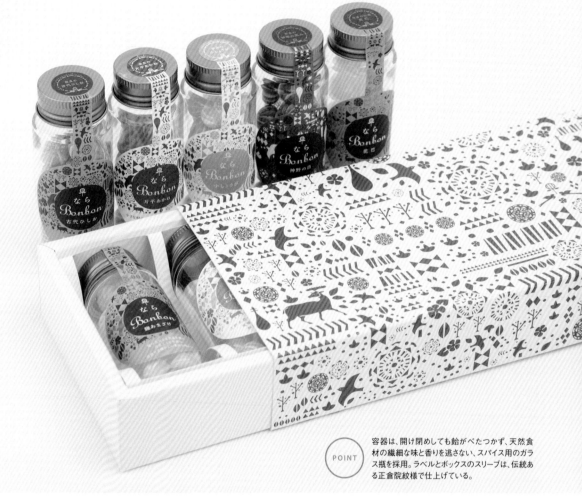

POINT　容器は、開け閉めしても飴がべたつかず、天然食材の繊細な味と香りを逃さない、スパイス用のガラス瓶を採用。ラベルとボックスのスリーブは、伝統ある正倉院紋様で仕上げている。

ワンランク上の加工技術を用いた「大和橘」「ジャバラ」「レモングラス」の3種は、ラベルのかたちやサイズ、正倉院文様を使用するという条件はそのままに、紙質やデザインでグレード感を表現。

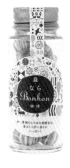

なら Bonbon直営店

### ■ DATA

販売元：ドネードゥガトー
D：本多り子、倉 有希（大和橘飴、
レモングラス飴、ジャバラ飴）

●商品名
・なら Bonbon（すべて限定商品）

●販売場所
・なら Bonbon直営店
・自社オンラインショップ

# タケミカヅチの神使 "白鹿" が、美味しい最中に

## 神鹿物語　有限会社多口製菓

奈良県産の素材を使用すること、県内の歴史に由来するもの、この2つにこだわり、2年かけて開発された最中。平城京の守護神タケミカヅチが、春日大社に参られる際に乗ったといわれる白い鹿「神鹿」をモチーフとしてつくられている。柿が好物といわれる神鹿にちなみ、奈良県産吉野柿や、奈良県産蜂蜜でキャラメリゼしたローストアーモンドをミルクあんに混ぜ込み、コーヒーや紅茶にも合う和洋折衷の味わいに。そのテイストはパッケージにも反映され、欧文を併記するなど洋の要素も織り交ぜながら、神話の世界観をモダンに表現している。

**POINT**

白い鹿のイメージから、パッケージも白を基調にデザイン。金箔を用いることで、シンプルな線で描かれた鹿の絵や菓銘が引き立ち、高級感もプラス。柿やアーモンドなどの原材料をポップに描いた細かい模様も、絶妙なアクセントになっている。

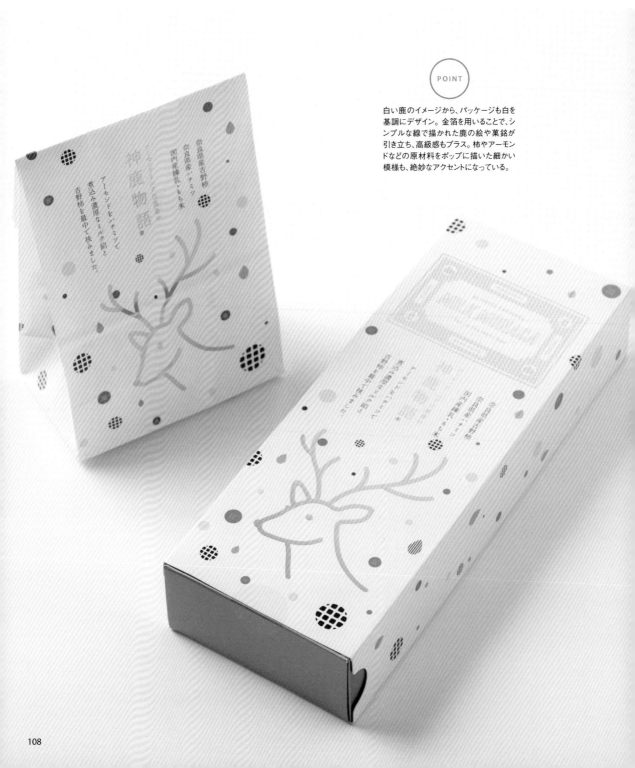

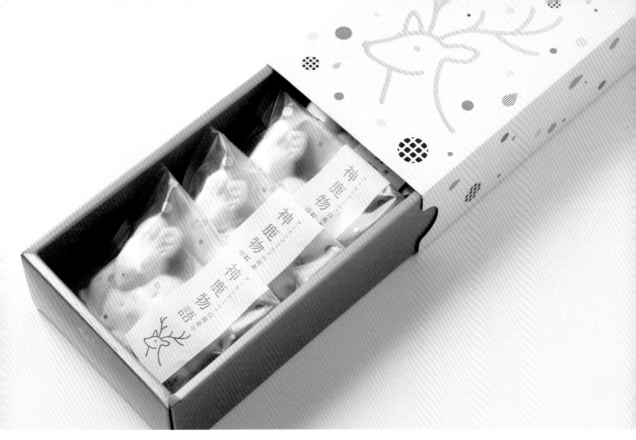

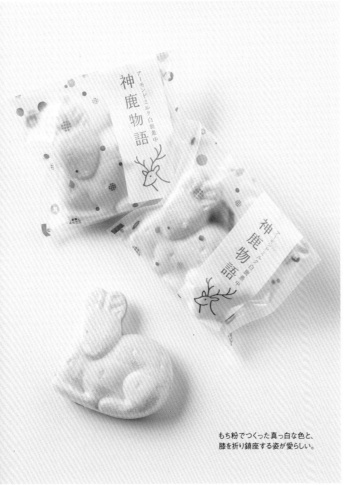

もち粉でつくった真っ白な色と、
膝を折り鎮座する姿が愛らしい。

## ◥ DATA

販売元：有限会社多口製菓
デザイン会社：ニュートラルデザイン
I：廣田敬一（ニュートラルデザイン代表）

● 商品名
・神鹿物語（しんろくものがたり）

● 販売場所
・近鉄奈良駅
・JR奈良駅
・近鉄百貨店奈良
・香芝SA上り
・奈良県庁前バスターミナル

## ぎっしりの鹿がかわいい "持ち帰れる奈良公園"

### しかじか　中川政七商店

奈良らしい「鹿がたくさんいる情景」をテーマにつくられた米粉菓子。奈良の新しいお土産として、社内公募の中から選ばれ商品化された。"古代人が食べていた栄養豊富な米"として知られる、奈良県産の赤米を生地に練り込み、丁寧にロースト。関西らしい旨味が広がる「だし醤油」や、千年前の和製チーズといわれる"蘇（そ）"をイメージした「古代チーズ」など、奈良の素材と歴史が味わえるフレーバーが揃う。中身も1個1個鹿がかたどられ、封を開けると、まるでたくさんの鹿がお出迎えしてくれているよう。

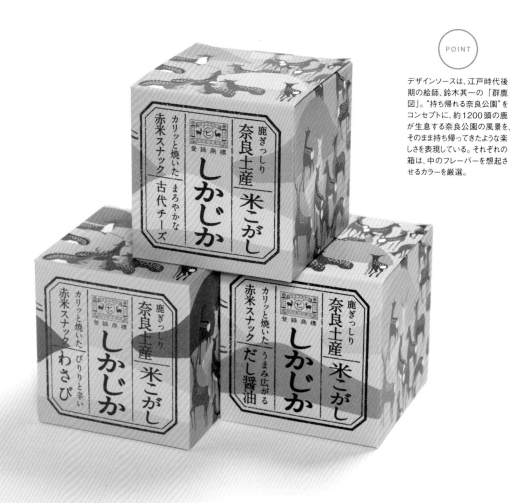

POINT

デザインソースは、江戸時代後期の絵師、鈴木其一の「群鹿図」。"持ち帰れる奈良公園"をコンセプトに、約1200頭の鹿が生息する奈良公園の風景を、そのまま持ち帰ってきたような楽しさを表現している。それぞれの箱は、中のフレーバーを想起させるカラーを厳選。

### ■ DATA

販売元：株式会社中川政七商店
企画・デザイン：株式会社中川政七商店

● 商品名

・しかじか 米こがし だし醤油
・しかじか 米こがし 古代チーズ
・しかじか 米こがし わさび（中川政七商店 分店 土産 奈良三条店 1店舗限定商品）

● 販売場所

・中川政七商店 分店 土産 奈良三条店
・中川政七商店 奈良本店
・中川政七商店 奈良 蔦屋書店
・中川政七商店 近鉄百貨店奈良店
・中川政七商店 分店 旅 大阪国際空港店

# 名産品の柿の味わいを素朴なイラストで表現

## 刀根早生柿・あんぽ柿・柿チップ 山中章弘農園

奈良県天理市の名産品、刀根早生柿を販売している山中章弘農園。脱渋方法として、従来の炭酸ガスに加えてアルコールを使用することで風味を際立たせている。また、濃厚な甘味が楽しめるのが、糖度30％を誇る「かよのあんぽ柿」で贈答品としても人気が高い。2018年、天理市の地域創生プロジェクト「めぐみめぐるてんり」の事業の一貫でリブランディング。柿をモチーフとした素朴な版画風のイラストと、手描き風の文字で実直な商品内容を表現している。

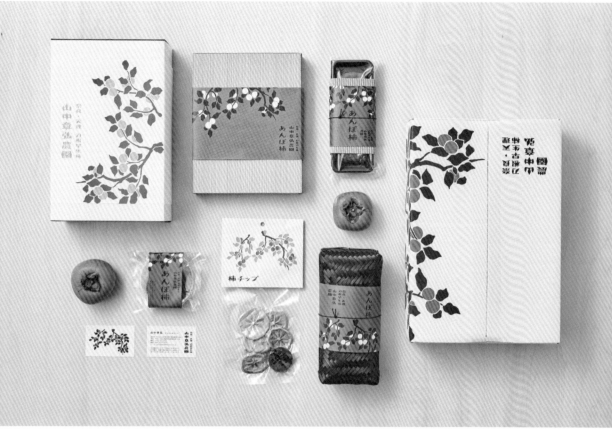

POINT

農園の直売所で販売されるため、地元の風土や山中章弘農園の実直な取り組みに似合うデザインにて検討。柿の木をモチーフに、柿、あんぽ柿、柿チップと加工によって変わる商品ラインナップを配色によってバリエーションを出している。梱包の負担を減らすため、紙を巻くだけでパッケージができる簡易な構造とした。

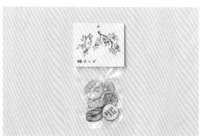

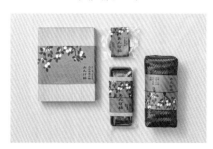

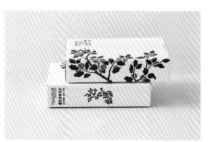

■ DATA

販売元：山中章弘農園
制作会社：paragram
AD・D：赤井佑輔
Ph：田中将平

●商品名
・刀根早生柿
・あんぽ柿
・柿チップ

●販売場所
・自店舗
・コフフンショップ
（天理駅内アンテナショップ）

# 紀州の秘境"龍神村"生まれの滋味深いあられ

## わかやまのあられ　龍神はーと×増田製菓

コロナ禍により観光客が姿を消した熊野古道に賑わいが戻ることを願い、地域おこし団体の龍神はーとが、地元のデザイナーや老舗米菓店と共同開発。「わかやまの呼吸を感じる、心がほぐれるお土産物」をコンセプトに、昔ながらの杵つき製法でつくられた素朴な味わいは、後を引く美味しさ。龍神村で受け継がれてきた手づくりの麦味噌や、龍神村産の採れたて生しいたけを生地に練り込んだ特製あられと、生産量日本一を誇る紀州の南高梅やぶどう山椒入りの4種の味が揃う。デザインモチーフは熊野古道のシンボル「牛馬童子像」。実物を見たくなるような、不思議な魅力が漂う。

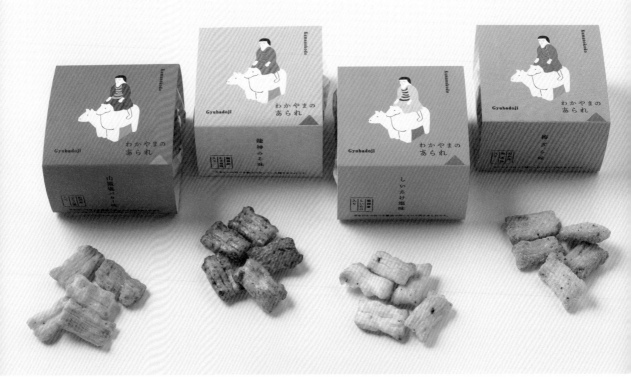

熊野地方に伝わる、旧暦11月23日に昇る月は、三体に見えるという伝説をイメージした「三体月」のイラスト。

食品表示シールを剥がした人だけにわかる、デザイナーからのメッセージもお楽しみ。

### POINT

モチーフの「牛馬童子像」は、熊野古道中辺路にある、高さ50cmほどの小さな石像。その愛らしさが一目で印象深く伝わり、若い世代にも親しんでもらえるようにと、ゆるいタッチで描かれたイラストが味わい深い。4種それぞれのカラーリングと外箱との配色バランスも美しい。

### ■ DATA

販売元：龍神はーと×増田製菓
デザイン会社：ROCA design
AD・D：濵田 幸

●商品名
・わかやまのあられ（梅ざら、龍神味噌、しいたけ塩、山椒塩バター）

●主な販売場所
・龍神はーと本店
・蔦屋書店和歌山市民図書館
・自社オンラインショップ など

# 和洋2つの岡山銘菓が、美味しく楽しくドッキング

## OKAYAMA BUTTERSAND with KIBIDANGO　　株式会社小町産業

岡山を代表する銘菓、山脇山月堂の「きびだんご」と、倉敷の老舗洋菓子店、葡萄園の人気商品「レーズンバターサンド」をドッキングした、新×旧・和×洋のハイブリッドスイーツ。「おいしい」「おもしろい」「大切な人のために」をコンセプトに考案され、斬新な組み合わせと見た目のインパクトが高評価を得、駅ナカショップを運営するジェイアールサービスネット岡山が主催の「第2回 地域を届ける。せとうちおみやげグランプリ」のグランプリ受賞に輝いた。パッケージはあえて明るい色は使用せず、落ち着いたトーンでイラストのユーモアを引き立てている。

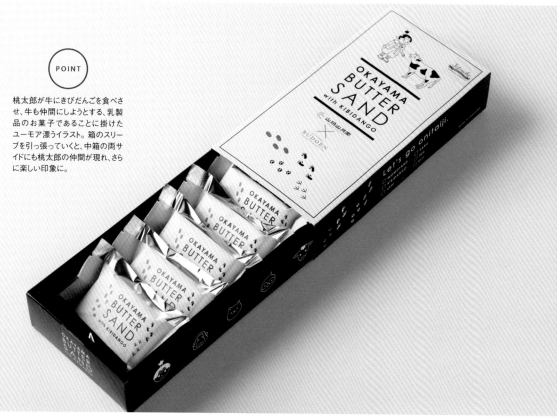

**POINT**

桃太郎が牛にきびだんごを食べさせ、牛も仲間にしようとする、乳製品のお菓子であることに掛けたユーモア漂うイラスト。箱のスリーブを引っ張っていくと、中箱の両サイドにも桃太郎の仲間が現れ、さらに楽しい印象に。

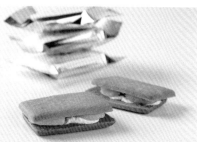

## ■ DATA

販売元：株式会社小町産業
制作会社：株式会社インバムクリエイト
D・I：佐藤 茜

● 商品名
・OKAYAMA BUTTERSAND
　with KIBIDANGO

● 販売場所
・岡山駅
・倉敷駅
・福山駅
・尾道駅
上記構内お土産店
（一部、販売していない店舗があります）
・岡山駅ナカお土産ネットショップ

## 桃太郎の世界観を、オトナ女子向けにキュートに表現

**きびだんご** 　株式会社つるの玉子本舗 下山松寿軒

創業から130年以上変わらない製法でつくられている、やわらか食感のきびだんご。岡山県産の清水白桃とマスカットオブアレキサンドリアを使用した、こだわりの素材をアピールすべく、パッケージのみ2018年にリニューアルされた。きびだんごといえば一般的に子ども向け商品が多い中で、桃太郎のストーリーにちなんだオトナかわいいイラストと、淡いやさしいカラーで幅広い年代の女性に愛されるデザインに。開けた時や食べた後まで楽しめるよう、箱の内側や、個包装に至るまで細やかな工夫がなされている。シェアしやすいので職場へのお土産にも。

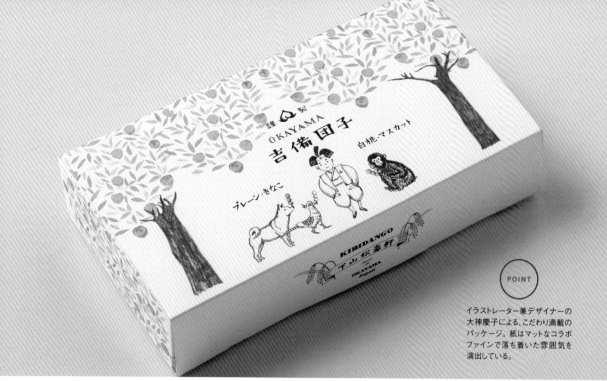

POINT

イラストレーター兼デザイナーの
大神慶子による、こだわり満載の
パッケージ。紙はマットなコラボ
ファインで落ち着いた雰囲気を
演出している。

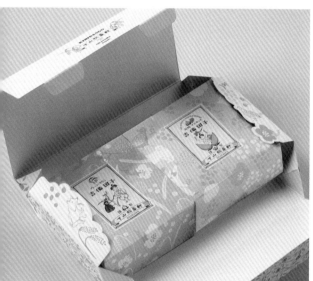

個包装は、お団子を食べた後、袋をかざしてみると、川から桃が流れてきたり、桃太郎と
お姫様がキスをしている絵になったりと、チャーミングな仕掛けがほどこされている。

## ■ DATA

販売元：株式会社つるの玉子本舗
下山松寿軒
D・I：大神慶子

●商品名
・きなこ・プレーン丸きびだんご
・白桃・マスカット串きびだんご
・きなこ・プレーン串きびだんご

●販売場所
・岡山駅（おみやげ街道）
・岡山空港（天満屋空港ショップ）
・天満屋ハピータウン
・自社店頭
・自社オンラインショップ

## 思わず手に取ってしまう、愛くるしい表情の紅だるま

### 吹屋の紅だるま・紅てんぐ・青だるま　株式会社さとう紅商店

岡山県の吹屋は、赤の顔料「ベンガラ」の生産で栄えた地区。その新しい"紅の土産"を開発しようと考えていた店主が、偶然、地元で食べられていた自家製の赤い柚子胡椒に出会い、味に感動。街の名物にしようという取り組みがスタートした。吹屋周辺で栽培された素材だけを使い、原材料を厳選。なんとも言えない愛くるしい表情のだるまの中には鮮やかな赤色の柚子胡椒が入っており、香りと辛味、2つの素材が合わさって料理の美味しさをより一層引き立てる。

**POINT**

パッケージデザインを手掛けたのは、地元・岡山で"あそびのデザイン"をテーマに活動する軸原ヨウスケ、武田美貴によるデザイン・ユニット「COCHAE」。手に取る人が笑顔になるように、インテリアやお土産に喜ばれるようにと、箱（商品）自体が生き生きと存在することを目指してデザインした。

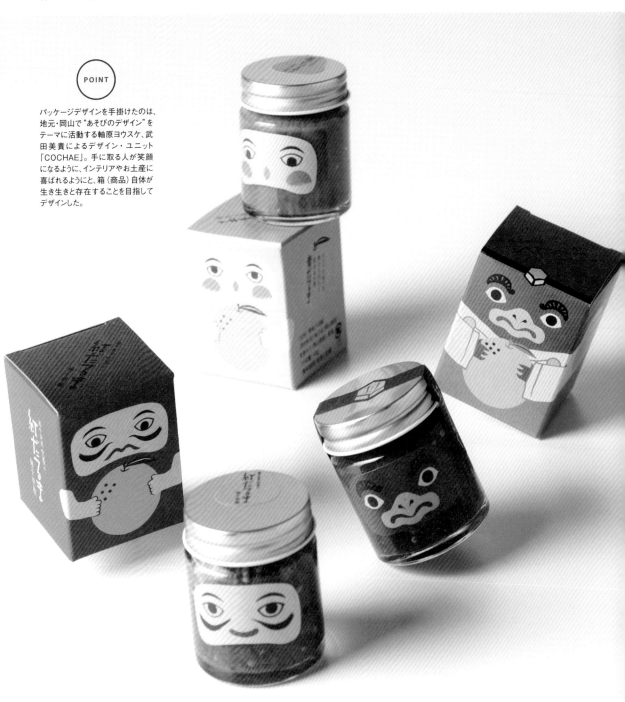

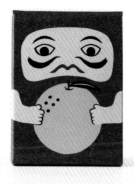
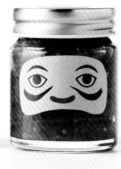

吹屋の
紅だるま

岡山県産で生産した赤唐辛子と完熟柚子の
表皮のみを使用した赤唐辛子胡椒。柚子の香
りと辛い唐辛子の味わいが特徴の
フタを開ければ、爽やかな柚子の香りとピリッと辛い唐辛子が食欲をそそ
ります。唐辛子の刺激など何に
でも合う万能調味料として、汁物・鍋物・炒め物のお供に
商品です。そのまま食べてもおいしく、お肉
や魚の刺身などにも。
抗菌使用しない場合でも柚子の風味が透けません。
でいただくと柚子の風味が透けません。

まずは少量(耳かき1杯)からお試しください。

【汁　物】味噌汁・豚汁・お吸い物
【麺　類】ラーメン・そば・うどん
【鍋　物】水炊き・おでん・すき焼き・湯豆腐
【肉　類】ステーキ・焼き鳥・餃子・唐揚げ
【魚　類】お刺身・焼き魚
【その他】納豆・卵かけご飯・冷奴

## ■ DATA

販売元：株式会社さとう紅商店
デザイン会社：COCHAE
AD：軸原ヨウスケ

● 商品名

・吹屋の紅だるま
・吹屋の紅てんぐ
・吹屋の青だるま

● 販売場所

・岡山空港
・岡山高島屋
・JR岡山駅
・自社オンラインショップ

瀬戸内の食材の魅力を言葉とビジュアルの２方向でアプローチ

## JR PREMIUM SELECT SETOUCHI　せとうちのおいしいシリーズ

西日本旅客鉄道株式会社 中国統括本部 岡山支社 ふるさとおこし本部、株式会社ジェイアールサービスネット岡山

岡山エリアの「いいもの」を見つけ出し、さまざまな活動を通してその魅力を国内外に発信する「ふるさとおこしプロジェクト」。JR西日本中国統括本部岡山支社が推進しており、その取り組みの一環として、地域の企業や生産者と協働し開発した商品「JR PREMIUM SELECT SETOUCHI」シリーズを展開。中でも人気なのが「せとうちのおいしいシリーズ」。瀬戸内エリアの食材をそのまま生かした食べきりサイズの商品だ。

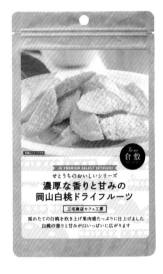

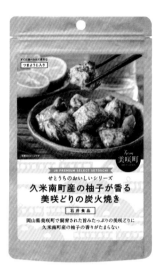

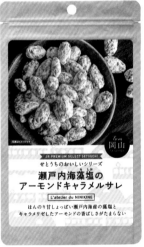

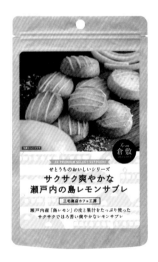

**POINT**

パッケージには、写真で中身を大きく紹介。商品名の背景には、テキスタイルデザイナーの鈴木マサル氏による、瀬戸内の多島美と列車イラストが描かれている。外装には未晒しのクラフト紙を使用して素朴な印象に。

提供：JR西日本

### ■ DATA

販売元：有限会社くま
デザイン会社：edge graphics
CD：秋岡寛子

●商品名

・バリバリ香ばしい瀬戸内海のいろどり小魚
・濃厚な香りと甘みの岡山白桃ドライフルーツ
・久米南町産の柚子が香る美咲どりの炭火焼き
・瀬戸内海藻塩のアーモンドキャラメルサレ
・サクサク爽やかな瀬戸内の島レモンサブレ
・高地栽培ピオーネで作った雲海セミドライピオーネ

●主な販売場所

・JR西日本中国統括本部岡山支社管内の駅ナカ店舗（おみやげ街道・セブン-イレブン ハートイン）
・岡山駅ナカお土産ネットショップ ほか
※一部店舗を除く

## 広島 広島名物をサクッと焼き上げた、目にも楽しい彩りクッキー

### 広島おさんぽクッキー　株式会社アンデルセン

ハンス・クリスチャン・アンデルセンの童話をモチーフとした童話クッキーをはじめ、人気を博しているクッキー缶シリーズの広島バージョン。手土産になるよう、世界遺産の厳島神社の大鳥居や平和の象徴の鳩など、広島の名所や名物をモチーフにしたクッキーとその下には8種類の定番クッキーが入っている。パッケージのスリーブは、宮島などに代表される広島のイメージカラー・赤をベースにデザイン。全面にクッキーのモチーフでもある広島のアイコンが楽しいタッチで描かれ、インパクトのあるカラーと共に遠くからも目を引く。

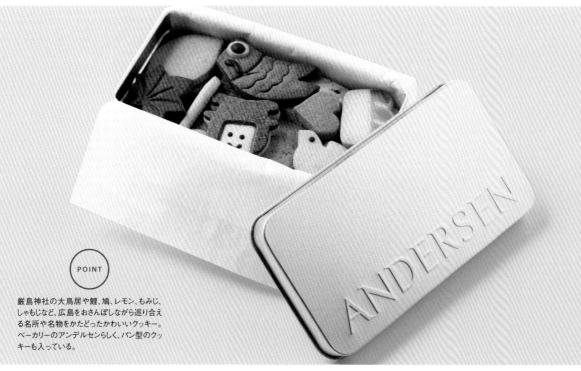

**POINT**

厳島神社の大鳥居や鯉、鳩、レモン、もみじ、しゃもじなど、広島をおさんぽしながら巡り合える名所や名物をかたどったかわいいクッキー。ベーカリーのアンデルセンらしく、パン型のクッキーも入っている。

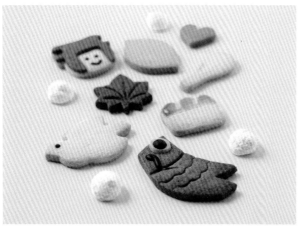

一緒に添えられているリーフレット。お土産にもらった人も広島散策の気分が味わえるよう、広島弁も織り交ぜながら、モチーフとなった名所・名物の魅力や由来を伝えている。

### ■ DATA

販売元：株式会社アンデルセン
D：株式会社アンデルセン

● 商品名
・広島おさんぽクッキー

● 主な販売場所
・広島アンデルセン
・広島県内のアンデルセン店舗 ほか
※取り扱いのない店舗もあります

119 at bottom right

ちょっとクセのあるキャラクターが、生産地の救世主に

## 因島のはっさくシリーズ　JA尾道市

瀬戸内海に位置する因島は、はっさく生産高2000トンを誇る生産地。JA尾道市が、独自のすっぱさと深い味わいを備えたはっさくを原料にさまざまなお土産品を開発して人気となっている。パッケージには、因島の地図がかわいいイラストで描かれ、フタを開けるとイラストのテイストが一変。キモかわいいと評判のはっさくBOYのパッケージがあらわれる。美味しさももちろんだが、このギャップがたまらない。

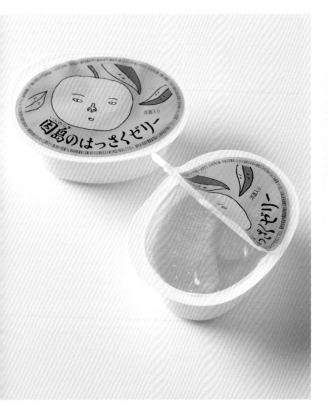

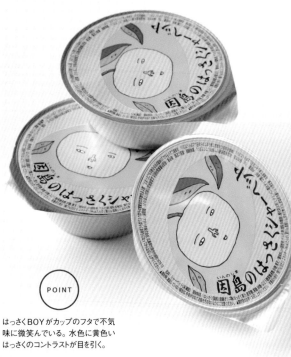

**POINT**

はっさくBOYがカップのフタで不気味に微笑んでいる。水色に黄色いはっさくのコントラストが目を引く。

箱の裏側にもイラストで因島が紹介されている。

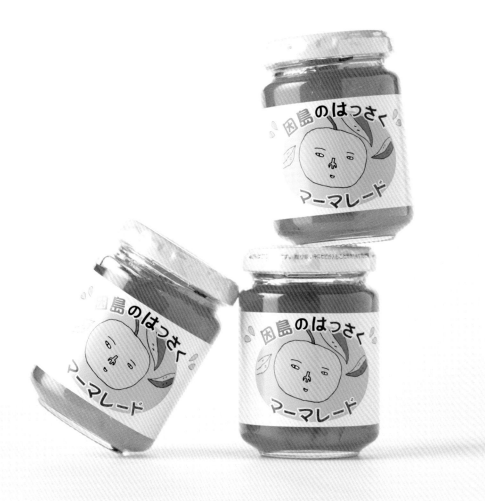

はっさくゼリーの好評を受け、はっさくマーマレードを展開。果実の風味が生きる低糖度タイプで、贈答品としても人気の商品だ。

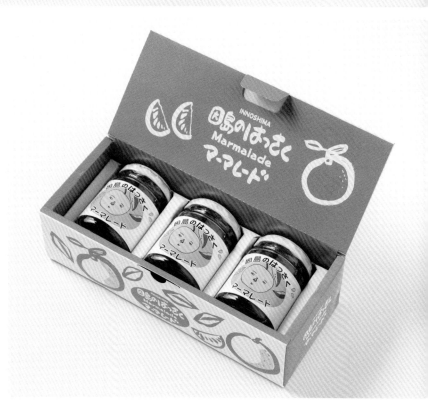

## ■DATA

販売元：JA尾道市

●商品名
・因島のはっさくゼリー
・因島のはっさくマーマレード
・因島のはっさくシャーベット

●主な販売場所
・JA尾道市産直市ええじゃん尾道
・広島県内の小売店や百貨店
・お土産店、SA など

広島 | みんなで分け合いたいお土産。幸せを運ぶひとくちカステラ

## もみじやき　　株式会社にしき堂

昔ながらの和菓子のイメージが強かった旧商品「紅葉焼」を、子ども向けの路線にリニューアル。中身も1年以上試行錯誤し、よりふんわりしっとりした生地のあん無しカステラ焼きに一新した。チョコレート味は甘さとチョコ本来の風味のバランスにこだわり、ミルク味はやさしい甘さでミルクの風味がしっかり味わえる一品に。男の子と女の子のキャラクターがかわいいパッケージのイラストは、広島在住の絵本作家ミヤタタカシ氏によるもの。美味しさや一緒に食べる時間、楽しい思い出など「わかちあう」をテーマに、心和むほのぼのとした世界観で描かれている。

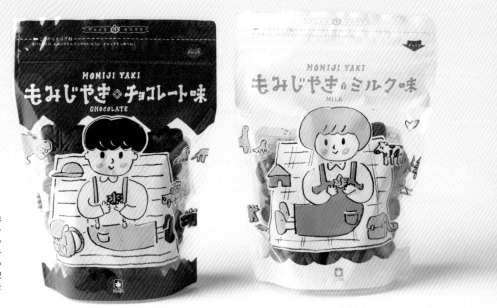

**POINT**

チョコレート味とミルク味を並べると、キャラクターのチョコくんとミルクちゃんが一緒に仲良くお菓子を食べている微笑ましい風景に。印刷は環境に配慮したバイオマスインキを使用。

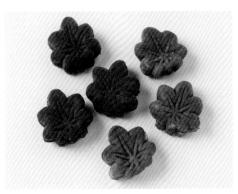

コロッとかわいいあんなしのカステラ焼き。

スマホでQRコードを読み取ると、チョコくんとミルクちゃん、それぞれのWeb絵本が見られる。

広島・光町本店　本社工場

### ■ DATA

販売元：株式会社にしき堂
デザイン会社・D：株式会社
総合広告社
I：ミヤタタカシ
CD：楢崎兼二

●商品名
・もみじやき ミルク味
・もみじやき チョコレート味

●主な販売場所
・にしき堂直営店
・広島駅売店
・自社オンラインショップ など

# 瀬戸内の風を運ぶ、香り爽やかなディップソース

## 瀬戸内レモンチーズディップ 　株式会社穂高観光食品

全国各地の特産品を使って「パンに合うディップソース」の企画を展開中の穂高観光食品が手掛ける、瀬戸内版ディップソース。瀬戸内といえばレモンのイメージから、瀬戸内産のレモンを使ったチーズディップを開発した。レモンの果汁と細かく刻んだ果皮の爽やかな香りがチーズの風味とマッチし、サンドイッチやフライ、サラダなどさまざまな料理と好相性。パッケージはレモンを全面に出しつつ、チーズらしい三角形のパッケージで、レモンとチーズを組み合わせた商品の特徴を巧みに伝えている。

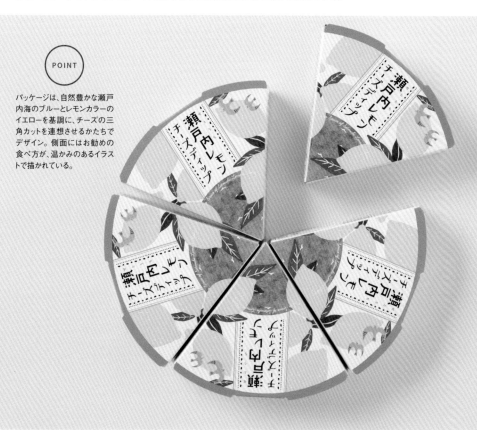

**POINT**

パッケージは、自然豊かな瀬戸内海のブルーとレモンカラーのイエローを基調に、チーズの三角カットを連想させるかたちでデザイン。側面にはお勧めの食べ方が、温かみのあるイラストで描かれている。

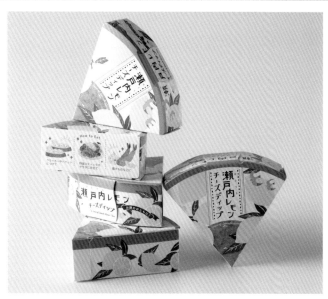

タルタルソース感覚で食べられる洋風ディップソース。レモンの爽やかな香りとチーズの風味が食材の旨味を引き立てる。

### ■ DATA

販売元：株式会社穂高観光食品
D：河原紙器株式会社

●商品名
・瀬戸内レモンチーズディップ

●販売場所
・広島県内のSA
・兵庫県のあわじSA
・淡路島内の道の駅
・ハウステンボス

広島 | レモンの美味しさと瀬戸内の魅力をギュッと一箱に

## 瀬戸内レモンばなし　豊上製菓株式会社

広島の特産品「瀬戸田産レモン」を使った、手のひらサイズのプチカップケーキ。スポンジだけでなく、トッピングの丸い花のようなホイップチョコにもレモンを加え、程よい酸味をプラス。口どけもやさしいので、大人から子どもまで楽しめる。パッケージも、レモンの爽やかなイメージと瀬戸内地方の地域性にこだわってデザイン。青い海に白い雲、たわわに実った黄色いレモンの彩り美しい絵に、穏やかな瀬戸内の風景が目に浮かぶようだ。

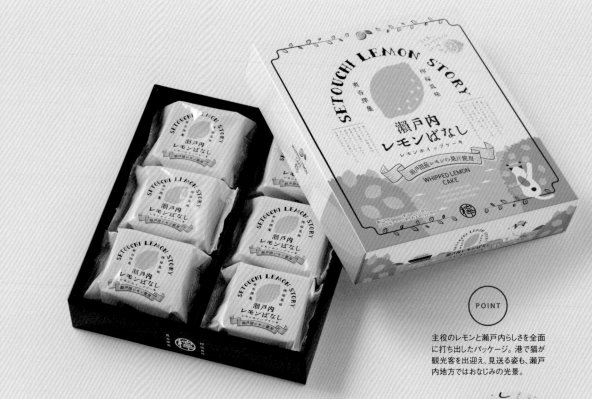

**POINT**

主役のレモンと瀬戸内らしさを全面に打ち出したパッケージ。港で猫が観光客を出迎え、見送る姿も、瀬戸内地方ではおなじみの光景。

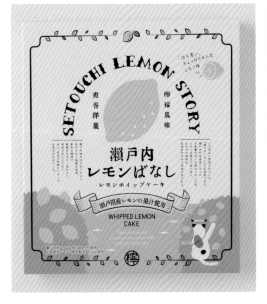

レモン味のホイップチョコでかわいくデコレーション。まろやかな甘さにレモンの酸味やレモンピールのほろ苦さが加わり、さっぱりとした味わい。

### ■ DATA

販売元：豊上製菓株式会社
デザイン会社：株式会社あんでるあん
PL：影浦 豪（豊上製菓株式会社）

●商品名
・瀬戸内レモンばなし レモンホイップケーキ

●主な販売場所
・自社売店（不定期販売）など

| 広島 | 瀬戸内地域で採れた果物を主役に、丹精込めて醸造 |
|------|----------------------------------------------|

## SETOUCHI Wine Series  瀬戸内醸造所株式会社

広島県を中心とした瀬戸内のエリア内は、ぶどうやりんごの生産地。古くから栽培されてきた果物の魅力を広く伝えるため、新進ワイナリーの瀬戸内醸造所が、食を愛する人々の共通言語ともいえるワインに加工した。果実本来の味わいを最大限に引き出した素直な味わいは、ワイン愛好家のみならず、お酒を愛する幅広い層に好評。エチケットラベルには商品の特徴やストーリーが記され、丹精込めて栽培・醸造したつくり手の思いが味に深みを添える。生食や贈答のためにつくられてきた果物に、加工という新たな選択肢を提案したこのワイン製造は、地域農業の持続可能性を拡げていく取り組みとしても期待されている。

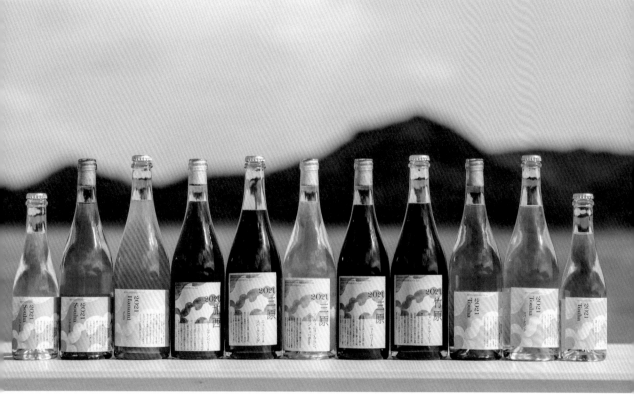

瀬戸内のマップをモチーフにしたエチケットラベル。瀬戸内海の情景や、使用している果物、味わいを想起させる、やさしい色づかいが目を引く。あえて前面で商品の背景や特徴を語り、ボトルの立ち姿だけで自己紹介ができるデザインを目指した。フォントや紙は、「読ませる」→「新聞」のイメージで選定。

### ■ DATA

販売元：瀬戸内醸造所株式会社
D：木住野彰悟（株式会社6D-K）

**●商品名**
・SETOUCHI Hare series（セトウチハレシリーズ）
・SETOUCHI Umi series（セトウチウミシリーズ）
・SETOUCHI Ringo series（セトウチリンゴシリーズ）

**●販売場所**
・自社オンラインショップ
・自社直営店

# こんぴら参りのお土産に、洋菓子専門店の本格プリン

## こんぴらプリン　株式会社ちきりや

「こんぴらさん」の愛称で親しまれる金刀比羅宮（ことひらぐう）の参道沿いに店を構える「こんぴらプリン」。コンセプトは、「懐かしくて新しい、縁起のいい黄色がイメージカラーのレトロなプリン専門店」。熟練のパティシエがつくり上げる、地元香川産の卵をたっぷり使った本格プリンが、季節限定品も含め常時6種類揃う。パッケージは、参道のイメージによく合うレトロな和の雰囲気。商品やキャラクターの子犬など、要所に香川の伝統菓子「おいり」がモチーフとして使用されている。

POINT

こんぴらさんの「幸福の黄色いお守り」にちなみ、黄色をキーカラーにツールを展開。老若男女が手土産として使える親しみやすいデザインに。

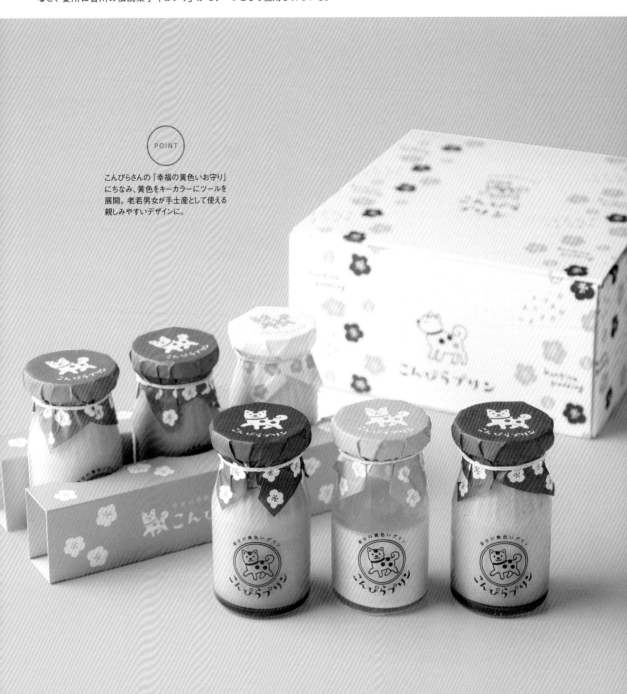

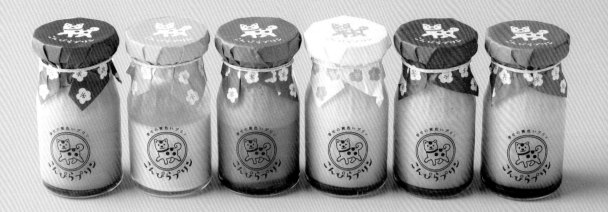

「おいり」をイメージした丸柄模様の子犬「おいり犬」がトレードマーク。

固めのレトロプリンから、とろけるなめらかプリンまで、食感や味の異なる6種類が楽しめるセット。瀬戸内レモンジュレを合わせた「幸せの黄色いプリン」は、中に「おいり」のような黄色いジュースボールが浮かぶキュートな見た目で、インスタグラムでも話題。

## ▼ DATA

販売元：株式会社ちきりや
デザイン会社：株式会社アンドエイト（&8）
D・I：大石百合子
PL：千切谷耕一郎
CD：千切谷佳代

●商品名
・こんぴらプリン6種
（幸せの黄色いプリン、レトロプリン、なめらかプリン、
コーヒー牛乳プリン、抹茶プリン、季節のプリン）

●販売場所
・こんぴらプリン店舗
・高松空港（商品の一部のみ展開）

こんぴらプリン

# 和と洋２つのイメージを訴求したユニークなボトルデザイン

## 神の島雫　株式会社楽農研究所

瀬戸内海に浮かぶ愛媛県今治市の大三島は、柑橘生産量日本一を誇る愛媛県の中でも有数の柑橘の産地。また、「日本総鎮守」と称される「大山祇神社」があることから「神の島」とも言われており、そこで育てたレモンを「神の島レモン」と名付けている。残量農薬ゼロ・防腐剤・ワックスなしの神の島レモンだけを使用した「神の島雫（今季初搾り）」は濃縮還元していない果汁をそのままピンに詰めた100％ストレートのレモン果汁。爽やかな皮の苦味・甘み・酸味が感じられ、ストレートならではの素材の風味を味わえる。

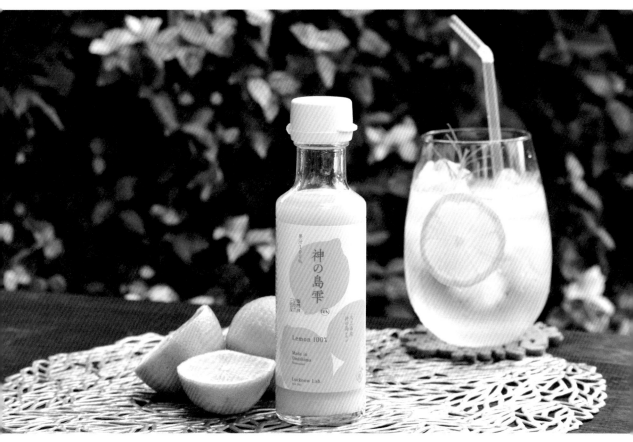

**POINT**

和と洋をイメージする2つのデザインを1枚のラベルにほどこしたボトルデザイン。和は神の島レモンをイメージしたもの、洋は100％レモン果汁であることをユーモアのあるデザインで訴求。レモン部分のみ特殊加工をほどこし、レモンの果皮の手触りを感じさせる仕様に。

### ■ DATA

販売元：株式会社楽農研究所
デザイン会社：グランドデラックス
AD：松本幸二

●商品名

・神の島雫（今季初搾り）

●販売場所

・自社オンラインショップ

愛媛

# 白い余白が清潔感と商品の鮮度を訴求する
# 老舗の新パッケージ

## 宇和島じゃこ天　　有限会社安岡蒲鉾店

400年近く続く宇和島地方のじゃこ天かまぼこづくり。宇和海の豊かな恵みである新鮮な魚を原料にしてつくる伝統の製法をこれからも続けていくという決意を胸に、昭和27年の創業から65年目の2017年にパッケージをリニューアル。近海小魚100%を一匹一匹手作業で丁寧に解体し、昔ながらの石臼で練り上げ菜種油で揚げてつくるじゃこ天は後を引く美味しさだ。高齢者に人気の"練り製品"を若い世代にも手に取ってもらえるようにと、英文を織り交ぜたモダンなパッケージが新鮮。

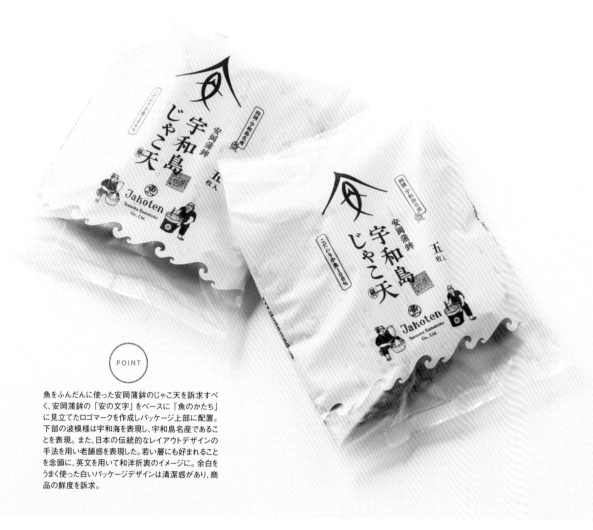

POINT

魚をふんだんに使った安岡蒲鉾のじゃこ天を訴求すべく、安岡蒲鉾の「安の文字」をベースに「魚のかたち」に見立てたロゴマークを作成しパッケージ上部に配置。下部の波模様は宇和海を表現し、宇和島名産であることを表現。また、日本の伝統的なレイアウトデザインの手法を用い老舗感を表現した。若い層にも好まれることを念頭に、英文を用いて和洋折衷のイメージに。余白をうまく使った白いパッケージデザインは清潔感があり、商品の鮮度を訴求。

## 📎 DATA

販売元：有限会社安岡蒲鉾店
デザイン会社：株式会社グランドデラックス
AD・D：松本幸二

●商品名
・宇和島じゃこ天

●販売場所
・安岡蒲鉾 本社工場
・安岡蒲鉾 道の駅みま店
・安岡蒲鉾 かけはし松山店（JR松山駅構内）
・松山空港
・阪神百貨店 うめだ本店
・京阪百貨店各店
・髙島屋 新宿店
・髙島屋 大阪店
・堺タカシマヤ
・泉北タカシマヤ
・せとうち旬彩館（東京・新橋）
・自社オンラインショップ

安岡蒲鉾 本社・工場

# 香川名物「おいりソフト」が、食べやすいクッキーに

## 香川おいりソフトクリーム風味サンドクッキー　株式会社濱惣

「おいり」とは、もち米でつくられた直径1cmほどの球状のお菓子。香川県では嫁入り道具の1つとして使う風習があり、出会いや良縁に恵まれるという意味の縁起物でもある。そのおいりをトッピングしたソフトクリーム「おいりソフト」をイメージしてつくられたのが、このクッキーだ。おいりのカラフルさをフリーズドライのフルーツで表現し、砂糖は香川の特産品・和三盆を使用。準チョコレート生地の中にコーンフレークを混ぜ込むことで、ソフトクリームのコーンのような食感を実現した。ピンクの愛らしいパッケージも、おいりソフトのイメージによく合う。

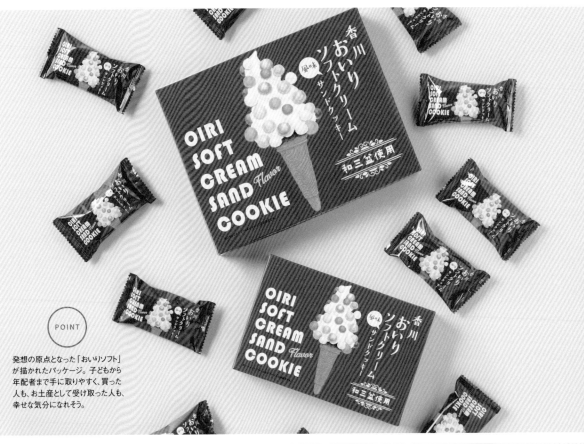

**POINT**

発想の原点となった「おいりソフト」が描かれたパッケージ。子どもから年配者まで手に取りやすく、買った人も、お土産として受け取った人も、幸せな気分になれそう。

裏箱には「おいり」の解説付き。

クリームの中には「おいり」をイメージしたフリーズドライフルーツとコーンフレークが。ザクザクした食感が楽しい。

## ◢ DATA

販売元：株式会社濱惣
D：株式会社濱惣

●商品名
・香川おいりソフトクリーム風味
サンドクッキー

●主な販売場所
・高松空港
・高松駅
・津田の松原SA上り線
・与島プラザ売店
・中野うどん学校琴平店
・自社オンラインショップ　など

シャレが効いたネーミングとPOPなデザインが話題のネタに

## い〜よかんしかしない！　一六本舗

看板商品で、松山の定番土産の「一六タルト」とは一線を画し、あえて一六本舗のイメージを打ち破る商品を目指してつくられた、愛媛県産伊予柑の風味豊かなマドレーヌ。「食べた人が幸せになるようなお菓子」をコンセプトに企画開発され、味はもちろん、ネーミングやデザインにも遊び心とこだわりが光る。伊予柑の濃縮果汁と細かく刻んだピールを混ぜ込んで焼き上げた生地は、しっとりジューシー。爽やかな香りが楽しめる。

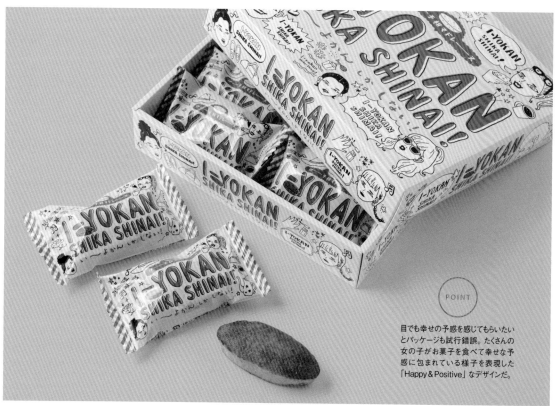

**POINT**

目でも幸せの予感を感じてもらいたいとパッケージも試行錯誤。たくさんの女の子がお菓子を食べて幸せな予感に包まれている様子を表現した「Happy＆Positive」なデザインだ。

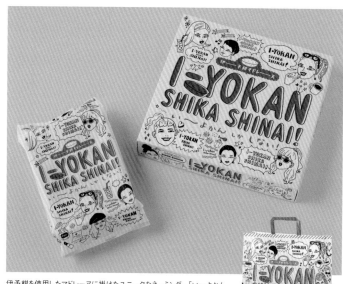

伊予柑を使用したマドレーヌに掛けたユニークなネーミング。「い〜よかんがする」ではなく、「い〜よかんしかしない！」と、あえて打消しの「ない」を用いることで、異質感とインパクト効果を狙った。

### 📕 DATA

販売元：株式会社一六
商品ネーミング：株式会社一六
CD・AD：佐々木 亨（電通西日本）
AD・D：西山あきえ（ポワント）
D：森田菜摘（ポワント）
I：藤本けいこ
広告会社：電通西日本
デザイン会社：ポワント

●商品名
・い〜よかんしかしない！

●主な販売場所
・直営店舗
　（一六本舗：県内28店舗）
・松山空港
・松山駅
・県内主要SA
・いよてつ高島屋
・松山三越
・公式オンラインショップ
・道後商店街お土産店
など

## 素朴な味とノスタルジックなデザインで若年層の心をキャッチ

### コメオコシ・パットライス　　株式会社金沢製菓

戦後、食べ物が不足していた時代に、子どもたちに甘いものを食べさせてあげたいという思いから生まれたポン菓子。愛媛では古くより結婚式など慶事の引き出物としても親しまれてきた。その文化を70余年にわたり受け継いできた金沢製菓の人気商品が、この「コメオコシ」と「パットライス」だ。若い世代にも親しんで欲しいと、現在の3代目が代替わりを機にパッケージを一新し、新しいフレーバーも投入。地元農家にポン菓子用に栽培してもらっているという良質で大粒の米を使い、代々伝わる手づくり製法で丁寧につくられている。秘伝の水飴で仕上げるまろやかな甘みとサクサクの味わいは、飽きのこない美味しさ。

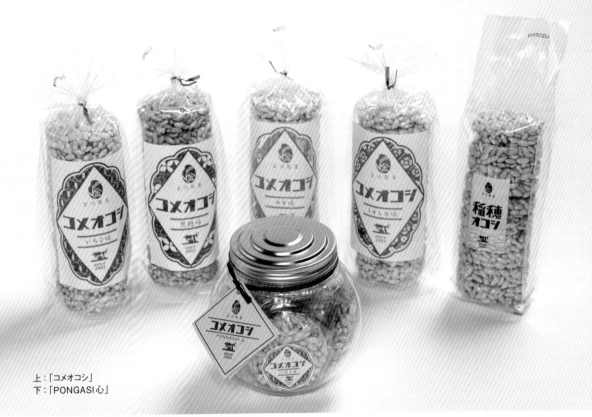

上：「コメオコシ」
下：「PONGASI心」

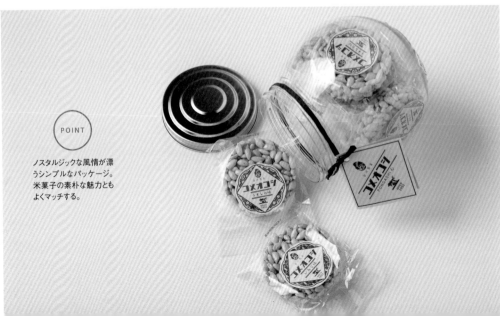

POINT

ノスタルジックな風情が漂うシンプルなパッケージ。米菓子の素朴な魅力ともよくマッチする。

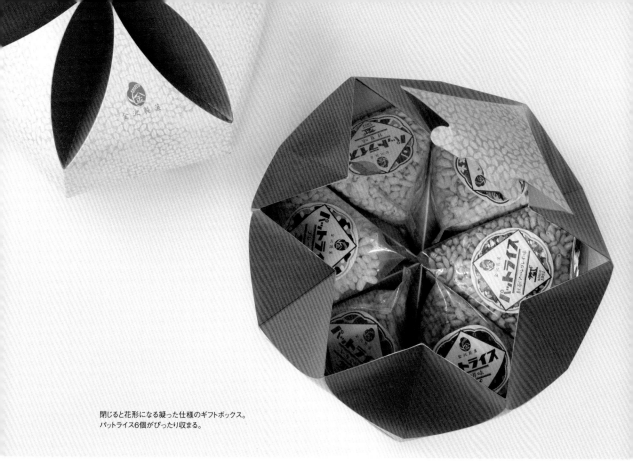

閉じると花形になる凝った仕様のギフトボックス。
パットライス6個がぴったり収まる。

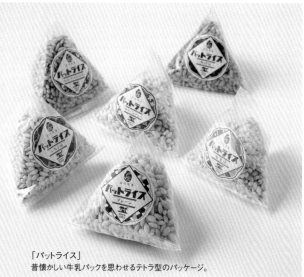

「パットライス」
昔懐かしい牛乳パックを思わせるテトラ型のパッケージ。

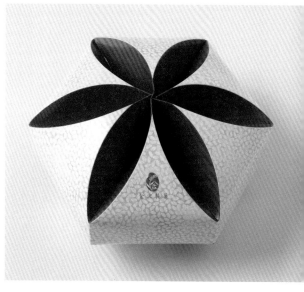

## ▌DATA

販売元：株式会社金沢製菓
D：株式会社フクイ商会

●商品名
・コメオコシ（うすしお味、黒糖
味、柚子味、いちご味）
・パットライス（プレーン味、いち
ご味、甘夏味、珈琲味、
グリーンティー味、アールグレイ
［紅茶］味）
・PONGASI心

●主な販売場所
・海街商店（金沢製菓直売店）
・松山空港
・成城石井
・阪神阪急百貨店
・セブン&アイグループ
・イカリスーパー など

海街商店

**高知** パプリカのレッドをキーカラーに南国の快活なイメージを発信

## パプリカソース・パプリカナッツ　株式会社道の駅南国

高知県の玄関口、南国市にある道の駅「風良里」のオリジナル商品「パプリカソース」と「パプリカナッツ」。地元の生産者を応援すべく、地元産の赤パプリカを使い、女性を身体の中から美人にする美味しさを届けようと考案。化学調味料、砂糖不使用で、サラダや肉料理、魚料理、パスタなど自由自在に使える万能ソースは一度食べたら病みつきに。

**POINT**

南国の明るく快活なイメージとパプリカの色から赤をキーカラーとし、プラスティックの容器でさまざまな料理に幅広く使える軽やかさを表現。また、ロゴマークは南国（なんこく）と「つくる（COOK）」を掛け合わせて「なんCOOK（こっく）」からイメージ。

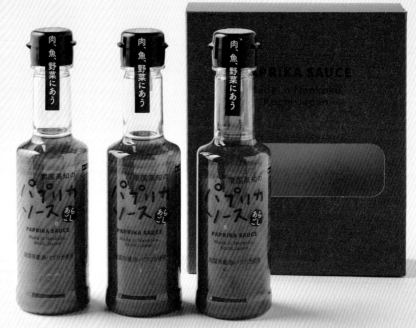

「パプリカソース」

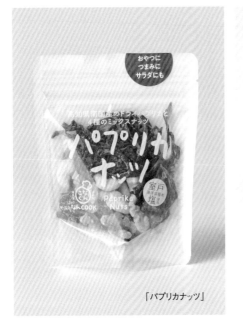

「パプリカナッツ」

**■ DATA**

販売元：株式会社道の駅南国
デザイン会社：坂東真奈（Bandesign）

●商品名
・パプリカソース
・パプリカナッツ

●販売場所
・道の駅南国
・高知龍馬空港
・アグリコレット
・自社オンラインショップ

# 切り抜きのシズル感あふれるラーメンに目が釘付け!

## 博多一杯ラーメンシリーズ　九州丸一食品株式会社

全国にファンを持つ博多ラーメンのお土産として注目される「博多一杯」。博多ラーメンの中でもそれぞれに異なる好みに対応すべく、あっさりからこってりまで3種類のスープを揃える。麺は独自製法で高水分を保った半生タイプで、口当たりなめらかな細麺がこだわりのスープとよく絡み、ラーメン通も納得の味。地元の常連や観光客で賑わう博多の屋台をイメージしたロゴや、スープの濃さまでわかるラーメンのビジュアルが食欲をそそる。

POINT

俯瞰で撮った調理例の写真を切り抜きで用いた、インパクトのあるパッケージ。太い黒文字であしらった「博多一杯」の商品名も、写真とバランスが取れている。

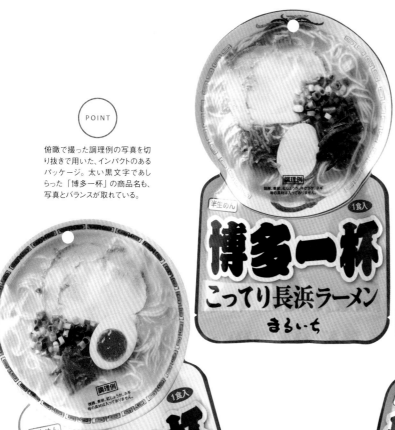

■ DATA

販売元:九州丸一食品株式会社
制作会社:株式会社第一紙行 九州支店
Dr:石川茉深加
D:宮近 靖

●商品名
・博多一杯 あっさり屋台ラーメン
・博多一杯 こってり長浜ラーメン
・博多一杯 特濃豚骨ラーメン

●主な販売場所
・JR博多駅
・福岡空港
・熊本空港
・九州各県のSA など

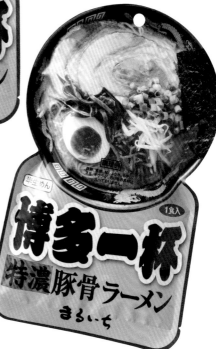

株式会社JALUX エアポート　BLUE SKY熊本空港店

「ラス君」のかわいさとコロコロ変わる表情に話題集中！

## ふくやラスク　株式会社ふくや

明太子でおなじみのふくやから、明太子の旨味を余すところなく生かした、ひとくちサイズのラスクが誕生。甘さの後に辛さがくる明太シュガーと、ガツンとパンチの効いた明太ガーリックの2種の味があり、気軽につまめるサクサクの食感は、おやつやおつまみにぴったりだ。さらに、キャラクターの「ラス君」をあしらった、インパクトのあるパッケージも注目の的。スリーブを動かすと表情がさまざまに変化するなど、楽しい工夫が随所にほどこされ、子どもも大人も笑顔になること請け合い。2022日本パッケージングコンテスト菓子包装部門賞。

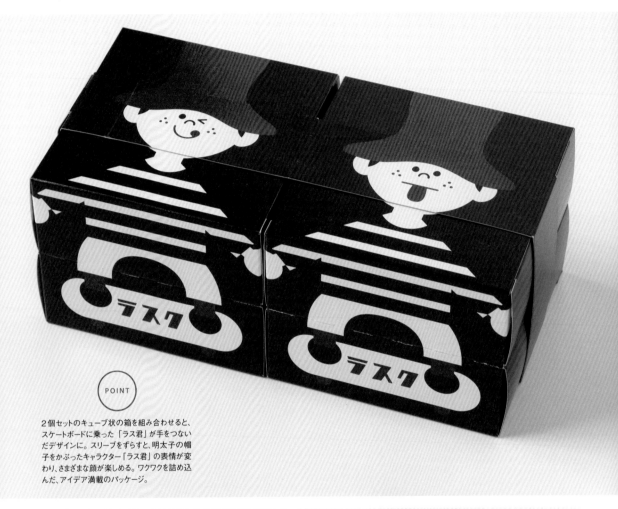

**POINT**

2個セットのキューブ状の箱を組み合わせると、スケートボードに乗った「ラス君」が手をつないだデザインに。スリーブをずらすと、明太子の帽子をかぶったキャラクター「ラス君」の表情が変わり、さまざまな顔が楽しめる。ワクワクを詰め込んだ、アイデア満載のパッケージ。

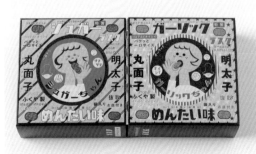

キューブ型のボックスは真ん中で本のように開き、中には昭和レトロなイラストが。真ん中が円状に切り抜ける仕様になっており、外した台紙はコースターやメンコに、切り抜いた台座はドリンクホルダーに使用できる。

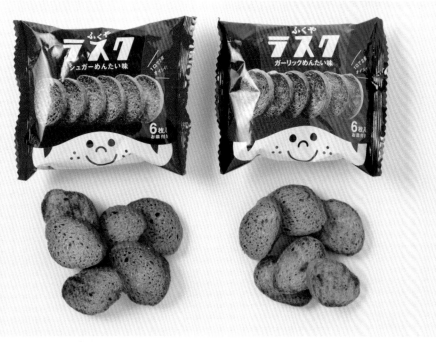

■ DATA

販売元：株式会社ふくや
AD：立元秀樹（株式会社ふくや）
CD：大野あすか（株式会社ふくや）
I：Koji Tomato

●商品名
・ふくやラスク めんたい味2箱セット

●主な販売場所

・ふくや直営店
・福岡空港
・博多駅
・自社オンラインショップ など

# 糸島産ブランド牛乳の、コクのあるやさしい甘さに舌鼓

## 糸島ミルクブランド　株式会社風美庵

福岡市場であまおう（いちご）に次ぐ新しい食材として、福岡を代表する糸島ブランドのノンホモ牛乳「伊都物語」に着目して開発された。ホワイトチョコを挟んだラングドシャはサクッと軽い口どけ。カスタード風味のあんを包み込み、ホワイトチョコでコーティングしたチョコエッグケイクは、文字どおり、卵さながらのかわいさ。搾りたてのように濃厚でコクのある伊都物語をたっぷり使っているため、口に含むとミルクの風味と自然な甘さがやさしく広がり、世代を問わず愛される味だ。ホルスタインのイラストをあしらったブランドラベルが目印。

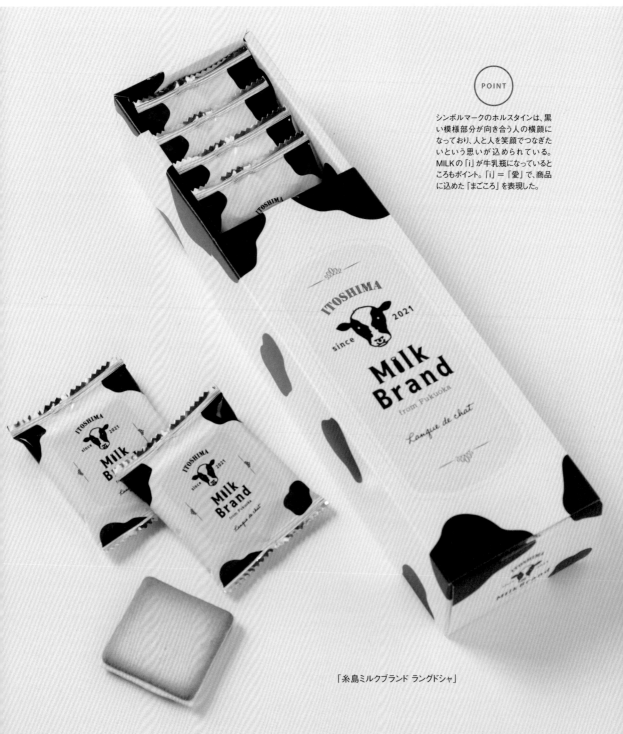

**POINT**

シンボルマークのホルスタインは、黒い模様部分が向き合う人の横顔になっており、人と人を笑顔でつなぎたいという思いが込められている。MILKの「i」が牛乳瓶になっているところもポイント。「i」＝「愛」で、商品に込めた「まごころ」を表現した。

「糸島ミルクブランド　ラングドシャ」

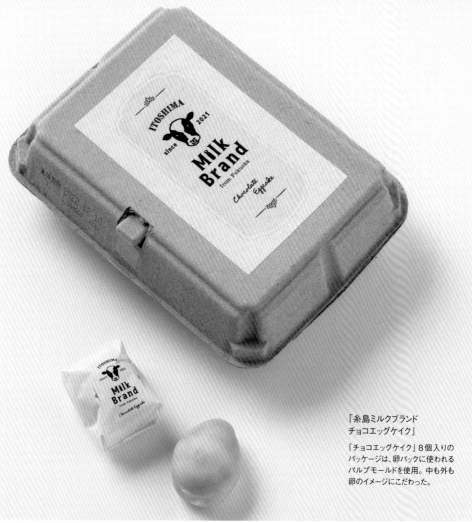

「糸島ミルクブランド
チョコエッグケイク」

「チョコエッグケイク」8個入りの
パッケージは、卵パックに使われる
パルプモールドを使用。中も外も
卵のイメージにこだわった。

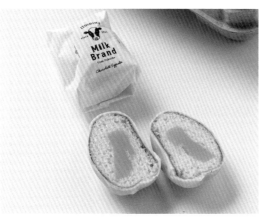

## ■ DATA

販売元：株式会社風美庵

●商品名
・糸島ミルクブランド ラングドシャ
・糸島ミルクブランド チョコエッグケイク

●主な販売場所

・直営店
・博多風美庵博多マイング店
・博多風美庵博多デイトス店

・博多駅
・おみやげ街道
・おみやげ本舗
・銘品蔵デイトス店
・小倉駅
・おみやげ街道ビエラ店
・福岡空港
・イオン福岡
・イオン糸島
・自社オンラインショップ など

博多風美庵マイング店

# 「博多手一本」から生まれた、縁起のいいハレの日のお菓子

## 祝うてサンド　石村萬盛堂

ロングセラーの博多銘菓「鶴乃子」で知られる老舗菓子屋・石村萬盛堂がつくる、福岡土産の新定番。「祝うてサンド」のおめでたい商品名は、博多の行事や祝いの席に欠かせない"締め"の風習「博多手一本」に由来する。手一本を連想させる手形のクッキーで、ほろ苦いキャラメルクリームとキャラメリゼしたクルミをサンド。食べ応えのある濃厚な味わいながら、クリームは後味のいい甘さでバタークッキーとの相性も抜群だ。ゆるいタッチのイラストや素朴な筆文字が、手にした人の笑顔を誘い、おめでたい席を盛り上げる。

**POINT**

ユーモラスなゆるカワの絵は、「仙厓さん」の名で知られる博多聖福寺の住職だった仙厓義梵の作。商品名の筆文字は福岡出身の書道家・西尾真紀氏が手掛けている。

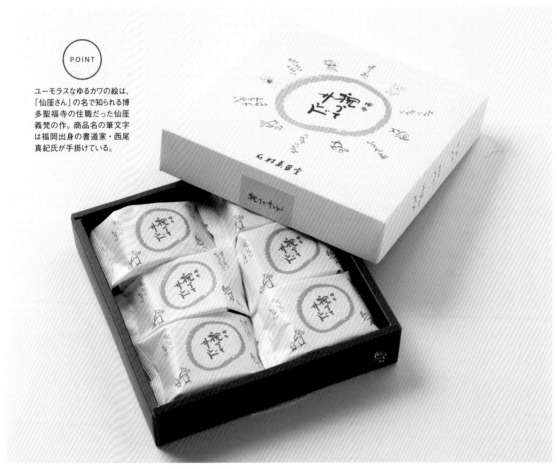

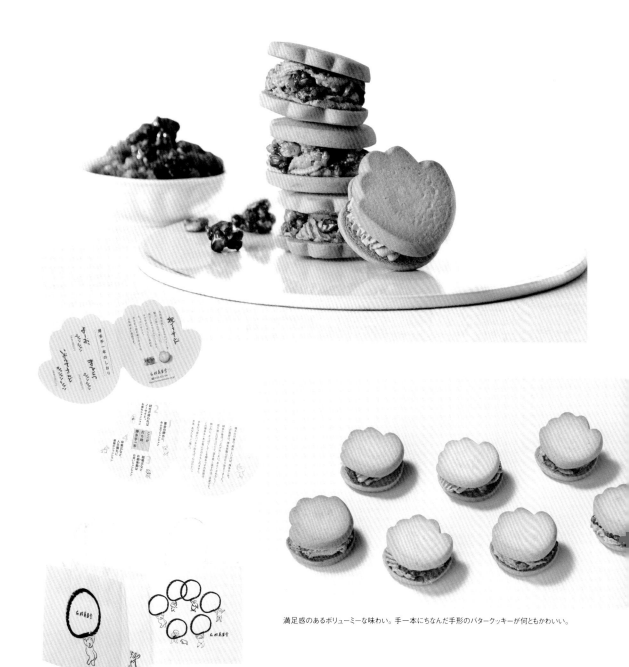

満足感のあるボリューミーな味わい。手一本にちなんだ手形のバタークッキーが何ともかわいい。

■ DATA

販売元：株式会社石村萬盛堂
D：株式会社石村萬盛堂
描き文字：西尾真紀（書道家）

●商品名

・祝うてサンド

●主な販売場所

・石村萬盛堂 各店舗
・いしむら 各店舗
・善太郎商店
・自社オンラインストア など

大丸 福岡天神店 催事出店

# あの地域の、あの味を、自宅で手軽に

## 茅乃舎 地域限定だしシリーズ　久原本家 茅乃舎

全国に茅乃舎の店舗が増えたことを受け、各店でのオリジナル商品を企画。その地域でしか買えないだしをつくることで、お土産としての付加価値を高め、各店の活性化につなげる目的で開発された。地域でなじみのあるだし素材を厳選し、その地域で食べられている郷土料理と相性のいい味を吟味。お土産、自宅用共に需要が高く、特に他県に送られるギフトには、この地域限定だしを入れたセットが人気だ。ご当地感あふれる素朴な魅力のパッケージや、だしの個性を生かしたレシピ付きの料理読本がついているところも、選ばれる理由のひとつ。

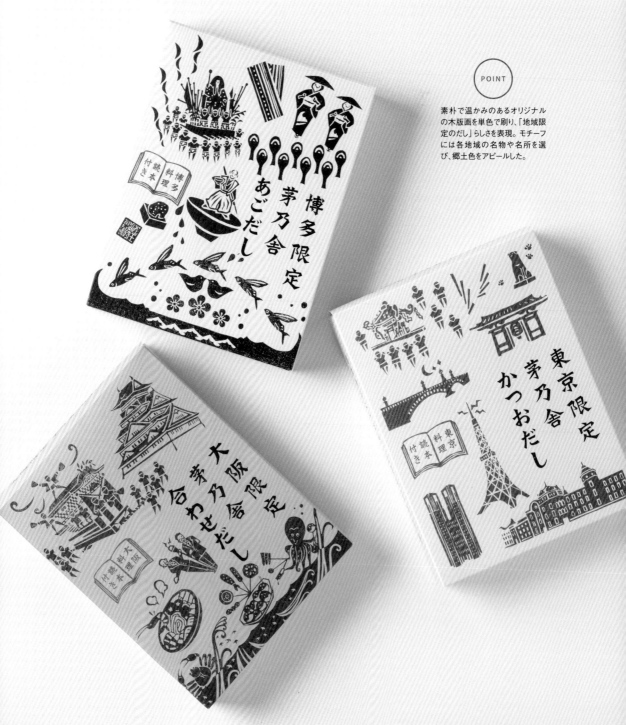

POINT

素朴で温かみのあるオリジナルの木版画を単色で刷り、「地域限定のだし」らしさを表現。モチーフには各地域の名物や名所を選び、郷土色をアピールした。

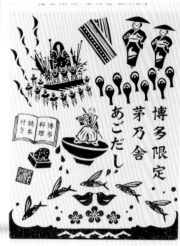

焼きあごとあご煮干し、2種のあごを中心に7つの素材を加えた、風味豊かな博多限定だし。

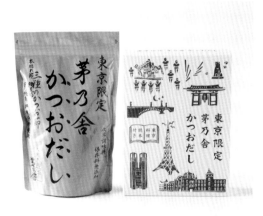

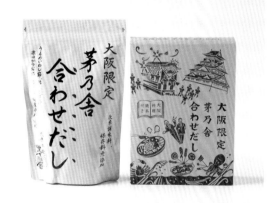

香りのよい鰹荒節、澄んだ旨味の本枯れ節、旨味の強い宗田鰹節。3種の鰹の風味に真昆布の旨味を加えた、キレのある味わいの東京限定だし。

うるめいわし節、枯れさば節、宗田鰹節など3種の節と真昆布を合わせた、しっかりした旨味の大阪限定だし。

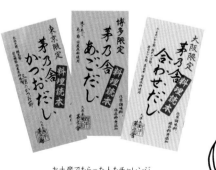

お土産でもらった人もチャレンジしやすい、身近な食材でつくれるご当地料理を紹介した読本付き。

## ■ DATA

販売元：久原本家 茅乃舎
CD：水野学（good design company）
D：久原本家クリエイティブ企画課
木版画作成：加藤光穂（竹笹堂）

●商品名

・博多限定 茅乃舎あごだし 贈答箱入
・東京限定 茅乃舎かつおだし 贈答箱入
・大阪限定 茅乃舎合わせだし 贈答箱入

●販売場所

〈博多限定 茅乃舎あごだし 贈答箱入〉
・久原本家 総本店
・久原本家 ららぽーと福岡店
・福岡天神岩田屋店
・博多駅デイトス店
・小倉井筒屋店
・福岡空港店（ゲート外）

〈東京限定 茅乃舎かつおだし 贈答箱入〉
・コレド室町 日本橋店
・東京駅店
・東京ミッドタウン店
・茅乃舎分店 アトレ恵比寿
・髙島屋新宿店
・玉川髙島屋Ｓ・Ｃ店
・髙島屋立川店

〈大阪限定 茅乃舎合わせだし 贈答箱入〉
・グランフロント大阪店
・髙島屋大阪店
・大丸心斎橋店

## チョコとあまおうの甘酢っぱさがベストマッチ

### あまおうチョコタルト　株式会社風美庵

東京風美庵がプロデュースする、いちごを使った焼き菓子専門店「苺のワルツ」が、福岡産のあまおうを主役に考案したチョコレートタルトクッキー。いちご型のサクッとしたクッキーに、あまおうのチョコクリーム&ホワイトチョコクリームの2層を入れて焼き上げた。いちごの甘酸っぱさとチョコの甘さがよく合い、シンプルないちごのかたちもキュート。パッケージは白とピンクを基調に、いちごをつまむ女性の指を描いた柔らかいタッチのイラストで、かわいらしくやさしい雰囲気に仕上げている。手土産からティータイムのお供まで、さまざまな用途に選びやすいさりげないデザイン。

**POINT**

コロナで増えた"おうち時間"に笑顔を届けたいと、自家需要を前提にデザイン。手描きのやさしいイラストを配した、日常にそっと溶け込むパッケージだ。

ころんとしたいちご型と、ほんのりピンクが愛らしい。

福岡空港店

■ **DATA**

販売元：株式会社風美庵
D・I：田本枝里

●商品名
・あまおうチョコタルト

●主な販売場所
・直営店
・博多風美庵博多マイング店
・福岡空港店
・エキュート立川店
・博多駅

・おみやげ市場
・銘品蔵デイトス店
・小倉駅
・おみやげ街道
・自社オンラインショップ など

# 野鳥ファンの心をわしづかみ！べにふうき100%の本格和紅茶

## 対馬紅茶 野鳥パッケージ　つしま大石農園

「渡り鳥の交差点」とも呼ばれる対馬にやってくる旅鳥たちをパッケージにした、対馬紅茶のティーバッグ。野鳥に関心を持つ人が増え、対馬の魅力を知ってもらうきっかけになればと、お茶と柚子を生産・加工するつしま大石農園が開発した。農園で栽培する「べにふうき」茶葉を手作業で丁寧に仕上げた対馬紅茶は、蜜のような甘さとフルーティーな香り、透明感のある濃いべっ甲色の水色（すいしょく）が特徴。和洋の食事を選ばず、専門家から高い評価を受けている本格和紅茶だ。バードウォッチャーはもちろん、幅広い層に喜ばれる対馬の新しいお土産として注目されている。

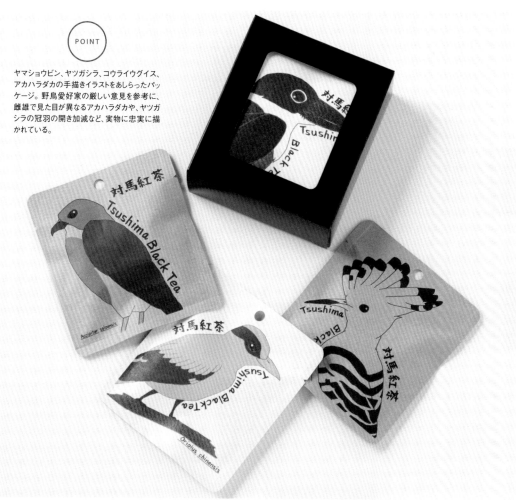

**POINT**

ヤマショウビン、ヤツガシラ、コウライウグイス、アカハラダカの手描きイラストをあしらったパッケージ。野鳥愛好家の厳しい意見を参考に、雌雄で見た目が異なるアカハラダカや、ヤツガシラの冠羽の開き加減など、実物に忠実に描かれている。

渡り鳥への興味が深まるよう、裏面には各鳥の特徴がわかりやすく説明されている。

**■ DATA**

販売元：つしま大石農園

●商品名
・対馬紅茶 野鳥パッケージ（ヤマショウビン、ヤツガシラ、コウライウグイス、アカハラダカ）

●主な販売場所
・対馬島内の主要お土産店（対馬空港、ふれあい処つしま など）
・ながさき食べんばLabo.（長崎駅かもめ市場）
・自社オンラインショップ など

## 美味しく食べて食品ロス削減に貢献できる五島列島グルメ

### おはようのスープ・おやすみのスープ・五島の鯛で出汁をとったなんにでもあうカレー

ごと株式会社

長崎県五島列島の食品メーカーが、規格外のさつまいもやトマトをペースト状やピューレにして使用することで食品ロス削減に配慮した商品として開発。「おはようのスープ」は「五島ごと芋」を使った濃厚ながらもやさしい甘口の味わいが目覚めの一杯にぴったり。「おやすみのスープ」は果実のような甘さが特徴のトマト「五島ルビー」をベースに、もち麦やひよこ豆、トリッパやごぼうを使用することでさまざまな食感を楽しめる、満足感のある一品。「五島の鯛で出汁をとったなんにでもあうカレー」も同様に食品ロス削減に配慮した商品だ。

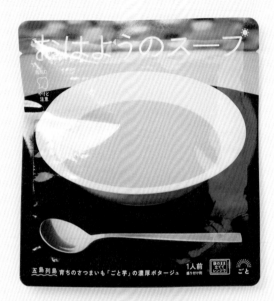
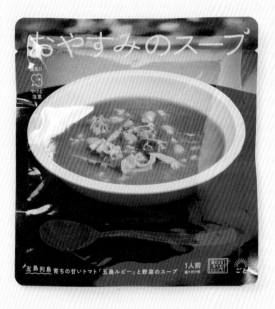

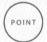
POINT

「五島の空気まで味わって欲しい」という思いから、まず「スープを食べながら海をのぞむイラスト」をイラストレーターの永井 博氏に依頼。海外の海を描くことが多い永井氏が描く五島の海は、五島が海外とのつながりの中で築いてきた文化や歴史をも感じさせる。パッケージではそのイラストの世界を実際につくり、朝の光と夜の光で撮影。イラストの持つ空気感を写真で再現する不思議な仕上がりを目指した。この世界観を音楽のように感じられるように、商品紹介リーフレットはレコードジャケットのサイズで制作。

朝と夜、時間がないときでも簡単に食べられるように電子レンジで温め可能な仕様に。レンジ対応タイプの中でも遮光性があるものなので、時間が経っても中身の劣化は少ない。その分色が沈みやすかったが、何度も色調整を行ない、デザインの表現と中身の劣化への対応、どちらも納得できるものに仕上げた。

POINT

五島近海の新鮮な鯛のだしがベースの
レトルトカレー。だしに昆布を加えること
ですっきりとした旨味が特徴。さまざまな
具材と合わせたり、カレーソースとしても
活用できる商品の特徴が伝わるように
極力要素を少なくし、シンプルなパッケー
ジで「なんにでもあう」ということを表現。
2色のカラーで分かれるラインは五島の
水平線をイメージする。素材をマットにす
ることで、よりシンプルでスタイリッシュに。
また、家庭で保存しやすいようパッケー
ジ全体を小さめにし、スタンドタイプで立
てられるように工夫している。

福神漬けのような小冊子

■DATA

〈おはようのスープ／おやすみのスープ〉
販売元：ごと株式会社
AD：大来 優（dentsu）
C：有元沙矢香（dentsu）
D・デザイン会社：姉帯寛明（ワーク
アップたき）
Ph：花房 遼
美術：宮守由衣（Diamond Snap）

〈五島の鯛で出汁をとったなんにでも
あうカレー〉
AD：大来 優（dentsu）
C：鳥巣智行
D・デザイン会社：姉帯寛明（ワーク
アップたき）
PR：下元翔太郎（dentsu）

●商品名
・おはようのスープ
・おやすみのスープ
・五島の鯛で出汁をとった
なんにでもあうカレー（プレーン、
チーズ、チキン、ポーク、ビーフ）

●販売場所
・おみやげ＆カフェ ごと
・五島つばき空港
・福江港ターミナル
・日本橋長崎館（東京）
・自社オンラインショップ

# 良質な小豆と地域ブランド「球磨焼酎」の風味が命

## 熊本焼酎もなか　　株式会社木村

熊本県人吉地区で銘菓として親しまれていた「熊本焼酎もなか」を、より多くの人に味わってもらいたいと、味、パッケージ共にリニューアル。厳選した小豆に、良質な米と水を使用した人吉・球磨の地域ブランド焼酎「球磨焼酎」を加えて炊き上げた粒あんを、昔ながらの瓶型最中に丁寧に手詰めした。豊かな風味と香りを残しながらも、アルコールは製造段階で0%になっているので、子どもにも安心。舌触りのいい程よい甘さの小倉あんと、なめらかで豊かな風味の栗あんの2種類アソートになっている。

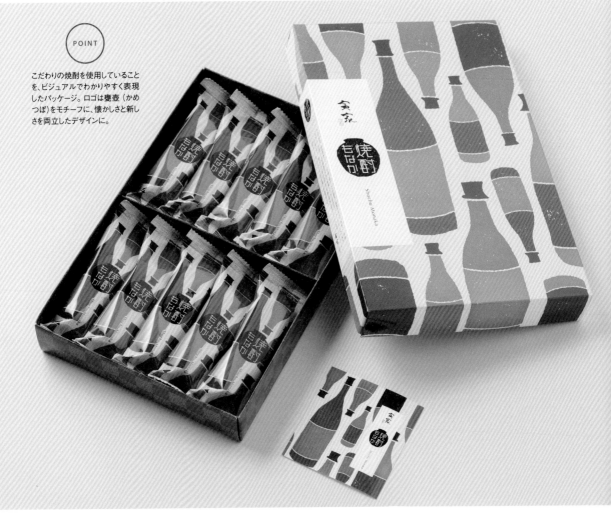

**POINT**

こだわりの焼酎を使用していることを、ビジュアルでわかりやすく表現したパッケージ。ロゴは甕壺（かめつぼ）をモチーフに、懐かしさと新しさを両立したデザインに。

焼酎瓶型のサクサク最中の中に、「球磨焼酎」の風味豊かな粒あんがたっぷり。

■ **DATA** ··········

販売元：株式会社木村
制作会社：株式会社木村

●商品名
・熊本焼酎もなか

●主な販売場所
・熊本空港
・鶴屋百貨店
・熊本県内各種SA
・道の駅大津 など

宮崎

# 高千穂郷・椎葉山地域の個性豊かな蕎麦の味わいを色で表現

## 九州山蕎麦 世界農業遺産5種　椎葉屋

九州山地に位置する高千穂郷・椎葉山地域には環境と共存した伝統的な農法が多く残されており、世界農業遺産の認定を受けている。この地域を構成する5つの町村の特産品を活かした蕎麦が「九州山蕎麦セット」。高千穂町の米粉を使用したもちもち食感が特徴の「米そば」、香り高い日之影町ゆずを使用した「ゆずそば」、五ヶ瀬町の釜炒り茶を練り込んだ深緑の「釜炒り茶そば」、「世界森林認証」を取得した、諸塚村産椎茸で仕立てた「椎茸そば」、椎葉村のそばの香りが楽しめるシンプルな「純そば」といった5種類の蕎麦が楽しめる。

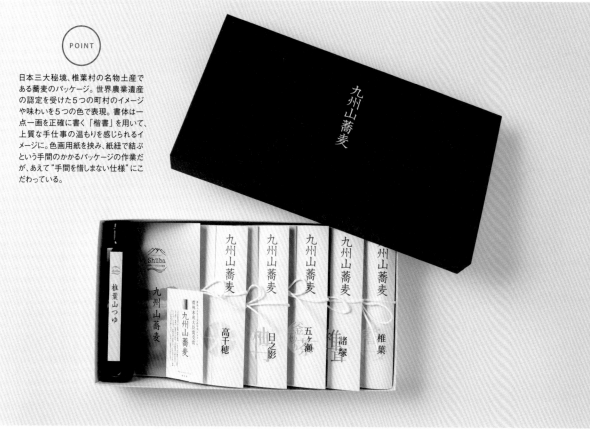

**POINT**

日本三大秘境、椎葉村の名物土産である蕎麦のパッケージ。世界農業遺産の認定を受けた5つの町村のイメージや味わいを5つの色で表現。書体は一点一画を正確に書く「楷書」を用いて、上質な手仕事の温もりを感じられるイメージに。色画用紙を挟み、紙紐で結ぶという手間のかかるパッケージの作業だが、あえて"手間を惜しまない仕様"にこだわっている。

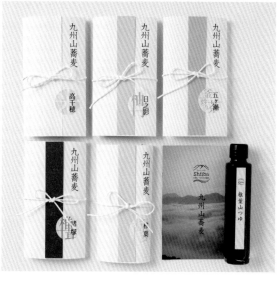

**■ DATA**

販売元：九州山蕎麦十割
デザイン会社：オノコボデザイン
AD：小野信介

●商品名
・九州山蕎麦 世界農業遺産5種

●主な販売場所
・自社オンラインショップ など

## 大分 いちご農園が自家製いちごでつくるスペシャルスイーツ

### 大分ごいち・大分バラッズ　オードファーム

大分のいちご農園・オードファームが、いちご本来の味が楽しめるお菓子を県内外に届けたいと、企画から手掛けて誕生したお菓子。雨の香りをイメージしてつくられた「大分ごいち」は、自家製いちごとあんのペーストを、ラム酒とシナモンで香りづけした生地でしっとりと焼き上げた。一方の「大分バラッズ」は、晴れの香りをイメージ。チョコレートクリームに大分の特産品であるかぼすのピールや柚子胡椒を加え、いちごの果肉を練り込んだ生地で挟んだ華やかでスパイシーなサブレだ。それぞれの世界観を表した美しいパッケージも、期待感を高める。

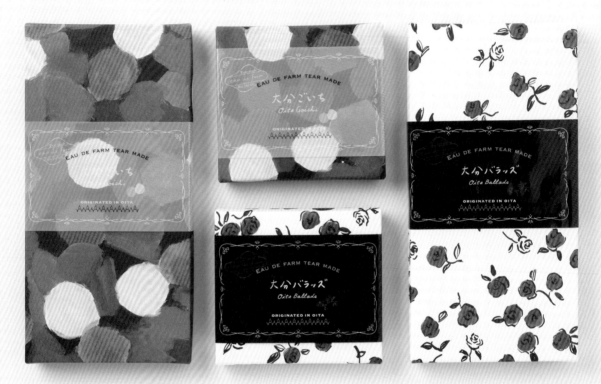

POINT　「大分ごいち」は雨の香り、「大分バラッズ」は晴れの香りのイメージで、人気イラストレーターの網中いづる氏がデザインを手掛けている。

フタの内側はシックなモノトーン。開けた時にお菓子が映える。

「大分ごいち」

いちごとあんをラムやシナモン
風味の生地で挟んだ「大分ご
いち」は、ロマンチックな風情
が漂う和風のお菓子。

「大分バラッズ」

チョコレートクリームに胡椒を
効かせた「大分バラッズ」は、
甘美なバラのようにスイート＆
スパイシー。「大分ごいち」共
に日持ちするので、どちらもお
土産にぴったり。

■ DATA

販売元：オードファーム
AD・D：西口顕一
I：網中いづる
PL：オードファーム

●商品名

・大分ごいち
・大分バラッズ

●販売場所

・大分駅銘品蔵
・別府駅銘品蔵
・星野リゾート 界 由布院

## 遊び心が楽しめる、見た目はタバコのご当地銘茶

### 鹿児島チャバコ（あらびき緑茶・あらびき玄米茶・抹茶）　株式会社ショータイム

見た目はタバコそっくり。ジョークと遊び心がたっぷり詰まったパッケージが話題の商品。お茶を通じて笑顔のひとときを提供したいという思いのもと、「世の中を、茶化そう。」をコンセプトに誕生した。販売方法のひとつとして、タバコの自動販売機を再利用していることでも注目されている。自然豊かな鹿児島の大地で育まれた茶葉を100%使用し、急須が不要なスティックタイプの粉末仕様で、ペットボトルに入れて振るだけで本格的な茶葉を味わえる。

POINT

お土産としてわかりやすく表面は西郷さん、裏面は桜島をモチーフにしたデザインに。タバコの警告表示の部分は、お茶ならではのポジティブな「宣伝文」に。楽しいコミュニケーションが生まれる工夫がされている。

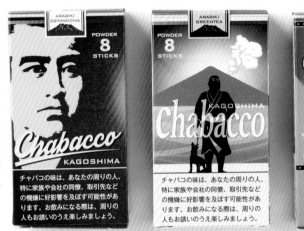

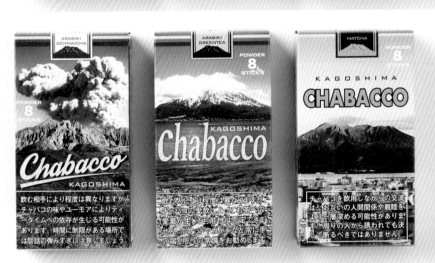

### ■ DATA

販売元：株式会社ショータイム

●商品名

・鹿児島チャバコ（あらびき緑茶・あらびき玄米茶・抹茶）

●主な販売場所

・鹿児島空港
・鹿児島県内の主要道の駅及びSA など

# 県内46酒造所の泡盛とダークチョコのマリアージュ

## 泡盛BONBONショコラ・MAKUKURU古酒泡盛BONBONショコラ　　株式会社ファッションキャンディ

沖縄の特性を生かしたインパクトのある男性向け商品の素材として、地酒の「泡盛」に着目してつくられた、大人のボンボンチョコレート。特筆すべきは、全46酒造所の泡盛を使っていること。泡盛の新しい味わいを提案することで県外に泡盛ファンを増やし、消費の拡大につなげたいと県内の酒造所に協力を仰いで実現した。沖縄の資源にもこだわり、泡盛の割り水には沖縄の地下から取水したミネラル豊富な古代海水「陸地珊瑚礁浸透古代海水」と、沖縄県産のきび糖を使用。コクのあるまろやかな味わいと、馥郁（ふくいく）とした余韻を堪能したい。

POINT

沖縄県内46酒造所を代表する泡盛のラベルシールを作成。外箱の紙は、控えめなエンボスと落ち着いた雰囲気が特徴の「タント」を使用。シックな黒に金の箔押しが映え、大人の男性にふさわしい高級感が漂う。

「泡盛BONBONショコラ」

厳選した人気の泡盛をダークチョコに封じ込めた「泡盛BONBONショコラ」。

「MAKUKURU古酒泡盛BONBONショコラ」

泡盛の中でも3年以上寝かせて熟成させた古酒（クース）を使った「MAKUKURU古酒泡盛BONBONショコラ」。カカオ70%のダークチョコレートのほろ苦さと、ブレンドした泡盛の香りと甘さが三位一体となり、芳醇な味わい。

### ■ DATA

販売元：株式会社ファッションキャンディ
デザイン会社：株式会社ファッションキャンディ

●商品名

・泡盛BONBONショコラ
・MAKUKURU古酒泡盛BONBONショコラ

●販売場所

・自社オンラインショップ

## 沖縄気分と美味しい食材を、目と舌で味わいたい

### 紅ちゅらまん・シークヮーサーまん　株式会社なはかた

「博多通りもん」でおなじみの明月堂が手掛ける、紅芋とシークヮーサーといった沖縄を代表する農作物を使ったおまんじゅう。「紅ちゅらまん」は、舌触りのいいクリーミーな紅芋と柔らかい白あんに波照間産黒糖のコクのある甘さを加え、紅芋を使ったしっとりとした皮で包んだ。沖縄県の本土復帰50周年記念に出した「シークヮーサーまん」はシークヮーサーをたっぷり使ったこだわりのジュレをイン。甘さの中にも爽やかな風味と酸味が楽しめる。沖縄らしくトロピカルで楽しげなパッケージは、旅の思い出や高揚感も一緒に持ち帰れそうだ。

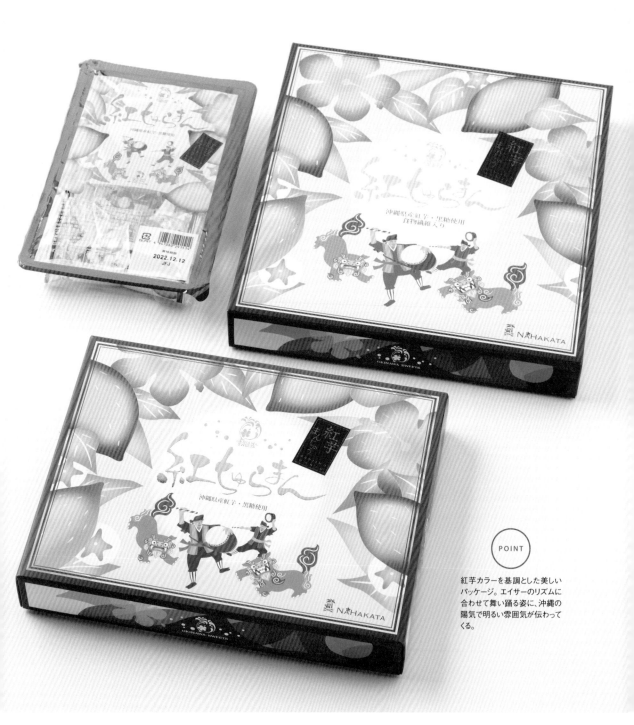

**POINT**

紅芋カラーを基調とした美しいパッケージ。エイサーのリズムに合わせて舞い踊る姿に、沖縄の陽気で明るい雰囲気が伝わってくる。

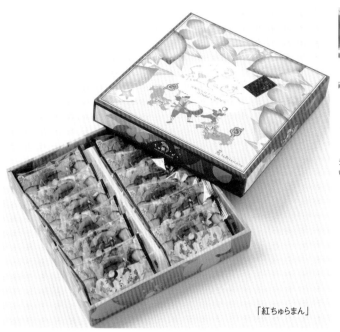

シーサーのイラストには、商品に関連する8文字のカタカナが隠されている。見つけられるかな？

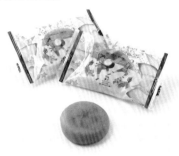

「紅ちゅらまん」

「シークヮーサーまん」
シークヮーサーを象徴するイエロー＆グリーンのパッケージは、たくさんのお土産が並ぶ空港の売り場でも目を引く。

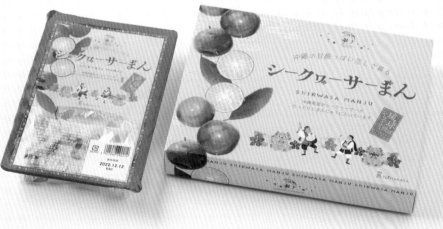

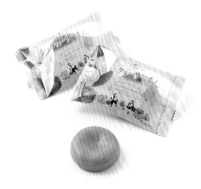

## ■ DATA

| | | | |
|---|---|---|---|
| 販売元：株式会社なはかた<br>製造元：株式会社明月堂 | 〈紅ちゅらまん〉<br>デザイン会社：九州パッケージ株式会社<br>AD：鰰澤亜継<br>D：小笹千晶<br>I：喜多佑介（喜多デザイン舎） | 〈シークヮーサーまん〉<br>デザイン会社：九州パッケージ株式会社<br>AD：鰰澤亜継<br>D：中尾翼子<br>I：小笹千晶 | ●商品名<br>・紅ちゅらまん<br>・シークヮーサーまん<br><br>●販売場所<br>・那覇空港<br>・自社オンラインショップ<br>（紅ちゅらまんのみ） |

沖縄素材と老舗和菓子店の技を織り交ぜた、新しい最中菓子

## 首里城最中　デパートリウボウ 樂園百貨店

沖縄唯一の地元百貨店、デパートリウボウが手掛ける自主編集ショップ「樂園百貨店」の看板商品として生まれた商品。2019年10月に焼失してしまった沖縄県のシンボル「首里城」をモチーフにした、新しい最中菓子。細やかに正殿をかたどった最中は1950年創業の最中の名店、東京練馬区のあわ家惣兵衛が製造。確かな技術で生み出される美味しい味わいに沖縄の素材が融合した、これまでになかった菓子で、フレーバーは塩や黒糖、シークヮーサーに紅芋などといった沖縄らしいラインナップ。沖縄の伝統的な染色技法「紅型」を用いたパッケージも特別感があり、お土産にうってつけだ。売上金の一部は首里城復興の支援金として寄付される。

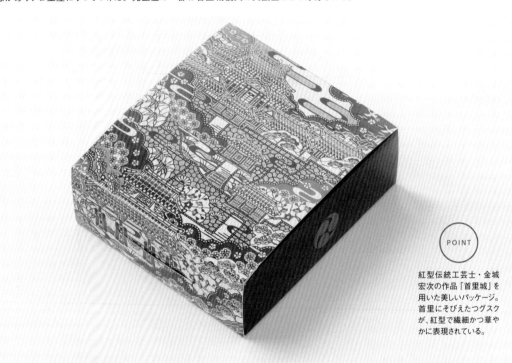

**POINT**

紅型伝統工芸士・金城宏次の作品「首里城」を用いた美しいパッケージ。首里にそびえたつグスクが、紅型で繊細かつ華やかに表現されている。

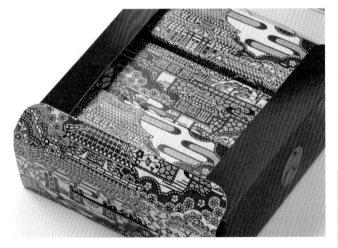

## ■ DATA

販売元：デパートリウボウ

●商品名
・首里城最中（塩あん&クリーム、黒糖あん、シークヮーサーあん、紅芋あん）

●販売場所
・デパートリウボウ 2階 樂園百貨店
・樂園百貨店オンラインストア
※一部商品は首里城売店「紅型」・「球陽」にて販売

首里城正殿のモチーフをかたどった最中。手頃なサイズ感ながら、あんがたっぷり詰まって食べ応えがある。

# 旨味の中のピリッとした辛さが後を引く

## 沖縄 島唐辛子せんべい　株式会社リウボウ商事

甘い系のお土産菓子が多い中で、「塩系（辛い）」「賞味期間が長い」「軽くて持ち帰りしやすい」をコンセプトに開発。一般的な唐辛子に比べて2～3倍の辛さがあると言われ、1kgあたり2万円以上する希少な「島唐辛子」をたっぷり使用した薄焼きせんべいは、パリッとした軽い歯ごたえと、後からくる辛味がクセになる旨さ。パッケージは、アメリカ文化に強く影響を受けている沖縄の地域性を踏まえた"アメコミ"風のデザインで、「沖縄とアメリカ文化のチャンプルー（混合文化）」をアピールしている。那覇空港でしか手に入らないレア商品。

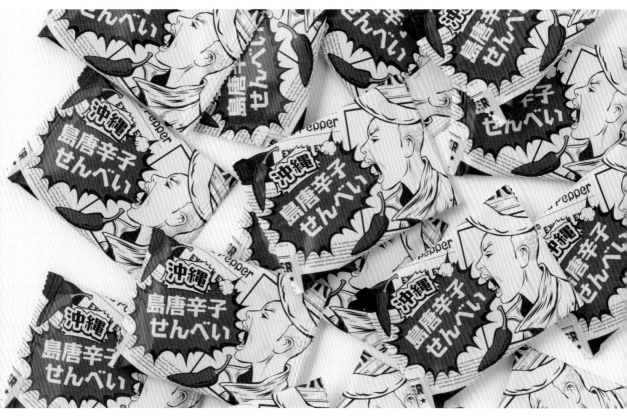

**POINT** アメコミ風の楽しいPOPなパッケージ。上下に描かれたシーサーが沖縄らしさを添え、沖縄とアメリカ文化との融合を表している。

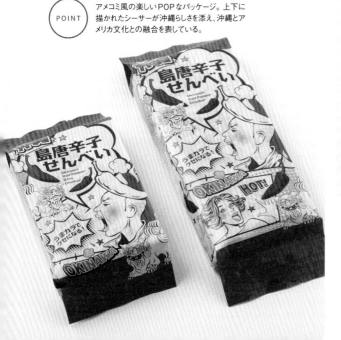

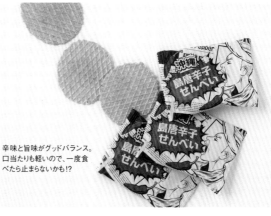

辛味と旨味がグッドバランス。口当たりも軽いので、一度食べたら止まらないかも!?

### ■ DATA

販売元：株式会社リウボウ商事
デザイン会社：株式会社フジノネ

●商品名
・沖縄 島唐辛子せんべい（8枚入、15枚入）

●販売場所
・リウボウ那覇空港店 JAL側売店
・リウボウ那覇空港店 ANA側売店

# 企業別索引

STAFF

カバーデザイン：赤井佑輔 (paragram)

編集：内田真由美 (impact)
執筆：杉瀬由希、横田可奈
本文デザイン：粟田和彦、粟田祐加 (impact)
撮影：髙橋 榮 (IDEAFOTO STUDIO)

# 地域を活かす！
# おいしいお土産のアイデアとデザイン

2023 年 2 月 25 日　初版第 1 刷発行

| | |
|---|---|
| 編　者 | インパクト・コミュニケーションズ |
| 発行者 | 西川正伸 |
| 発行所 | 株式会社 グラフィック社 |
| | 〒 102-0073 東京都千代田区九段北 1-14-17 |
| | TEL 03-3263-4318　FAX 03-3263-5297 |
| | http://www.graphicsha.co.jp |
| | 振替 00130-6-114345 |
| 印刷・製本 | 図書印刷株式会社 |

ISBN978-4-7661-3718-7 C3070
2023 Printed in Japan

[本書の掲載情報について]
本書に掲載した情報は 2023 年 1 月時点のものです。掲載した商品及びパッケージには現在販売（使用）されていない
ものもあります。商品及びパッケージについて各メーカー・店舗へのお問い合わせはお控えください。